WHY WE MAKE

Art

AND WHY IT IS TAUGHT

RICHARD HICKMAN

Richard Hickman is Senior Lecturer in education at Cambridge University, UK and is a practising artist.

Frontispiece: *Untitled* Acrylic on Board 30x60 cm Gareth Watkins, 1999. Gareth was Artist in Residence at Homerton College Cambridge during 1999; he took his own life the following year. **Royalties from sales of this book will be given to Amnesty International.**

Why We Make Art
and Why it is Taught

Richard Hickman

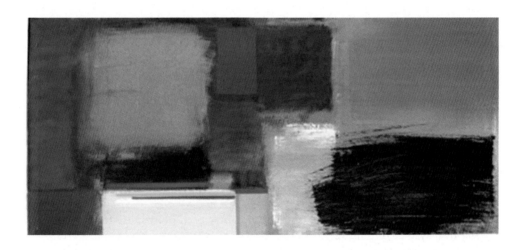

intellect™
Bristol, UK
Portland, OR, USA

First Published in the UK in 2005 by
Intellect Books, PO Box 862, Bristol BS99 1DE, UK
First Published in the USA in 2005 by
Intellect Books, ISBS, 920 NE 58th Ave. Suite 300, Portland, Oregon 97213-3786, USA
Copyright ©2005 Intellect Ltd

A catalogue record for this book is available from the British Library

ISBN 1-84150-126-3
Copy Editor: Wendi Momen
Book & Cover Design: Gabriel Solomons
Production: May Yao

Printed and bound by The Cromwell Press, Wiltshire, UK.

Contents

Acknowledgements

I would like to put on record my gratitude to the University of Cambridge Faculty of Education for giving me time and space.

Many people have given practical, emotional and intellectual help with this book. I want to highlight the following people without whom the book could not have been written: Dr Anne Sinkinson for her helpful and perceptive observations on the initial draft; Ros McLellan for her extremely efficient and thorough analysis of questionnaires and Anastasia Planitsiadou for her general support and help with Greek questionnaires. I would also like to thank my wonderful PGCE students and all the people I interviewed, especially those who later took the trouble to e-mail or write to me with their thoughts on art-making.

RH

Preface

Are artists born or made? What is the driving force behind producing art works? Are schools facilitating or denying artistic development? What kind of art curriculum in our schools could cater for the developing needs of young people? What is the value in learning *about* art? Is assessment of young people's performance in art a help or a hindrance? These are the kind of questions which are examined in this book. Interviews with artists, school pupils, students and others who create things we might call art have helped provide an insight into the artistic process and the motivating force behind it.

The biggest and perhaps the most controversial of the above questions is the first. As Steven Pinker has noted [1] it has become taboo to even consider the possibility that human beings are born with certain aptitudes. When I was a young art teacher, the standard response to parents, colleagues and others who dared to suggest that a desire to draw and paint might be inherited, was that that sort of thinking ended up with the holocaust. This book is not about individual talent or artistic 'giftedness', it is concerned with the notion that the desire to create is a fundamental human urge which often unfolds naturally, but can be stunted or developed by cultural influences, including schooling.

Section One gives a brief general overview of the nature of art and its relationship to education. For the purposes of this book I use a fairly broad brush in the first section, to sketch in some background information. I have chosen to focus on artistic development as this is a theme which is fundamental to the issues which I am exploring. The core issues discussed in this book are derived from some introspection and contemplation upon my own practice and this has helped inform focused conversations with a number of people from differing backgrounds. The educational and other settings where I have worked and studied have enabled me to interact with other individuals who have been involved in art-making. This has given me many opportunities to talk about art in a personal and meaningful way. I have had the opportunity to meet with and talk to a range of different people about their art-making activities; the outcomes from these meetings are presented and discussed in Section Two. I have therefore chosen not to focus upon social and cultural issues, instead I have taken a broadly psychological perspective, informed by individual people's accounts as well as drawing upon autobiographical and textual information.

Section Three explores some of the issues which arise from the testimonies given in Section Two. These include a consideration of the nature and purpose of imagination and the role of expression in art-making as it relates to personal fulfilment; I make connections between this and themes of self-identity and self-esteem. Psychological issues are discussed, including the nature of creativity and its association with art. A major focus of this section is on schools

and schooling. I present a view of schools as institutions which are antipathetic to creativity in general and art-making in particular.

The final section, Section Four, considers the notion of 'creating aesthetic significance' as a fundamental human urge. It develops some of the issues highlighted in Section Three and puts forward some suggestions for an educational approach based on developmental psychology, with the art room as a model for schools and schooling. I advocate the desirability of giving school students more of a voice and also devote some space to the perennially problematic issue of assessing art.

I have attempted to draw together quite a few diverse ideas, culminating in reflections and observations in the final Section. Some of these ideas are more difficult to handle than others, and this is reflected in the various sections – some are lighter and easier to read than others – and, although there is a development of an argument hidden in there somewhere, each section ought to make sense on its own. To help the flow of the writing, I use the term 'art' throughout the book as a kind of shorthand. I hope that readers will be able to determine from the context whether this refers to 'art and design' – the preferred current nomenclature in the UK – or 'the arts', or indeed simply 'art' in the sense of painting, drawing, sculpting, printmaking etc. Similarly, I have made use of 'notes' at the end of each section which, in addition to giving precise references, amplify some of the points made.

Note

[1] Steven Pinker is Johnstone Professor of Psychology at Harvard University. See Pinker, S. (2003) *The Blank Slate*. London: Penguin. The sub-title is 'The modern denial of human nature'.

Richard Hickman, Cambridge 2005

Foreword

We should welcome and inwardly digest this excellent book that examines the necessity for art as a basic human need. It is often argued that art is a luxury, some kind of extra add-on to our lives, which should be concerned with the hardware of survival. This view is not only simplistic but fundamentally wrong. Art is the means by which life reflects on, transforms and indeed creates its values; human life without it would not properly be human at all. Once we have the means to sustain life, art is the way that life expresses itself – this expression is no add-on but part of its sustainability.

In education, the experience of making through art emancipates the individual from the already-made world by re-enforcing her as a maker. It allows the individual to become aware of and to value the uniqueness of her perceptions and acts; it is the most direct form of learning – where an openness to a self-acknowledged failure becomes the most useful weapon against the values of external conformity to an ever more standardized world.

Richard Hickman makes the critical distinction between learning about art as opposed to learning through it. Learning from the experience of making is an organic and therefore evolutionary practice – nothing to do with copying concepts or given forms but everything about interpreting things.

Perhaps the most important argument for the centrality of art in education is that the art room can become a zone dedicated to the exercise of curiosity, a place where the instincts of questioning can find their own paths to language. What happens when I mix this with that? How does what happens affect me/how does it affect others? There is an implicit injunction in the art room to take responsibility for the experiments the individual makes because she has chosen to make them; and when that focusing on response is sharpened by the sharing of the intentions of the maker and the perceptions of peer perceivers, the individual can both give form to and gain an appreciation of the value of her unique contribution to the world, allowing her to become an active maker of a living culture, rather than a passive consumer.

It does not matter whether the individual ends up becoming a professional artist: the important thing is that the direct experience of art makes the individual.

Antony Gormley

Art and art education

Art

The *art* in the title of this book refers to a multifaceted, complex and contested phenomenon. Most people have at least a tacit understanding about the nature of art – that it is in some way concerned with making. Further discussion on this particular subject could run to many chapters, and while not wanting to reinvent the wheel, I feel that it is necessary to define our terms, although one might think that enough has already been written about art and that further debate is superfluous. However, the very nature of art as a dynamic and fluid phenomenon means that previous debate often needs to be revisited.

It was not until the late 18th century that the distinction between 'artisan' and 'artist' became more general; the terms share the same root – the Latin *artis* or *artem,* which refers to skill. Dictionaries give at least 14 different senses of the word 'art' as it relates to skill; only one of these is in the sense of what is often referred to as 'Fine Art'. The general association of art with creativity and the imagination in many societies did not become prevalent until the late 19th century. I would say that in industrialised societies a commonly accepted notion of what 'art' is includes the concepts of not just skill but also expression and organisation, in addition to creativity and imagination. The distinction between 'art' and 'design' and that between 'art' and 'craft' is relatively recent and is generally regarded by many commentators as a western phenomenon. However, there are certain distinctions that can be made and some authorities have felt it necessary to distinguish between 'art' and 'craft', drawing attention to what are sometimes considered to be basic characteristics of craft that are absent in art [1]. Firstly, crafts involve the idea of an end product, such as a basket or pot, which has some utility; secondly, there is a distinction between the planning and the execution of a craft; thirdly, every craft requires a particular material that is transformed into an end product and which thereby defines the particular craft.

These three distinctions between art and craft might apply also to art and design, if 'design' were to be substituted for 'craft'; the distinction being more a matter of emphasis and degree, rather than of kind. Many artists plan their work and then execute it in a particular medium. Moreover, the notion of utility need not be confined to physical phenomena. Any distinctions that may be made between art and design would be similar to those proposed for art and craft, and again, those distinctions would be simply differences of emphasis. For example, one might view art and design as part of a continuum which has expressive/philosophical qualities at one end and technological/utilitarian

11

qualities at the other; in this sense, art and design are indivisible, although some do not share that view. Misha Black, for example, writing in 1973 on design education in Britain, asserted that the view that 'art and design are indivisible' is a misconception, stating:

> *At their extremities of maximum achievement art and design are different activities sharing only creativity and some techniques in common. Art I believe to be expressive of the human condition; it provides clues to what cannot be explained in rational terms . . . Design is a problem solving activity concerned with invention and with formal relationships, with the elegant solutions to problems which are at least partially definable in terms of day-to-day practicability* [2].

I prefer the view of the concepts of art and design as being at either end of a 'philosophical/technological continuum', that is, the differences in epistemological terms are in degree rather than in kind. Practicability appears to be an essential aspect of design, while being an unnecessary and occasionally undesirable aspect of art. It could, of course, be argued that art that is expressive of the human condition is an essentially 'practical' phenomenon in that it serves to give meaning to life.

In art education, the term 'art' is often used to cover 'craft' and 'design'. This extended use of the term is usually made explicit, as in the UK government's *Art in the National Curriculum* (England) which declared that 'art' should be interpreted to mean 'art, craft and design' throughout the document [3]. This declaration does not appear in the later edition published in 2000, which includes the word 'design' in the title, although there is a note to say that 'art and design includes craft' [4]. 'Art & Design' has come to be the term favoured by examination boards and award-giving bodies in the UK and so it would seem that the concept of 'art & design' (if not the label itself), although complex and wide-ranging, is the most frequently encountered concept which refers to the kinds of activities that normally occur in school. The polarised view of 'art' and 'design', exemplified by Misha Black underlines the often uneasy relationship between different approaches to art in education. This is eased to some extent by the term 'design & technology', a designation that can be said to give a clearer focus to the concept of design as a utilitarian and problem-solving enterprise [5].

It can be seen, then, that there may be some degree of overlap between the concept of art and the concept of design. The main area of difference seems to lie in the extent to which the notion of producing something to fit a particular requirement is considered important. There is clearly a lot of scope for confusion, as the terms 'art' and 'design' are both used in a number of ways. In the case of art, we also have the distinction between using the term 'art' in its

classificatory or categorical sense – as a means of categorising or classifying it as distinct from other things – and using the word 'art' in its evaluative sense, that is, giving value to something as in 'a work of art'.

What is commonly known in industrialised societies as 'art' has undergone many changes. The concept of art does not reside in art objects but in the minds of people; the content of those minds has changed radically to accommodate new concepts and make novel connections. It is perhaps odd that what is popularly referred to as 'modern art' is often work from the early part of the last century. 'Modernism' is a preferable term and, paradoxically, many people appear to be more aware of this term as a result of the coming of age of 'post-modernism'. In October 2002 I observed a group of post-graduate trainee art teachers in a gallery training session run by the education officer. They were divided into two groups of about ten. One group was asked to discuss and identify concepts associated with modernism, while the other group focused upon post-modernism. To my surprise, the group discussing modernism had some difficulty coming up with ideas related to the term, while the other group quickly produced a list of words which they felt were associated with post-modernism. These were 'plurality', 'eclecticism', 'irony' and 'humour': a group of words as good as any, perhaps, to describe the loosely knit body of ideas which make up post-modernist thought.

Post-modernism is derived in part from the writings of 20th century philosophy (especially French philosophy), in particular those influenced by Marxist theory [6]. It has generated a whole new range of issues; these include the notion that art is a redundant concept and that it is inextricably bound up with hierarchies, elites and repression. In particular, many artists working within the post-modernist framework consciously seek to challenge and subvert many of the presuppositions which have been made about the nature of art over the past two centuries. These presuppositions include the notions that an art object is made by one person, usually a white male; that it is of value as a commodity; and that the viewer needs to be educated and informed (usually by a critic) in order to appreciate it fully. Further to this, if the artwork is deemed to be of value (by critics acting on behalf of the art establishment), then it should be in an appropriate setting, i.e. an art gallery or museum, where it will be seen by suitably educated and respectful people for years to come. As a reaction to these notions, therefore, we have instances of artworks that are made by groups of people rather than individuals; by minority groups and by women who celebrate their status through their artwork; artworks that are not meant to last, created from non-traditional materials (or no material at all), displayed in non-reverential places and that are conceived as being of no value.

It is, of course, ironic that the work of artists, who are already valued by the art establishment as 'important figures', choose to attempt to subvert the commodification of art by sending their work as a fax, by making multiple copies

or by making it out of ephemeral material. The irony, in true post-modernist fashion, is compounded when such work is itself considered to be of value as a commodity, representing 'cutting edge' contemporary art. The real irony, however, is that much of what passes for contemporary art is even more inaccessible than the modernist art it supplants. More than ever, contemporary art is in need of interpretation by critics before many people can begin to appreciate it, by which time potential viewers will have lost interest or will have deemed that such art is only to be viewed by a privileged elite.

Art remains a contested concept, all the more so when we examine the shaky foundations upon which it is built. Some might say that 'art' is such a fuzzy concept, fraught with contradiction and ambiguity, that we need to sub-divide what currently comes under its umbrella into several different concepts, or that art itself is but one aspect of a broader concept of visual culture. Of central significance is the need for those concerned with inducting young people into a greater understanding of their world to examine carefully their own presuppositions about art and its relation to that world.

Art in education

In the UK provision for the training of specialist art teachers has gradually been eroded in recent years, particularly for the primary phase of compulsory education. There has also been a cutback in allocated time to allow for more emphasis on so-called 'core' subjects. Such developments have fuelled the fears of art advocates and have contributed further to a kind of siege mentality, where art rooms are isolated behind barricades to fend off further incursions by the barbarians. Overall however, art has rarely been more secure in terms of its (currently) assured place in the curriculum, at least in the UK, with record numbers of young people taking public examinations in the subject [7].

In English primary schools the subject has nevertheless been under threat, largely as a result of a misguided drive to get 'back to basics', as if art itself were not a basic and fundamental part of education and culture. At the time of writing there are signs that strategies which in many places supplanted creative activity with rote learning, are being phased out, with a welcome return to a more enlightened approach to the curriculum. However, the fact remains that specialist teachers of art in English secondary schools and elsewhere are in short supply, owing principally to the closure of specialist courses for pre-service training. Roy Prentice, in a report commissioned by the Qualifications and Curriculum Authority (QCA) noted that from September 2002, owing to government directives, 'students will have reduced opportunities to develop their subject knowledge in art and design' [8].

At post-16 level, the outlook appears relatively buoyant, with large numbers continuing to pursue the subject beyond the years of compulsory schooling, but the relationship between what is taught in schools and practice in Higher

Education remains, for the most part, tenuous. There is little conceptual overlap – some would say a huge chasm – between school art and the kind of art that occurs in art colleges. But this is to be expected. A similar kind of gulf would exist between the school and university versions of most subjects, and probably more so between classroom practice and professional practice. Some would say that this is not only to be expected but also desirable – asserting that, for example, conceptual art is to school art what quantum physics is to school science. My contention here is straightforward – that in order to understand art concepts at an advanced level, it is necessary to have an understanding of the building blocks for those concepts. Partly in support of this contention I discuss the role of developmental psychology later in this section.

There are those who advocate a real connection between art education in schools and the rarefied world of contemporary art. Some argue that it is crucial for art education to concern itself with all aspects of visual culture, including theme parks, shopping malls, television and the internet, claiming that this would give art education a central place in our thinking about cultural forms [9]. The problem here, however, is that there is a weighting towards a kind of literate understanding rather than creating. In much of the current literature there appears to be little attention given to *making*, with fewer references to the importance of practice.

Current and ongoing debate about the nature of art and its relationship with education and the rest of society is exemplified by Duncum and Bracey [9]. As editors, they draw upon a range of disciplines, including anthropological and sociological accounts of the nature of visual form, to present a polemical account in the form of a collection of essays. The authors of the essays take different stances, with arguments presented and counterarguments given. Taken together, these essays help unravel the complex nature of art and aesthetic understanding and its relevance to contemporary education. The central question in Duncum and Bracey's book is 'How can art be known?'. This is answered to some extent by posing other questions, such as the following, asked by Graham Chalmers:

how, in a variety of cultures, is visual culture talked about, viewed, understood, misunderstood, valued, trashed, ignored, used, and labelled? [10].

Chalmers answers his own question by asserting that those aspects of visual culture, which some term 'art', are known through knowing what is considered of value within one's particular social group. Elsewhere in the book, Elizabeth Garber, an ethnographic researcher, declares that in order to know art it is necessary to know the cultural, social and anthropological study of the contexts in which it was produced [11]. That is surely so but do young people in schools necessarily need to be aware of these contexts when *making* art? This issue is discussed below.

The place of 'knowing and understanding' art

I have taken this phrase – 'knowing and understanding art' – from the English National Curriculum documentation; it has become a kind of shorthand for those activities that occur in art lessons that are not directly concerned with making. For several years, since the initial introduction of a statutory framework within which art teachers were to operate, the phrase 'AT2' – attainment target two – was used as an even more abbreviated form. I have heard several art teachers erroneously refer to 'AT2' as the 'art history' component of the curriculum. This was never intended to be the case. If anything, the 'knowledge and understanding aspect' of the art curriculum is related to the old term 'art appreciation' but current practice goes beyond that and also goes beyond what is associated with the more contemporary term (at least in the UK) 'critical and contextual studies'. It is expected, amongst other things, that pupils should be taught about formal aspects of art as well as about 'the roles and purposes of artists, craftspeople and designers working in different times and cultures'. Pupils are assessed according to the extent to which they have analysed how codes and conventions are used to represent ideas, beliefs and values in different genres, styles and traditions. They are also expected to be able to evaluate the contexts of their own and others' work and 'articulate similarities and differences in their views and practice', developing their ideas and their work 'in the light of insights gained from others'. These are huge areas of study but nevertheless refer to only one aspect of the requirements for art in English schools. There is an explicit expectation that 'knowledge and understanding' in art is related to and informs studio practice.

I have outlined the development of the critical and contextual studies aspect of the art curriculum elsewhere [12] but will briefly recapitulate here to give a context to the discussion. Since about the end of the Second World War there has been an off-on debate in education regarding subject-centred approaches and student-centred approaches. Subject-centred approaches are concerned with instruction that is based on the transmission of knowledge and skills, and are generally concerned with 'declarative knowledge', i.e. 'knowing that'. This has been contrasted with learner-centred education, which Herbert Read referred to as 'originating activity' and is generally concerned with facilitating creative expression or 'procedural knowledge', i.e. 'knowing how'. Read advocated a synthesis of these two approaches in the teaching of art [13] but remained firmly committed to the idea of education *through* art, as the title of his book suggests.

In the UK, Dick Field's influential book of 1970, *Change in Art Education*, drew attention to the need for a change in emphasis, arguing for a balance between 'concern for the integrity of children and concern for the integrity of art' [14]. Field's book echoed many of the ideas that were developing in America at that time and introduced the beginning of a new development in art

education. Manuel Barkan's 1962 article 'Transition in Art Education' [15], the theoretical foundations of which can be traced back to Bruner's conception of the structure of a discipline [16], proposed that art should be taught in a more structured way than had been advocated previously in American schools. Barkan's article was a precursor to his 1966 paper [17], which recommended that art curriculum development should be derived from its disciplinary sources: the artist, art historian, art critic and the aesthetician. This approach was later endorsed by the Getty Center for Education in the Visual Arts and the subject- or 'discipline'- centred approach to art education became established in American schools by the 1980s. Characteristics of 'discipline-based art education' (DBAE) were outlined by Dwaine Greer, who asserted that a curriculum based on DBAE

- focuses on the intrinsic value of art study;
- operates within the larger context of aesthetic education;
- draws form and content from the four professional roles, i.e. art historian, art critic, aesthetician and artist;
- is systematically and sequentially structured;
- inter-relates components from the four role sources for an integrated understanding of art;
- provides time for a regular and systematic instruction;
- specifies learner outcomes [18].

It can be seen that these seven features, which epitomise the nature of the 'discipline-based' approach, are far removed from the notion of the child as artist and from the concept of learner-centred education. There is an emphasis on art as an area of study, composed of four disciplines (art history, art criticism, aesthetics and studio practice), delivered by way of an objectives-based sequential curriculum.

The notion of sequential learning in art was taken up in the UK by Brian Allison. Allison stressed the need for learning in art to be cumulative and systematic, covering four inter-related 'domains':

- the Expressive/Productive Domain
- the Perceptual Domain
- the Analytical/Critical Domain
- the Historical/Cultural Domain [19].

This curriculum model was designed to address cognitive as well as affective aspects of art and was therefore deemed to be 'balanced'. It marked the beginning of an analytical, critical and historical dimension to art in British schools, coinciding with a concern for more measurable 'accountability' and

'standards', culminating in the Education Reform Act of 1988, which laid the foundations for a national curriculum.

It can be seen that there has been an inexorable move away from child-centred art education towards a more subject-centred approach, with an ever-increasing concern for more measurable aspects of art in education linked, as ever, to a general concern about standards in education. Key concepts underpinning this move are *sequentiality* – a concern for learning to be developmental and progressive; *subject-centred* – teaching about the subject as a body of knowledge; and *objectives-based* – an approach that pre-specifies lesson goals in terms of desirable learning outcomes. These concepts led inevitably to a concern for cognitive rather than affective aspects of art, aspects that are measurable, can be sequentially structured and can largely be specified in advance.

We have, then, a curriculum that is not aimed at the needs of individual young people but is the result of a perceived, but to my mind misguided, need to give a kind of academic respectability to art in schools. It is misguided because the subject does not need this kind of status – it has enough value in other ways – but more than this, because, in an effort to prove art's status as a discipline, far too much has come to be within its remit. The result leads inevitably to superficiality and a shallowness in understanding the nature of art through attempting to cover everything that is associated with it.

Developmental issues in art education

'Sequentiality' in the present context refers to the structuring of learning by teachers so that progress builds upon previously learned skills and concepts. Some educators have maintained that children, if left to their own devices, develop artistically without the need for adult intervention. The notion of non-intervention in a child's artistic development was developed by Franz Cizek, an Austrian educator in the early 19th century, and popularised through the writings of Viola [20]. Cizek encouraged children to express their personal reactions to events in their lives through art and held that all children have creative power and blossom naturally. Because of the lack of a sound pedagogical base, the idea of non-intervention in child art floundered but its legacy lives on amongst those educators who do not want to 'interfere' with children's natural development.

It is clear that children appear to be predisposed towards a certain pattern of development in art. It has been observed that in this pattern there appear to be particular stages, which have been well documented since the late 1880s. Rhoda Kellogg and co-workers [21] devised a scheme where stages of development in art are very roughly associated with ages and can be summarised thus:

Scribble	2-3 years
Shape	2-4 years
Outline	3-4 years
Suns, Radials	3-5 years
People	4-6 years
Almost pictures	5-7 years
Pictures	7 + years

Of course, one needs to be cautious about believing an age-stage correspondence to be accurate. These stages are merely 'averages' – individuals might not always conform to them. More importantly, as work by Wilson [22], for example, shows, environmental and cultural influences are a crucial factor.

Victor Lowenfeld's influential book *Creative and Mental Growth* outlined stages of artistic development that have become virtually enshrined in many art education publications, especially those aimed at teachers working in the primary phase of education [23]. Lowenfeld referred to the main stages of artistic development: the 'scribbling stage', the 'figurative stage' and the 'stage of artistic decision'. These stages are divided into different phases and are outlined below.

'The Scribbling Stage'
The first phase of this stage was identified by Lowenfeld as being the 'uncontrolled' or 'disordered' scribble phase. The very first attempts at graphic expression by young children consist of apparently disorganised broken lines and dots. There appears to be a lack of correlation with visual images. The child's interest seems to lie primarily in handling the materials and in the pure joy of physical movement and there is little coordination of small muscles in this phase. As a result, the child is unable to grasp drawing instruments with fingers, nor is the child able to draw with fine wrist movement, being more likely to grasp the instrument with the whole hand and move the arm from the shoulder. Attention span is often short but intense. Phase two of Lowenfeld's 'Scribbling Stage' he termed the 'Controlled Scribble' – a phase where order is increasingly apparent in the scribble, with concentration on repetition of the same kind of line – usually longitudinal or circular. A great step forward made in this phase is the attainment of a certain amount of motor control. Muscle coordination enables the child to draw continuous lines without the breaks of the previous phase. Of importance also is the fact that the child now realises the connection between physical activity and the marks that can be seen on the paper. The final phase of the scribbling stage is known as the 'Named Scribble' phase. This is when the scribble begins to exhibit a greater variety of direction and shape. In earlier phases physical movement was the prime interest; a change in thinking is indicated when the child names a scribble and begins to relate the marks on

the paper to concepts. The finished scribble may remind the child of an incident, person or object and thus a name or title is given to the work or an attempt to represent these may be made, naming the work before beginning to draw. During this stage it has been observed that there is a change from what is known as 'kinaesthetic thinking' to imaginative pictorial thinking.

Lowenfeld's 'Figurative Stage'

During what is labelled as the 'Early Figurative' or 'pre-schematic' phase of this stage children begin to realise the value of drawing as a unique form of communication and as a means of exploring the visual world. It is an aid to forming concepts about themselves and their environment. It is often suggested that colour use at this stage is emotional rather than logical but, of course, children use their own logic, which might not be accessible to adult observers. The unintelligible scribbles of the previous stage become personal, but recognisable, symbols. Both the child and the observant adult are able to see some resemblance to visual reality. The first recognisable symbol is usually a figure, indicating the child's interest in humans; there is a lot of variability between individuals with regard to the amount of detail employed. Features associated with the 'Middle Figurative' or 'schematic' phase are exhibited by children at many age levels – from pre-school through to secondary school age – but the awareness of the concept of space during this phase is often associated with the age range of seven to nine years in western cultures. Children during this phase form stable concepts of themselves and the world around them, expressed through art as symbols. These remain fairly constant in form, whereas in the previous phase symbols for the same thing could change totally from day to day. Details in the symbols become more complex and show great individuality. Symbols at this phase often show a different sense of proportion when compared with the work of older children (a head might be much bigger than a body or arms longer than legs). Children who are identified as being in the Middle Figurative Stage begin to see the relationship between things in the environment and themselves; this is indicated by the use of the 'base line' – things may stand on the bottom edge of the page or on a drawn line. Where before children saw themselves as the centre of the world, they now see that they stand on the ground. They also see that things can exist independently without necessarily relating to themselves. An interesting point to note is that the sky is often painted as a strip of colour at the top of the page. There might be variations with the base line, such as a double base line, which may be used to represent foreground and background, showing a desire to depict depth. Objects drawn at right angles on either side of a base line may be used to indicate things on two sides of a central point. There is a reluctance to overlap or 'occlude' objects; I say 'reluctance' rather than inability, as it has been demonstrated that children who normally occlude can overlap objects in their

drawings if they consider it important to do so. Other characteristics of this phase include 'X-ray pictures'. A child may wish to express the total concept of a structure that has an outside and an inside. In drawing a house, a wall may be left out to reveal the inside, as both might be considered to be of equal importance. There is often a combination of plan and elevation; in the same picture, some forms are drawn to be looked at from above. The forms that are 'tipped up' may be forms that the child considers important and which are intended to be viewed clearly. A narrative approach to picture making is another characteristic of this phase, with a combination of different time sequences; events that occur at different points of time and continuous sequences of events might be included in the same picture (see Figure 1 below).

At the 'Late Figurative' phase children realise that they are members of society, particularly of their own peer group. For this reason the Late Figurative phase is sometimes called the 'gang age' or the 'age of dawning realism'. The most noticeable feature of this phase is the child's willingness and ability to work in a group, coupled with a desire to act independently of adults. Portrayal

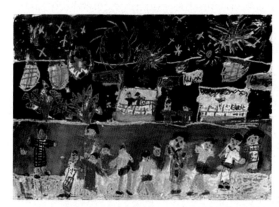

Figure 1: Examples of children's artwork, typical at 'Middle Figurative' stage (see note 24).
1a: *Celebration* by Miki.
1b: *Market Stalls* by Mami.

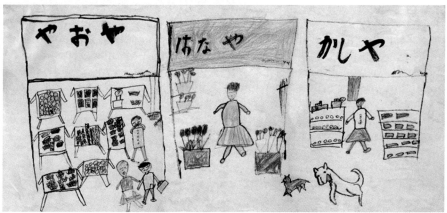

of the human figure, which in the last phase was a standard symbol composed mainly of geometric shapes, now shows more differentiation, with characteristics such as occupational roles clearly defined. Concentration is focused on details of the body: eyes, ears, nose and so on are included. The concept of space in picture-making undergoes further change, with the base line disappearing. Figures are arranged in space with greater attention to visual realism and there is use of overlapping. In children's work of the Late Figurative phase we might see attempts to depict three-dimensional space, with representation of distant objects being made smaller; the sky is usually filled in to the horizon instead of being a strip of colour at the top of the page.

The 'Stage of Artistic Decision'

This stage in Lowenfeld's descriptions of artistic development usually occurs during early adolescence and is sometimes referred to as the 'pseudorealistic' stage. It occurs at a time of transition from the relatively uninhibited period of childhood to the critical awareness of adulthood; with it comes a concern for the quality of the work produced, with a focus on the end product which takes precedence over the process of art-making. Adolescents are often self-conscious about changes taking place in their bodies and evidence of this concern is frequently seen in their drawings. In most cultures girls often emphasise 'feminine' characteristics, while some boys emphasise 'masculine' ones. Sometimes a feeling of shyness resulting from the growth of self-criticism and/or fear of criticism by peers appears to inhibit spontaneity. The world of fantasy and dreams is said to be a source of interest to both girls and boys and they might have a tendency to be attracted to heroic figures. At this stage cognitive development has reached a point where the child tends to cope more easily with abstract concepts.

Sometimes children at this stage might prefer to create artwork that shows visual realism and might be concerned with how the subject would appear to the eye. At other times they might feel as if they are part of the action going on and portray the subject in an emotional way. Often a child combines the two approaches. It is rare to find a child who is always visually stimulated or always emotionally stimulated but it is considered important to know that such a child might exist. Lowenfeld referred to these two types of learners as 'visual' and 'haptic'. The visual learner, according to Lowenfeld, is one who relates better to tasks that are well defined and concerned with naturalistic representation, while the haptic learner relates more to tasks that involve expression. Below are the characteristics of the two extremes.

The visual child
- draws or paints as if he or she were a spectator at a scene;

- is concerned with light and shade and differences produced in colour by lighting;
- tries to represent three dimensional space;
- concentrates on the whole rather than on details;
- tries to represent colour in a visually realistic way (as it appears to the eye);
- is analytical in approach.

The haptic child
- draws or paints as if directly involved in the action;
- gives space significance only if it is necessary to the expression of emotions and the self;
- concentrates on details;
- uses colour emotionally.

The implications for the art curriculum are clear – that it should cater for both kinds of learner.

I have given a fairly full account of Lowenfeld's work, as his influence on western art education has been enormous. More recent commentators have suggested that early studies in children's artistic development are characterised by their lack of emphasis on cultural and environmental factors [24]. There is also evidence to suggest that young children are more capable of using visual imagery as a mode of communication and expression than previously acknowledged. John Matthews, for example, argues that even the earliest pictorial behaviour is not limited to a simple sensori-motor exploration. His research suggests that early drawings can have deep meaning and demonstrate significant intellectual activity. Matthews also draws attention to the importance of learning contexts in early art activities. He asserts that as learning environments in early education are often dominated by women, there is significant impact of gender-biased practice upon the pictorial expression of both boys and girls.

Research in Australia, such as that reported by Cox [25], notes that cultural influences are important in children's development. This is exemplified by the artwork of the aboriginal Australian Walpiri people. Walpiri school children use and develop both the indigenous and westernised styles of drawing – they are pictorially 'bi-lingual', using traditional conventions as well as incorporating western ones in their drawings. Other developmental features, such as the tendency to resist overlapping during pre-adolescence, remain. Other authorities in the area of children's artistic development, such as Anna Kindler, make the important point that, in moving away from modernism, our conception of what child art is or could be changes. A whole new area opens up, giving, in Kindler's words:

opportunities to incorporate in art education realms of pictorial representation that have traditionally remained outside of its boundaries [calling for a] 're-evaluation of our understanding of the notion of artistic development' [26].

What is apparent is that children's artistic development is a complex process of interaction between children's growing awareness of themselves and their environment. The importance of recognising this is that children who do not receive support, direction and guidance are disadvantaged; development might well occur without adult 'interference' but potential will be unrealised.

Intellectual development and artistic understanding

Several researchers have investigated the relationship between intellectual development and artistic understanding; one of the earliest studies was Elliot Eisner's work on the Stanford Kettering project [27]. The aim of this project was to produce a sequentially structured curriculum that was based on learning in productive, historical and critical aspects of art. This was part of the general move, at least in America, away from an emphasis upon practical studio art towards what was felt to be a more 'balanced' curriculum. As with other developments in general education which have impinged upon art education, much of the theoretical framework for the Stanford project was derived from Bruner [28]. Eisner's work at Stanford University was concerned principally with developing art curricula that related the development of artistic understanding to the learning of concepts and practical skills.

Other researchers in the early seventies were keen to explore the intellectual dimension of art education; Denise Hickey for example, studied intellectual factors in art appreciation through an analysis of the development of 26 critical abilities [29]. She established a matrix of perceptual and cognitive abilities for art criticism based on developmental stages of cognitive growth. Ninety 'elementary and middle school' children from an American urban school were asked to respond to artworks using Edmund Feldman's strategy for art criticism, which is based around the four student activities of Description, Formal Analysis, Interpretation and Evaluation [30]. Hickey equated emphasis on each of these activities with stages of development originally identified by Piaget [31], thus Description was related to critical abilities associated with observation; Formal Analysis was related to concrete operations and Interpretation and Evaluation were related to the development of interpretive and judgemental skills at the stage of formal operations.

A project that has focused more particularly on developmental psychology and its role in art education is Project Zero, based at Harvard Graduate School of Education and overseen by Howard Gardner [32]. Gardner has published extensively in this area [33], investigating the relationship between children's affective and cognitive development in art and stages of intellectual

development. Rosentiel and co-workers from Project Zero [34] used Piaget's theory of developmental stages to consider whether children's critical judgement of artworks followed a developmental sequence. They found that such a sequence could be determined according to the number and appropriateness of criteria for judgement. For example, younger children (at the concrete operational stage) gave limited responses, while older children gave more considered responses, with reference to formal properties of the artworks. However, the study did not attempt to equate specific types of responses to specific levels of development.

It can be seen that the Piagetian stage model has provided a useful starting point for many of these studies but this is not to say that Piaget's findings have been adopted uncritically. Gardner regarded Piaget's tendency to concentrate on logical and rational thinking as narrow and incomplete, stating that Piaget's work shows 'scant consideration of the thought processes used by artists, writers, musicians, athletes . . .' [35]. A particular point of departure from Piaget's stage theory lies in Gardner's notion that children as young as seven (i.e. at a 'pre-formal operations' stage) can be 'participants in the artistic process' at a sophisticated level, claiming that the groupings, groups and operations described by Piaget do not seem essential for mastery of understanding of human language, music, or plastic arts [36].

According to Gardner then, artistic development can occur outside the processes of formal operations. By the age of seven years, children's symbol systems will have become increasingly identified with cultural conventions; in other words, there is a movement from the private to the public domain. Development after this age is said to be a process of refinement, building upon existing skills and understandings. This does not necessarily contradict the findings of Hickey, whose work was concerned with language-based critical development (which could be said to be associated with Bruner's 'Symbolic' phase) rather than with the development of the process of art-making.

Other early studies by Gardner and co-workers have investigated children's responses to artworks from a developmental perspective. Of particular interest here is a study reported by Gardner *et al* that focused on a group of 121 four to sixteen year olds and revealed that children's levels of response to artworks could be correlated with three age bands [37]. The subjects' responses were grouped initially by age of the respondents as well as by the level of maturity reflected in their responses. There was such an overlap between chronological age and what might be termed 'developmental stage' that the two groupings were collapsed together, so 'age' and 'stage' were in effect synonymous. What were termed 'Immature' responses were found, not surprisingly, mainly amongst the 54 four to seven year olds; 'Intermediate' or 'Transitional' responses were generally found amongst the 51 eight to twelve year olds; 'Mature' responses were typically found amongst the 16 fourteen to sixteen year

olds. An open-ended 'clinical' procedure was employed by the researchers, which provided freedom to probe and follow up responses. The interviewees were shown various works of art and asked questions about them, such as 'Where did it come from?' and 'could you make it too?' It is worth noting that the research focused upon verbal rather than pictorial responses.

Typically, the youngest subjects revealed the most basic misconceptions about the nature of art but nevertheless had a certain magic; for example, a reported type of response suggested that paintings simply come into being by rising out of the paper. The middle, 'Transitional' group gave a 'mixture of mature and immature views' but certain characteristics were evident, such as a rather rigidly held view of art as a striving towards realism. Additionally, the subjects' responses to questions were seen to be extremely literal, with no generalised interpretation of the questions asked and giving responses based on the most concrete interpretations. The rigid views of the Transitional group were replaced in the oldest group by a tolerance of diverse artistic judgements, in some cases to the point where almost anything was acceptable as art. Although the oldest respondents appeared to hold a more complex and sophisticated view of art, they were reported to have a view of art-making as a mechanical process that focused upon naturalistic rendering and did not appreciate the relationship between form and content. This calls into question the designation of 'Mature' as applied to the older adolescents. It seems reasonable to assume that between the ages of eleven and sixteen there exists a wider range of understandings of art and art concepts, including more sophisticated notions as to the nature of art, and that the designation 'Mature' would be more appropriately applied to a more sophisticated type of response. My own work in this area (described below) has found that, typically, there are at least three levels of understanding of the concept of art amongst secondary age students [38].

Gardner *et al* reported that artworks were not 'universally' seen as essentially related to aspects of human cognition (rather than, for example, motor skills) until adolescence. In addition, many of the respondents in the fourteen to sixteen years group revealed an appreciation of expressive and personal aspects of art. Amongst the Intermediate group it was reported that one quarter of the subjects held the belief that animals could paint as humans did; those who did not agree with this assertion gave cognitive rather than physical reasons. This is in contrast to the youngest group, where some children apparently believed that the constraining factor was lack of hands or that 'their claws get in the way'; there was little awareness of any intellectual or perceptual skill involved. With respect to formal properties of artwork, there was apparently less evidence of development across age. Regarding the question of when a work is finished, it was reported that 'subjects of the older groups did not reveal appreciably greater sophistication' than younger respondents. There appeared to be a lack of

understanding of aesthetic criteria, as evidenced in the typical response, 'When the canvas is covered'. Very few subjects gave what was considered by the team to be an appropriate response – that a painting is finished when it feels right. The interesting thing for me about this study (apart from the delightfully surreal responses) is that the equating of appreciating with making was implicit in the questioning and therefore gives some insight into the development of intuitive understanding of the making process – something that previous studies had apparently overlooked or considered marginal.

Other researchers associated with Project Zero, such as Dennie Wolf [39], have investigated developmental phases with regard to art. Wolf reported three phases, each with its own distinctive way of inquiring, observing and making. The first phase, from four to seven years of age, is characterised by judgement criteria being based upon rudimentary preferences. Children in this phase can 'decode pictures' and can interpret to some extent but their interpretations are limited by a relative inability to distinguish between pictures and the objects they represent. During Wolf's second phase, from eight to twelve years of age, the effect of conventional education (particularly the learning of visual conventions and culturally-specific rules for image making) brings an intolerance of artworks that break such rules. The third of Wolf's phases is associated with the thirteen to eighteen age range. During this phase, according to Wolf, adolescents become more sensitive to the work of mature artists and can see the relationship between form and content; older adolescents can begin to distinguish between technical and expressive skills and can begin to see the difference between what they like and what is considered by others to be good. It should be emphasised, however, that only those who have received appropriate tuition reach the more sophisticated levels of this third phase.

Michael Parsons, working in the area around Salt Lake City in the USA undertook a long-term study, examining the responses of children and adults to art in light of his understanding of developmental psychology [40]. He formulated a series of five developmental stages that relate to different levels of response to artworks, focusing on four areas. Three of these areas are aspects of artworks: subject matter; emotional expression; and medium, form and style. The fourth area, which was termed by Parsons 'the nature of judgement', became most important at what Parsons termed Level 5 – the highest level. Parsons' five stages can be described briefly:

Stage 1 is characterised by a sensuous response to paintings; where subject matter is discernible, it is responded to according to its associations: 'I like it because of the dog. We've got a dog and its name is Toby' [41]. At this stage paintings are judged on the basis of their association with other experiences and liking a painting is the same as judging it.

Stage 2 is characterised by an emphasis on the importance of representation. Aesthetic judgement is on the basis of the extent to which recognisable things

are realistically depicted; the depiction of beautiful or attractive subject matter makes the painting better: 'You expect something beautiful, like a lady in a boat, or two deer in the mountains' [42].

Stage 3 is characterised by a concern for the expressive and emotional aspects of art, often to the exclusion of other considerations: 'You've got to have a gut feeling for it. It doesn't matter what the critics say about form and technique' [43]. The criteria of originality and depth of feeling are used as yardsticks at Stage 3. Parsons noted that at this stage respondents are sceptical about the possibility of objective judgements about art and about the value of talking about painting.

Stage 4 is characterised by an awareness of painting as a social phenomenon, existing within a historical and cultural tradition. There is a concern for and awareness of style and form and because art is seen as belonging to the public domain, reference is made to the views of others.

Stage 5 is characterised by an ability to reconstruct the meanings associated with artworks through critical appraisal of the values underpinning such meanings. Judgement is seen as an individual responsibility within the framework of social discourse.

We can see from these descriptions of the five stages that there are parallels with Kohlberg's stages of moral development [44]. This is to be expected, as Parsons acknowledges the influence of Kohlberg upon his own theoretical framework. The adoption by Parsons of Kohlberg's work as the model for his developmental theory has been criticised by others in the field, such as Goldsmith and Feldman, who feel that it 'leads to a confusion of moral, social, and cultural forces in the development of aesthetic judgement' [45]. Goldsmith and Feldman state that Kohlberg's theory does not offer a sufficiently broad account of cognitive development, noting that the highest level of moral development is not acquired without 'sustained instructional effort' and is therefore not universally achieved (although the sequence of acquisition is, like other stage theories, universally invariant and inviolate). Their principal criticism of Parsons' work is his omission of any reference to the distinction between universal and non-universal cognitive domains, an area in which Feldman has published extensively [46]. By this Goldsmith and Feldman infer that as not everyone is engaged in art activities, then any development in the artistic domain is going to be non-universal, that is, restricted. This, however, depends upon how broadly one defines 'art-making activities'. Parsons claims that the aesthetic domain (if not the artistic) is universal, at least at the less sophisticated levels of achievement, and that mastery in any domain, including Piaget's stage of Formal Operations, is dependent to a greater or lesser extent upon instruction.

Other criticism concerns Parsons' methodology, in particular his sample of interviewees [47] and his choice of artworks, which consisted of a set of eight

reproductions. Parsons based his stage theory for aesthetic development on interviews of 'over' 300 people of various ages, conducted over a period of 'almost' ten years. Despite the time frame for this investigation, it is not a longitudinal study; each respondent appears to have been interviewed once, the interview consisting of what Parsons refers to as an hour's 'gentle questioning'. I have no problem with this approach as such; of more concern with regard to Parsons' work is the reliance on a narrow set of materials for eliciting responses. The material used consisted of reproductions of western paintings that were produced between 1820 and 1936 (including two by Picasso, painted in the same year). There are several problems associated with the use of this stimulus material: firstly, reproductions of artworks are not artworks and give no indication of actual size (for example, Picasso's *Guernica,* used in the study, is over 25 feet long) nor do they give sufficient indication of the originals' surface qualities. Secondly, the reproductions were all of paintings, and so any conclusions drawn from responses to them would refer only to paintings, not art in general. Thirdly, most of the paintings referred to were well-known and there would therefore be a possibility that responses to them would be 'text-book' type responses. Moreover, their visual power could have been reduced as a result of over-exposure. Fourthly, the eight paintings chosen were limited to a narrow geographical and chronological range, reflecting Parsons' apparent bias towards expressive work, or more accurately, done in the expressionist school of aesthetics. This last point is particularly important because it relates to Parsons' overall view of the nature of art and therefore to his theory about 'how we understand art'. The importance attributed to expression and emotion in Parsons' framework is likely to be due to the choice of paintings used as stimuli, seven of which are clearly emotionally charged; crucially, the influence of the art schooling received by the interviewees cannot be discounted.

David Pariser, in reviewing Parsons' work, refers extensively to the Doctoral research of Housen as an example of research which is concerned with sequential developmental in art; however Housen's work remains, to the best of my knowledge, unpublished and any comment here is based on Pariser's account [48]. Housen investigated the development of artistic understanding in adolescents and adults by analysing 'stream of consciousness' verbal responses to a set of reproductions. Her work is apparently methodologically 'tighter' than Parsons', avoiding Parsons' 'gentle probing' and allowing her subjects to speak at length without intervention, thus eliciting responses which can be seen to be authentic and untarnished by implicit expectations on the part of the interviewer. I have adopted this approach when asking people about their artwork and it appears to be a useful way of obtaining, with some degree of veracity, this kind of information; however, my criticism of the use of reproductions in research of this kind remains.

There is a degree of consensus between Parsons' and Housen's stage theories; they both put forward the notion that there is a decline in egocentric responses and an increase in more reflective, socialised activities. The stages are loosely related to age but Housen suggests that there are four stages between the ages of fifteen and fifty-five, while Parsons found evidence for only two. As these two researchers examined different age spreads (from different sample sizes), it is possible that they were describing the same phenomenon but that it occurred differently in the two populations. Housen claimed that most children under the age of fifteen are at Stage 1 – the 'accountive' stage, where the respondent is concerned principally with the content of a painting. To have only one stage of development of artistic understanding from the pre-school phase through to middle adolescence seems unlikely; to suggest this on the basis of not looking at that age span would appear to invalidate the claim.

Nevertheless, the principal concerns of all of these developmental researchers is that artistic stages do exist (although they might be determined by environmental factors) and that in order to achieve the higher levels of aesthetic and artistic development, teaching is necessary. As can be seen in Table 1, which gives an overview of the work of Parsons (1987), with reference to Lowenfeld (1970), Housen (1983) and Gardner et al (1975), progression through the stages is characterised by a decline in egocentrism and an increase in more reflective socialised activities. It should be noted that this table, which describes stages in artistic development, refers to 'principal concerns' of individuals with regard to their engagement with art objects, not with art-making.

Table 1:

Stages in artistic development: an overview, with reference to Parsons' stages

Stage 1: Favouritism

Lowenfeld: 'Scribbling Stage' (ages 2-4)
'Early Figurative' or 'pre-schematic' (ages 4-7)
Gardner: 'Immature' (ages 4-7)
Housen: 'Accountive' (from pre-school up to age 15)

Stage 2: Beauty and realism

Lowenfeld: 'Middle to Late Figurative' or 'schematic stage' (ages 7-9)
'The Stage of Dawning Realism' (ages 9-11)
'The Pseudo-Naturalistic Stage' (ages 11-13)
Gardner: 'Intermediate' (ages 8-12) – rigidity, concern for realism
Housen: 'Constructive' phase (later adolescence) – viewer constructs a framework for understanding art)

Stage 3: Expressiveness

Lowenfeld: 'The crisis of adolescence' (ages 3-17)
Gardner: 'Mature' (ages 4-16) – extreme tolerance
Housen: Development of intellectual understanding*

Stage 4: Style and form

Housen: Emotional content* (later adolescence/adulthood)

Stage 5: Autonomy/reconstruction of meaning

Housen: 'Re-creative', viewer can reflect upon reflections (mature).

NB: Lowenfeld's stages refer more particularly to children's development in art-making, while Parsons' stages refer to principal concerns in terms of general engagement with artworks.

* Parsons' Stage 3 (concern with expressiveness) precedes a greater concern for intellectual understanding, whereas the reverse is the case with Housen's stage theory. However, in all stage theories, the sequences are considered to be invariant – stages are not jumped, and *higher stages are not achieved without instruction.*

In my own research work [49] I investigated the artwork and attitudes to art of early adolescents and found a range of different understandings about the nature of art. In this study I argued that the concept 'art' can be understood at different levels and that the principal tasks of art educators are to build upon students' personal conceptions of art and to facilitate a development towards a broader and more abstract 'public' concept of art. I further argued that by ascertaining levels of abstractness and degrees of complexity intrinsic to the concept of art, it would be possible, through an analysis of students' responses to artwork, to identify levels of students' understanding and teach in ways that initiate individuals into a higher level of understanding. The specific aspect of the research described here is concerned with fieldwork that sought to validate theoretical levels identified as a result of conceptual analysis. This analysis yielded four levels which indicate theoretical levels of difficulty. It was assumed that difficulty is related to abstractness, as abstract concepts are said to be acquired at later stages of cognitive development; difficulty is, in my view, also related (although to a lesser extent) to complexity. The designations 'Level 1', 'Level 2', 'Level 3', etc. are used for clarity and are not meant to imply that there may be fixed, static, quantifiable differences between the levels; the system for coding is outlined at Appendix I. The four levels found were:

Level 1: The concept 'art' might be used in a restricted and particular way, as in 'art is what we do in school'. The concept of art at this level would tend to be classificatory and may be dependent upon a limited media based view (e.g. 'Art is painting and drawing'). An individual operating at this level of understanding may have little awareness of the relationship between art done in school to the 'real art' of the art world; a school student could have a concept of art that is relevant to the context of art in the classroom but this may not be transferable to art in art galleries.

Level 2: At this level the concept of art might still be classificatory but will be broader, referring to a more extensive range of media (e.g. 'painting and drawing, sculpture, printing, etc.'). In addition, there may be a limited 'concept based' view (e.g. the concept of art might be limited to a single viewpoint such as 'Art is self-expression' or 'Art is creativity'). At this level there may be a need for a broader understanding of the nature of art so as not to be negatively disposed to art forms that do not conform to a particular view.

Level 3: This level is termed 'extended concept based'. It is suggested that there may be an awareness of art as a qualitative concept, concerned with the (skilful) arrangement of visual elements according to principles of organisation, to achieve meaningful (expressive, didactic, beautiful or 'significant') form.

Level 4: This higher, more abstract, level refers to the notion of art in what is known as its 'intensive' and 'extensive' forms. An individual operating at this level of understanding would be able to synthesise theories of art and formulate new ones.

In order to validate these theoretical levels of difficulty, a fieldwork study was undertaken. The respondents involved in the fieldwork were a group of nearly one hundred school pupils with an age range of eleven to fourteen years – an age group that was not examined in detail in many of the studies cited above. Three discrete levels were identified in school students' understanding of the concept art. There was, as one might expect, an indication that older students tended to be coded at the higher levels. Level 1 type responses were termed 'restricted media based' and tended to refer to school art, as in the following written response from a 12 year old boy:

I think art is a time to think about colour and what sorts of colour you would need for curtain [probably 'certain'] things . . . You also get a chance to draw/make what you want.

Other responses at this level tended to restrict art to certain materials:

[art] is about drawing painting colours and most important is the shading because if the shadings are not right then the picture will not look right.
(12-year-old girl)

This type of response can be contrasted with the 'extended media based' responses at Level 2.

In general, the more naive responses to the stimulus artworks tended to be statements of like or dislike or simple affective responses such as, 'It looks very nice'. However some of the more sophisticated responses were affective in nature, in that they were personal and expressive reactions to the artworks, sometimes using poetic or metaphorical language. These did not fit easily into the categories of response that were formulated to analyse them and points to a need for a less mechanistic approach to art criticism, concentrating on the affective and reflective types of response which often characterise meaningful dialogue with art.

Most of the responses to the artworks shown were designated 'Level 2' according to the coding system employed. This indicated an understanding of the concept of art that is broader than the restricted media based responses that characterise Level 1. Additionally, Level 2 responses were characterised by references to expression and feeling; this ties in with Parsons' description of

Stage 3, at which level such things as creativity, originality and expression are appreciated. There is also a tendency at this level to define art in very broad terms, saying, 'Art is anything you want it to be'. This echoes the findings of Gardner *et al*, who referred to the extreme views that often characterised children's ideas about art in what they termed the 'Transitional phase'. Extracts of typical Level 2 written responses are given below.

14 year old boy:

It can be made out of anything, look like anything and still be considered as art. You can draw and make art at any age. Art can still be called art even if it is the worst picture you have ever drawn.

13 year old girl:

Art is a way of expressing ideas and opinions, creating something which other people can understand and interpret.

12 year old boy:

You don't have to be an artist to be able to do art. You can do a couple of scribbles and colour it in a weird way you can call that art.

13 year old girl:

Art for me is to do more with drawing and mixing colours it is just like a form of expression and a different way to express our filings [sic].

11 year old boy:

Art is drawing and painting and models and there is forms like music. Art is different forms of drawing . . . 3-D painting movies animation.

Although many responses referred to the affective or emotional and expressive elements of art as being fundamental, some also referred to its cognitive aspects; even some of the most basic responses indicated that art could be about 'what people are thinking about' (12 year old boy). Level 3 responses were termed 'extended concept based'. They referred to both cognitive and affective aspects of art and many such responses referred to the different uses of art as well as the range of forms it can take:

Art is a mixture of things, it can mean drawing and painting and imagining things and life things. It can also mean sculpting and a lot of good pieces of artwork have been drawn from your own imagination. There are a lot of different implements you can use – paint pencils, paper, clay sand etc. A lot of artwork portrays someone's mind or feelings and it can also tell a story.
(14 year old girl)

Definitions of art given above referred to a range of concepts associated with it, such as expression and creativity. The majority of the responses referred to art in terms of media employed and to the formal, observable properties of art; the next largest group referred principally to art as a vehicle for expressing feelings, while a smaller number (about 10%) felt that art was essentially concerned with creativity and imagination, while others referred to art only in terms of representation and image making. Surprisingly, there were no references to skill or to beauty.

This study provided some evidence to suggest that three definable stages of development with regard to the understanding of the concept of art can be found amongst English-speaking English school students in the eleven to fourteen age range. There were no responses which were designated 'Level 4', (that is being able to synthesise theories of art and formulate new ones) but this does not mean that adolescent school students are unable to operate at this level. There was a clear indication that levels of understanding of the concept of art are associated with school year, with older students in general performing at higher levels. Although there was no firm evidence to link teacher input with the levels of students' responses, the responses can be seen to give some insight into the influence of school activities upon students' understandings of the nature of art.

It is important here to reassert that the relevant literature seems to indicate that development of artistic understanding is related to general maturation but is dependent upon environmental factors. At the more sophisticated levels, instruction is essential; therefore the role of the teacher is crucial and schools have a central role to play. Much of the recent research into artistic development has focused on understanding art, gaining data from analysing responses to art objects rather than from people reflecting upon their own making. This is in keeping with the notion that everyone is a consumer of art but not everyone is an artist. However, I would argue that while not everyone is an artist (in the same way that not everyone is a critic or an art historian), in general everyone is capable of producing objects of aesthetic significance, some of which might be called art. More importantly, everyone has the desire to create for aesthetic pleasure, whether it be a cake, a garden or a pleasing arrangement of a beer-mat collection. There is a need for more research on the development of art skills and understandings in later life, bearing in mind that although stages are loosely correlated with ages, there is no reason why a young person cannot attain the highest levels of skill and understanding given the right environment. What such an environment might be is another area that demands research; I contend that it is unlikely to be the repressive and authoritarian ethos that characterises many schools.

Learning in art

Many commentators, including those involved in writing the English National Curriculum requirements, refer to the need for subject areas in the school curriculum, including art, to be concerned with developing knowledge, understanding and skills. There is an implicit expectation that at the end of a course of instruction, learners will know, understand and/or be able to do something that they were unable to prior to the lesson or series of lessons. This sounds like common sense but the terminology, in a similar way to the use of the word 'effective' when discussing schools achievement, is more at home in the factory or military barracks. Words like 'fun', 'joy', 'awe' or any positive affectation are ill-suited to the language of those who could be called 'effective curriculum delivery officers'. It is nevertheless incumbent upon adults, preferably trained experts in their field, to help young people to become familiar with the range of human accomplishments and to encourage learning at a deeper level than would be acquired simply through maturation. In art we are concerned with the acquisition of skills involved in such things as rendering, constructing and sculpting; we are also concerned with the development of understanding and the acquisition of subject-related knowledge. Of these, I suggest that skill acquisition should be our priority in the first years of schooling up until about the age of fourteen, with the focus for teaching being on 'threshold skills'.

The notion of 'threshold skills' is perhaps best illustrated by using an analogy of a frog at the foot of a flight of steps:

The frog wants to get to a juicy fly at the top of the steps, which are each ten centimetres high. The frog can only jump nine centimetres and so never gets even to the first step. After tuition in jumping technique and practice, the frog manages to jump the extra centimetre and can therefore leap all the way up to the juicy fly.

An alternative approach might be to teach the frog to use its long sticky tongue and capture the juicy fly without having to jump at all – this could be seen as analogous to an intuitive leap in understanding as opposed to gradual step-by-step progress. Either way, the objective is to get the juicy fly, a concrete and easily discernable goal. For the teacher, having a clearly defined objective is a relatively easy way to organise learning activity and is appropriate for certain kinds of learning. It is relatively easy because skills-based activities such as throwing a pot are concerned with concrete concepts with clear perceptible outcomes: 'by the end of the lesson each pupil will have centred half a kilo of stoneware clay on the wheel and will have produced a hollow form twenty centimetres high'.

This kind of approach is appropriate and probably desirable for some kinds of activities, especially ones such as learning to weld or solder when there might be a safety element to consider and where a very particular skill is being sought. It becomes counterproductive when it is used for other kinds of skill or concept acquisition, such as colour theory. Teaching colour theory has a certain attraction for many art teachers probably because, like linear perspective, it contains rules and expected outcomes, it is concrete and is a (more or less) fixed body of knowledge. However, the potential for dead and deadening lessons is enormous. That perennial favourite, the colour wheel, exemplifies the kind of tedium to which I refer: 'By the end of the lesson pupils will know the terms primary, secondary and tertiary colours and will be able to mix them accurately using powder paint and brush.' Firstly, the pupils probably already know, intuitively if not consciously, about colour mixing; secondly, the colours will often not do what is expected – most ending up various kinds of brown; thirdly, they are being introduced to ambiguous concepts that conflict with what they will already have learned in science. This example is not a straw man – set up to be knocked down – it is one I have seen on literally hundreds of occasions. The most depressing thing, however, is the lost opportunity for teaching something really interesting and stimulating that involves colour and is relevant to the lives of young people. In terms of aims for art education, I would find it quite difficult to locate the place of painting a colour wheel and even harder to justify the time spent on the activity when there are so many other exciting, relevant and meaningful things to do. The little knowledge acquired, and the low level skills expected, could be picked up at each learner's own pace, almost as a by-product of a more stimulating activity involving colour. As young people progress in their skills and knowledge of art, the development of understanding becomes more important. This inevitably involves the teaching and learning of concepts. The following section reviews the nature of concept learning with particular reference to art and seeks to clarify some of the issues surrounding the learning of concepts.

Concepts and art learning

It could be said that owing to its over-use in everyday language, the term 'concept' has caused difficulties for those who need a clear working definition. Whatever the cause, the term is often seen as being rather vague. Many researchers over the years have arrived at helpful definitions, some of these are summarised below. Bruner, Goodnow and Austin [50] gave an overview of what are perhaps the major characteristics of concepts, referring to them as having the following uses:

- they reduce the complexity of the environment
- they reduce the necessity for constant learning

- they provide a direction for activity
- they are essential for effective communication

These characteristics indicate what concepts do and thereby help build up a picture of what they are. A general insight into the nature of concepts is provided by Peel [51]. He stated that there are three parts to a concept: the intensive, the extensive and the name. The intensive aspect refers to ideas with some general property; using the concept 'art' as an example, the intensive aspect would refer to the criteria that need to be met (such as expressiveness) in order for something to be termed art. The extensive aspect would be all the examples of art that are known to exist, such as individual paintings, sculptures and so on. The name of the concept is the word or label that identifies or symbolises the concept, in the present case, the word art. Klausmeier, Ghataler and Frayer drew attention to the fact that the term 'concept' is used to refer to both individuals' personal mental constructs as well as to public entities and they gave a definition that is general enough to cover both uses:

Ordered information about the properties of one or more things, events, processes, that enables any particular thing or class of things to be differentiated from and also related to other things or classes of things [52].

Central to this definition is the notion that concepts are units of information that have a particular relationship with other units of information. Schaefer [53] referred to the 'logic core' of concepts, which he defined as being the constant pattern of properties of a class of things or events; the concept name is associated with this logic core and serves as a vehicle for communication between individuals. A further aspect of concepts according to Schaefer is the 'associative framework'; this differs from the notion of the extensive aspect of concepts in that it is unique to each individual; it is a network of associations surrounding the logic core and is additional to the concept name.

Another distinction between concepts can be made in terms of levels. For the present purpose these levels can be called primary concepts (such as 'red'), which are taken from direct experience and classified; secondary concepts (such as 'colour'), which develop as a result of being abstracted and classified from other concepts; and tertiary concepts (such as 'art'), which are abstracted and classified from secondary level concepts. These distinctions are often referred to as 'higher order' and 'lower order' levels. It is important to note that the concept name can remain the same while the concept itself can be understood at differing levels of abstractness and complexity. To continue with the example of art, an eleven year old will probably have some understanding of art which would be functionally sufficient for that child's educational needs but the same level of understanding would be inadequate for the needs of a

professional artist, yet the concept name 'art' could be applied to both. Some concepts may be seen to be intrinsically more difficult to grasp than others, due mainly to their levels of abstractness and complexity: an abstract concept such as 'Aesthetic', for which there are no obvious perceptible instances, is likely to be more difficult than a concept such as 'Collage', which has a clear concrete referent. A distinction needs to be made here between two uses of the term 'abstract': one use refers to the idea of 'drawing away' while the other refers to the essence or idea of an object or event.

The factor of complexity could be said to be related to the hierarchical nature of concepts, that is, the extent to which the understanding of a concept is dependent upon the understanding of more basic, lower order concepts. This is sometimes referred to as 'level of dependence'. An understanding of a complex concept (that is, one made up of many elements) such as 'Colour' as an abstraction would therefore be dependent upon the ability to identify individual colours. However, the process of abstraction is not simply a case of moving from the particular to the general; it is possible that the general is already tacitly known and is intuitively perceived within the particular. This notion is based on the view that it is not possible to perceive an object in isolation from other phenomena and that one is tacitly aware of potentialities surrounding and emanating from the object. Bolton [54] refers in this context to the 'predictive nature of concepts' and argues that the abstracted general form of a concept is not the end result of a linear process but that 'generality is implicit in the experience of what we call the particular' (p. 16). It is likely that concepts and concept names are acquired according to what is known as their 'level of utility' [55]; 'Red', for example, would be acquired before both the more specific 'Carmine' and the more general 'Hue'.

Different worldviews embrace different conceptions of the nature of concepts. Bolton, in his later work, takes a phenomenological stand in his criticism of cognitivism, asserting that it is a fundamental mistake to treat mental phenomena as abstractions [56]. This is because by doing so one fails to take account of the individual social contexts from which the mental phenomena develop. Gilbert and Watts [57] note two underlying approaches to understanding the nature of concepts, referring to them as 'erklaren' and 'verstehen'. These two approaches and their associated ways of operating have polarised into what can be termed the scientific/quantitative/experimental paradigm and the artistic/qualitative/naturalistic paradigm. The scientific paradigm is concerned primarily with clarifying concepts through explanation – the 'erklaren' tradition – while the artistic paradigm is primarily concerned with understanding – the 'verstehen' tradition. These two worldviews are associated with differing conceptions of the nature of concepts: the traditional scientific view that concepts are static, finite, definable and public, and what we might call the 'artistic' view that concepts are not easily definable because they are

dynamic, developing phenomena, existing only in the personal domain. Gilbert and Watts refer to three approaches to the concept of concept, which are related to the two paradigms: the 'classical', the 'actional' and the 'relational'. The classical view holds that all instances of a concept have properties in common and that these properties are necessary and sufficient to define the concept. Gilbert and Watts object to this notion on the grounds that, amongst other things, it 'bears little resemblance to the rather messy actuality' of everyday life (p. 65). The classical view is also characterised by the notion that knowledge is made up of units of cognition and organised in the mind in static hierarchical layers, so that progress is dependent upon previously mastered units. The actional view contrasts with this and sees concepts as being dynamic and fluid, continuously reconstructing in the light of new experiences. A researcher operating within the artistic paradigm will tend to be concerned with individuals' personal conceptions rather than with universals. The third approach mentioned by Gilbert and Watts refers to the 'relational' view of concepts and is constructed from aspects of both the classical and the actional views. The relational approach emphasises the importance of the relational organisation of a concept, that is, its status relative to other concepts in a conceptual network, in addition to it having definable characteristics. This approach is implicit in Schaefer's view described above.

The move away from the 'child as artist' model for art education, with its emphasis on expression and creativity, towards an approach that emphasises the more cerebral aspects of art, necessitates clearly-defined goals that are related to bodies of knowledge. Bodies of knowledge, such as those in the areas of art history and art criticism, for example, are in the public domain. Art in the lives of young people is more concerned with personal constructs of knowledge and with self- identity – there are no generally accepted 'bodies of knowledge' in art that are necessary for young people to acquire. When attempts are made to identify what young people need to know in the arts the results are disputable, if not controversial. There needs to be a balance between subject-centred and learner-centred approaches to learning in art, with the emphasis on the former in the earlier years, moving towards a focus on the subject after basic skills and concepts have been acquired at the learner's own rate of individual development.

Where the learning of a particular area of knowledge in art is felt to be a necessary or worthy endeavour, it is not simply a matter of exposure – people need to be taught. Research has shown that the learning of abstract concepts in art is made easier by the use of visual support; because of the nature of the subject, such support can be readily drawn upon to facilitate learning. Contextual support, in the form of, for example, paintings or sculptures, would enable the learning of art concepts at sophisticated (i.e. more abstract) levels. Koroskik, Short, Stravopoulos and Fortin [58] conducted research based on

showing a reproduction of Marc Chagall's painting *The Birthday* to 120 undergraduate students, together with different supporting art contexts, to find the effects of contexts and verbal cues on students' levels of response to the painting. The 'supporting contexts' consisted of comparative conditions in which the key artwork was shown: with other paintings by the same artist; with paintings depicting the same theme; with works in other art forms (a dance, a lithograph and a poem). A second independent variable was introduced that consisted of verbal cues being given/not given which related the key artwork to its comparative context. They found that greater understanding of artworks amongst pupils could be facilitated by showing comparative art contexts, accompanied by explicit verbal cues about the artworks' shared characteristics. Further to this, it was extrapolated from their findings that it is wise to base art comparisons on key ideas that have some relationship to students' existing knowledge; this is likely to involve the transference of concepts learnt elsewhere to a new (art) context, thus expanding the students' understanding of those concepts.

Learning in art is much the same as learning in other areas of human endeavour but art can offer something special. This 'something special' has been examined by David Perkins, working alongside people such as Howard Gardner at Harvard Project Zero [see note 32]. Perkins, in *The Intelligent Eye* [59] referred to three different kinds of intelligence: neural intelligence, which is associated with the inherited mechanics of the brain and its networks; experiential intelligence, which is derived from learning; and reflective intelligence, which is concerned with the ability to stand back and make sense of learnt information. If we use a combination of experiential and reflective intelligence, we can then make creative connections in an artwork and this helps us to develop our thinking skills in a more general way. Art objects are particularly suited to this approach for a number of reasons. Perkins cites six:

1) Sensory anchoring: artworks provide an anchor for attention over an extended period of exploration.

2) Instant access: You can check something with a quick glance or you can point to it in the artwork; the picture is here and now.

3) Personal engagement: works of art beckon you to become involved with them – we are rarely neutral.

4) Dispositional atmosphere: art can provide a context that facilitates or cultivates a range of positive thinking dispositions.

5) Wide-spectrum cognition: through thoughtful looking at art, we can use many

different styles of cognition, including analytical thinking, visual processing and testing hypotheses.

And finally

6) Multi-connectedness: Perkins asserts that a typical feature of artworks is that they allow us to make connections between a great variety of things, which can include 'social themes, philosophical conundrums, features of formal structure, personal anxieties and insights and historical patterns'.

Perkins goes on to say that interacting with art can help develop a particular kind of intelligence, specifically reflective intelligence, described as 'a control system' for experiential intelligence [60]. The important point in all of this is that we need to give time for reflection and for thoughtful and organised looking, which, to use Perkins' words, should be 'broad and adventurous' and 'clear and deep'.

There is great potential for art to contribute to the wider school curriculum – not only to basic skills of reading, writing, listening, measuring and use of information technology but in a significant way to thinking skills. According to developmental psychology, learning occurs naturally, in stages but, as noted earlier in this section, the higher stages cannot be reached without structured teaching [61]. Art teachers can provide an environment that facilitates 'natural' learning but, again, this is not enough. In addition we need to direct, guide and instruct in a focused way, a way that focuses on both the learner and that which is to be learnt. We all learn by building upon our existing conceptual framework. To make art understandable and meaningful to pupils, it makes sense to teach through building upon pupils' initial affective reactions to it. Like a great work of art, classrooms and therefore art classrooms are complex and multi-layered; it is up to the art teacher to ensure that the layers are meaningful and the activities that take place are worthwhile with due regard for reflection – giving pupils space and time to reflect as well as to research.

Among educators who have made contributions to the debate on the relationship between the art curriculum and artistic development is Ralph Smith. Smith (who has been, among other things, the long-time editor of the *Journal of Aesthetic Education*) represents to many the reactionary face of art education. He has often been considered to be guilty 'in popular parlance, of politically incorrect thinking, or, worst of all, of being a conservative' [62] but he has stoutly defended his position as a radical liberal with a propensity for valuing 'excellence'. How such 'excellence' is to be determined is another matter. In Smith's view, there is no place for political labelling when it comes to scholarship and learning but it must be said that all thinking has to be grounded within a cultural and, by extension, political milieu. Post-modernism has, rightly, drawn attention to the dangers of various other 'isms' that beset western

thinking: ethnocentrism as well as elitism and its bed-fellows sexism and racism. Smith asserts that art is 'a special kind of human accomplishment that is expressive of indispensable human values' [63] and proposed a curriculum based on teaching art as a humanity. Smith's proposed curriculum consists of five stages of aesthetic learning that he claims to be appropriate for today's world. The proposed phases are developmental and can be compared with Michael Parsons' stages described above.

Table 2 shows Smith's and Parsons' stages together with a suggested practical focus for each stage [64]. The five stages represented are not, strictly speaking, age related; they cover the entire range from early years through to old age. An individual could be at any stage at any age but will have progressed through the earlier stages. Smith's first stage is 'exposure and familiarisation', which is put alongside Parsons' Stage 1 'sensuous responses'. During this early phase, people (usually young children) are introduced to the notion of visual form and become familiar with the idea that such things as paintings and other art forms exist and that they are created by people. Responses to these are affective rather than cognitive. Throughout this initial phase, media and materials are introduced and psychomotor skills are developed. 'Threshold skills' could include grasping a crayon and making a mark in a deliberate way and responding to that mark by making further marks that have some relation to it. They could also include, at later phases, learning how to gouge into or build up a surface for the purposes of making a relief print, mix paint to achieve a particular shade or solder together wire to form an armature.

During Stage 2 individuals look carefully at things and begin to make connections between phenomena. In Parsons' scheme there is a concern for beauty and realism, although, as anyone who has observed young boys draw can confirm, beauty is not always a primary consideration; arresting imagery that catches attention is a more accurate description of the concerns at this phase. There is certainly a desire for accurate representation and this is addressed through teaching that focuses upon looking carefully and which consolidates and builds upon the practical skills acquired in earlier phases.

During Stage 3 Smith highlights historical awareness. Individuals at this stage can readily acquire an understanding of historical time and a synchronic knowledge of art forms. Parsons' Stage Three has the focus on expression – individuals tend to be drawn to the expressive qualities of art. It follows, then, that practical work will similarly be concerned with developing skills in, for example, painting and drawing, with a concern for self-expression and a need to establish identity. Earlier concerns for verisimilitude give way to a tendency to favour expressive and emotional impact. People at this stage are more open to the full range of media and materials available for art-making.

By Stage 4 examples of different kinds of art objects from different times and places can be fully appreciated in terms of their social and cultural context.

Individuals are now in a better position to refine their own practical work in the light of others' artwork. A return to a concern for skill and proficiency in the use of media is evident. The final stage, which is normally attained only by those who have specialised in the subject (and have therefore been taught), is one where the individual can synthesise earlier knowledge and understanding of art forms. An informed personal view of the nature of art is developed and this is reflected in individuals' creative practical output; a personal style is constructed. The four levels identified in Section One can be located across the five stages, with Level 1 (a 'restricted' understanding of art) occurring in the later phases of Stage 1 and Level 2 (having the ability to synthesise theories of art and formulate new ones) occurring in the earlier phase of Stage 5.

Table 2: A developmental model for art learning

Smith's stages of aesthetic learning	Parsons' stages	Possible practical focus
exposure and familiarisation	Stage one: sensuous responses	Threshold skills
perceptual scrutiny	Stage two: representation	Perceptual training, using a range of media
historical awareness	Stage three: expression	Exploration of expressive use of media; identity
exemplar appreciation	Stage four: social and cultural awareness	Refining skills in the light of others' work
building a philosophy of art	Stage five: reconstruction	Development of personal style

NB: this is not a framework for the school curriculum. In general, it refers to stages of development from pre-school to maturity and old age but in any individual the final stages could be attained at any time after adolescence, given the appropriate environmental influences.

Aims, rationales and desirable outcomes

In order to consider what the nature of art in schools is, could be or should be, we need to examine why it is thought to be of value in the curriculum in the first place. Commentators on the role of art in education have considered many aspects of the subject and have come up with various strategies for course design, desirable outcomes and justifications for the inclusion of art in the school curriculum. The purpose of this section is to help clarify some of these issues. Put simply, aims, stated as desirable outcomes, and goals for art education come under the heading of *what* we are hoping to achieve. Rationales examine the principles underpinning the aims and explain *why* the aims are considered to be of value; they are concerned with justifying the aims. We could, for example, say that a desirable aim for art education is to promote creativity but a rationale would attempt to explain, from a philosophical perspective perhaps, why creativity is desirable.

First I will outline the nature of art in education as it has developed in many industrialised countries. Arthur Efland, in his important overview of the history of art education [65], identified what he termed three 'streams of influence' that underpinned its development: expressionist, scientific rationalist and reconstructivist.

Art educators adopting an expressionist approach are concerned fundamentally with individual growth, with facilitating creative expression and giving opportunities for exercising the imagination. Related to this are ideas associated with 'art for art's sake', and the notion that participating in art-making activities is intrinsically a good thing. Art activities derived from the expressionist philosophy are often seen as a kind of therapy, perhaps giving a respite from the rigours of what are often perceived as more academic subjects.

The scientific rationalists claim that art education is itself a distinct discipline with its own methods for conducting inquiry and forming judgements. Several commentators, such as Louis Arnaud Reid, have put forward the view that art is, or facilitates, a particular way of knowing [66]. The philosophical basis for this is supported by, for example, the work of Nelson Goodman. Goodman asserted that images are an integral aspect of cognition; the arts are said to provide an alternative (or complementary) symbol system. In addition to eminent philosophers identifying the visual arts as essentially cognitive, Rudolph Arnheim, in outlining his thoughts on learning from a psychological perspective, identified 'visual training' as one of three central areas, alongside philosophy and language training. Visual training, he asserted, is an area where students learn to handle visual phenomena as an important means of dealing with the organisation of thought [67].

The reconstructivists see art as a means to an end, as a tool for social change, rather than an end in itself. This can take many forms but is associated in recent times with art educators who are concerned with the promotion of 'visual

culture' and a radical reappraisal of the whole concept of art and its contexts. John Steers, General Secretary for many years of the National Society for Art and Design Education (NSEAD), notes that

> *those who espouse art education as an important vehicle for multicultural and anti-racist education are an example of the more socially-critical reconstructivists* [68].

These three streams can be seen as relating to three academic disciplines – the psychological, the epistemological and the sociological. Of these, 'expressionist' was the dominant theory associated with the non-interventionist teaching of the post-war years. Since that time the prevailing orthodoxy has tended to reflect the concerns of modernism, with a mix of formalist and expressionist approaches dominating classroom practice, at least until relatively recent times. The three streams cover the range of approaches to art in education that have developed over the decades. There is some overlap between them and it is rare to find practice that is solely within one camp. However, at their fundamental level, reconstructivist and expressionist approaches are probably mutually exclusive. Herbert Read is an interesting figure in this respect (and in many others). He has often been associated with a child-centred expressive approach to art education but in truth he was much more concerned with art as a social tool. He has influenced generations of art teachers through his passionate belief in what we might call 'the civilising effects' of art, encapsulated in the following from *Education Through Art*:

> *The lack of spontaneity in education and in social organisation is due to that disintegration of the personality that has been the total result of economic, industrial and cultural developments since the Renaissance* [69].

This quotation reveals Read's concern not so much with the psychological dimension as with the sociological; he was in fact a pioneer in advocating the socio-cultural dimension of art in education. Although Read's writing appears to emphasise feeling and expression, his focus went beyond this, being concerned with making society more civil by fostering 'the organic unit of society, the citizen' [70]. Read's vision of art education did not include the advocacy of art for art's sake; he asserted that aesthetic education is fundamental to general education in nurturing individual growth. After World War II this idea of what became known as 'creative growth' was taken up by Read's contemporary Viktor Lowenfeld in *Creative and Mental Growth* (described above). It is instructive to re-examine some of these earlier rationales for art in education, which in reality emphasised not free individual expression so much as the value of art as a civilising instrument. Its value,

though, was not seen in terms of the civilising effects of exposure to great art but in the potential it offered for emotional and intellectual growth through active engagement in making art.

The art education programmes of many countries have grown out of modernism and are based largely upon concepts derived from expressionist and formalist theories of art. In some countries, however, traditional art practice and its attendant culture has formed the underlying principles for art programmes. Many government documents concerning the role of art in education refer to 'imagination', 'creativity' and 'expression', even in those countries where traditional art activities have not prioritised such concerns. However, other concerns are given a high priority, such as the identification of cultural values and attitudes and developing an understanding of the relationship of the arts to the political and economic environment of society and how political and economic considerations influence arts practice in addition to understanding how the arts transmit and reflect social and cultural values [71]. It is clear that some cultures and political systems value social cohesion over individual fulfilment. This contrasts with apparently similar lists of aims put forward elsewhere, particularly in America, where individual expression and consumer education figure prominently [72].

Art as a way of knowing
Arthur Efland has elsewhere, in his book *Art and Cognition,* made a convincing case for learning through art and the value of interacting with art in a cross-disciplinary way [73]. Efland's is one of several relatively recent publications which have argued the case for a more cerebral account of art and its role in education; others include Dorn's book of 1999 and Eisner's of 2002 [74]. Dorn's book looks at the role of cognition in art learning and suggests some useful strategies for the classroom which underline the notion that art-making is an 'intelligent' activity. Eisner also challenges the supposition that the arts are in some way intellectually undemanding, arguing that some of the most complex and subtle forms of thinking occur when one is engaged in art-making and appreciating. Each of these publications is a product in part of the American public education system which, to an extent greater than that in the UK, creates an environment where art needs to defend itself in terms of public utility – giving rise perhaps to an instrumental view of art education, where the subject is expected to defend itself in terms of its contribution to 'higher' thinking skills. Efland presents a view of art in education that emphasises the intellectual status of art and challenges what he sees as the persistent perception of art as being 'emotive'. We can look to Efland to give us a sound overview of trends in art education and the historical basis for them. For example, in discussing Vygotsky's 'zone of proximal development', he notes that this construct contrasts sharply with the long-standing notion in art education that 'the best

teaching is no teaching at all and where artistic accomplishments are judged primarily for their therapeutic rather than their educative value', a notion which has made it 'difficult to recognize the study of art as a cognitive endeavour' [75]. However, this last point reveals a fault line in the argument, in that this implies that the *study of art* rather than the *making* of it is the principal focus of attention when discussing cognition and art. There appears to be an emphasis, common in books of this kind, upon *responding to* rather than *making* art, although this is perhaps inevitable, given the thrust of the argument. With regard to education in general, he asserts that both declarative and procedural forms of cognition emerge from a common source but this is not acknowledged in curriculum construction:

Schooling for most students occurs within a curriculum where knowledge is experienced as a series of isolated, random facts. This compartmentalized curriculum reflects a long tradition in Western philosophy, which in large part is the consequence of a divided mind [76].

While making a case for integrating the curriculum, Efland also underlines the particular contribution of art/the arts, as in the following passage:

The arts are places where the constructions of metaphor can and should become the principal object of study . . . It is only in the arts where the processes and products of the imagination are encountered and explored in full consciousness [77].

Efland's emphasis tends to be upon engaging with art objects rather than on producing them. Elliot Eisner, on the other hand, has long advocated the specialness of art-making as a way of understanding the subtleties of life. In *The Arts and the Creation of Mind*, he articulates clearly ways in which participation in art activities contributes to the development of higher order complex thinking skills, arguing that

the tasks that the arts put forward – such as noticing subtleties among qualitative relationships, conceiving of imaginative possibilities, interpreting the metaphorical meanings the work displays, exploiting unanticipated opportunities in the course of one's work – require complex cognitive modes of thought [78].

As a subject in schools, art has its full quota of advocates who advance a range of worthy reasons for pursuing it at public expense. Four basic ones are associated with notions of self-esteem, therapy, leisure and vocation. Self-esteem can be related to self-knowledge. Before people can cooperate effectively

with other people they must understand themselves; the production of art is said to bring about a greater understanding of the self through exploration of personal ideas and feelings [79]. Promoting young people's self-esteem is, apart from anything else, a socially useful aim – people who feel good about themselves will be more socialised individuals than those who are bitter and resentful. The negative side to this is that in the current hierarchy of disciplines, such sentiments exacerbate the view that art is (only) for the socially and probably intellectually challenged (they are no good at anything else). David Hargreaves, in remarking positively upon what he found, refers to this as 'compensation' [80]. This sentiment is compounded by the view that art is some kind of therapy, designed to help release pent-up feelings through self expression and/or it is a leisure activity – a hobby which not only channels undesirable feelings but gives people something to do that is relatively undemanding and harmless. These rationales may well be true to some extent but they are not often promoted by art educators, nor is the vocational rationale (learning a practical skill), as this goes against the notion that art is something more elevated than anything concerned with simply making a living. I suspect that while the self-esteem, therapy, leisure and vocational rationales are quite commonly held, they are not often found in print, although Hargreaves claims that 'a very large number of art teachers recognise that the art room can be a sanctuary for difficult pupils' [81].

Art in the English national curriculum
There is a brave attempt in the English national curriculum documentation to set out the 'importance of art and design to pupils' education'. It describes ways in which art can 'promote learning across the curriculum in a number of areas such as spiritual, moral, social and cultural development, key skills and thinking skills'. These are grand statements of the kind art educators are wont to propound. They fit neatly into the standard government template but are nevertheless worthy and appropriately vague.

Pupils' 'spiritual development' is said to be promoted through 'helping pupils to explore ideas, feelings and meanings and to make sense of them in a personal way in their own creative work'. In addition to this, there is an expectation that pupils will be helped to 'make connections with the experiences of others' through engaging with others' artwork; this element is amplified in the use of exemplary artwork which has a moral component (the example given is 'Picasso's condemnation of warfare in his painting *Guernica*'). Suggesting that art teachers teach about moral issues through the use of artwork is getting into potentially difficult waters. What, for example, is to stop a latter-day Jean Brodie idealising the fascist sentiments of the Futurists? Teaching about the life and work of Caravaggio might not appeal to some conservatives; I have known of art teachers who have explicitly avoided referring

to David Hockney or his work because of Hockney's sexual orientation. Who should be responsible for the choice of artwork that is to be the focus of attention? The government? Art teachers? The students themselves? Issues associated with these questions are considered in Section Three.

The advice on cultural development reveals a wider interpretation of what an education in art can mean, with an emphasis on context – and with a recognition that visual form outside the traditional canon can be a meaningful activity in an art lesson. The examples given are 'the use of icons in religious art' and, more radically, 'corporate advertising'. We see here a nod towards a 'visual culture' approach.

The English national curriculum documentation goes on to recommend collaborative working to facilitate social development; this is reiterated under the heading of promoting what are identified as 'key skills'. Working with others and negotiating ideas are put forward as desirable activities, for which art as a subject in schools is said to be well placed to deliver. There are other attempts to elevate art activity by association with other alleged 'key skills'. Of interest here is that they are in the main related to practical making activities, 'knowing how' rather than 'knowing what'. These key skills include *communication* through pupils 'exploring and recording ideas' as well as 'discussing starting points and source materials for their work'. Another key skill, identified as *application of number*, is directly associated with making activities:

> *Through understanding and using patterns and properties of shape in visualising and making images and artefacts, working in two and three dimensions and on different scales, understanding and using the properties of position and movement (for example, rotating and transforming shapes for a repeat pattern), and scaling up a preparatory drawing for a large-scale painting* [82].

An additional 'key skill' identified is the use of Information and Communications Technology, which is a vital aspect of contemporary art education. Art is also seen to be of value in promoting learning skills, of 'improving pupils' own learning and performance'. This is achieved through pupils' critical discussion and reflection upon their own practical work. The notion of 'problem-solving' makes an appearance here. This particular key skill is, according to DFEE, developed in art through:

> *manipulating materials, processes and technologies, responding, experimenting, adapting their thinking and arriving at diverse solutions, synthesising observations, ideas, feelings and meanings, and designing and making art, craft and design* [83].

And so we can see that even in terms of promoting 'key skills' across the curriculum, the emphasis is upon the practical aspect; there are few attempts to single out the allegedly more cerebral aspects of art in order to justify its inclusion in the curriculum. Even in the section on promoting *thinking skills*, the emphasis remains upon teachers encouraging pupils to:

> *ask and answer questions about starting points for their work, explore and develop ideas, collect and organise visual and other information and use this to develop their work, investigate possibilities, review what they have done, adapt or refine their work, and make reasoned judgements and decisions about how to develop their ideas* [84].

There is no doubt that 'their work' refers to the practical art-making activities of pupils.

Earlier in Section One I referred to the common association of art with creativity and imagination. I have also noted the importance given by some educators to 'personal growth', which includes elements such as self-expression, intuition and imagination as ideas that are central to an individual's development. It is of interest, then, that the notion that pupils in school should be creative and imaginative and should use their intuition comes under the heading of art promoting 'enterprise and entrepreneurial skills'. The idea is that these skills are facilitated by teachers

> *developing pupils' willingness to explore and consider alternative ideas, views and possibilities, developing characteristics such as being prepared to take risks and to persevere when things go wrong, and encouraging pupils to be creative and imaginative, to innovate, to use their intuition and to develop self-confidence and independence of mind* [85].

The vocational aspect of art activities in schools makes a further appearance in the contribution of art to 'work-related learning'. The national curriculum documentation here is rather unambitious, asking teachers to do little more than make pupils aware of 'the range of possibilities for employment in the creative and cultural industries'. There is a further section on 'education for sustainable development' that talks of 'developing pupils' knowledge and understanding of the role of art and design in shaping sustainable environments'. The section continues with the observation that art offers opportunities to explore 'values and ethics within art and design'.

Tellingly, there are no references to self-expression or expressive activities anywhere in the document. It is not clear what the principal underlying rationale is for the inclusion of art in the English national curriculum. One thing is clear, however, and that is that notions of self-expression and related ideas about

personal growth do not figure prominently. We have seen that where self-esteem and/or self-confidence are mentioned, it is (along with those other concepts long associated with art – creativity, imagination and intuition) in the context of 'entrepreneurial skills'. Many artists and teachers will associate these affective aspects with the subject; I would suggest that there is at least an unspoken understanding that they are essential and intrinsic to work in the arts. There are numerous other published aims for art education, found in prospectuses and syllabuses elsewhere. An education in art is said to promote a lot of desirable outcomes. The following is a sample gleaned from various countries:

- Knowledge and understanding of one's cultural heritage
- Knowledge and understanding of the cultural heritage of others
- Understanding of the visual world – perceptual training
- Understanding of one's inner world, of feelings and imagination
- Practical problem-solving through manipulation of materials
- Enhancing creativity through developing lateral thinking skills
- Facilitating judgements about the made environment
- Inventiveness and risk taking [86].

This list shows the range of concerns, which in various forms and with differing emphases come within the general remit of art teachers. Since putting forward these eight concerns of art education, as a synthesis of published work on the subject, I have considered how they impinge upon the individual and upon actual art curriculum content. One thing that again stands out is the lack of reference to the role of individual expression and personal response. In broad terms, we can think of rationales for art in education as being concerned with social utility, personal growth and visual literacy. The eight aims listed above can be related to these three areas in the following ways.

Social utility
This refers to aspects of art education that can have a practical effect upon individuals in terms of their contribution to, and role within, society. It is related to promoting creativity and the development of fine motor skills and can have a clear vocational element to it. The aims of 'inventiveness and risk taking', 'practical problem-solving' and 'enhancing creativity through developing lateral thinking skills' fall largely within this category. It is noteworthy that in a survey of the careers of British art graduates [87], Harvey and Blackwell make the following comments:

Art and design, probably more than any other sector, develops graduates'
critical and creative abilities and their imagination.
In the modern world, employers crave new ideas and want risk-takers, lateral

thinkers and creative problem solvers, in short, people who can suggest solutions without requiring a full set of information upon which to base any decision. Art and design graduates have enormous potential in this respect and should be encouraged to develop and make the most of these elements that are 'natural' to the art and design environment and which respondents considered were well-developed on their courses [88].

Personal growth

This area refers to individual development; it is concerned with self-expression, intuition and imagination. There is also an association with the therapeutic aspects of involvement with art – the pleasure of making. The aim of 'understanding one's inner world, of feelings and imagination' is central to this rationale.

Visual literacy

This area is concerned with promoting knowledge and understanding of visual form, culture and heritage, in addition to developing aesthetic perception. The following aims fall largely into this category:

- Knowledge and understanding of one's cultural heritage
- Knowledge and understanding of the cultural heritage of others
- Understanding of the visual world – perceptual training
- Facilitating judgements about the made environment.

There is some overlap. For example, 'perceptual training' could be seen to be an important aspect of personal growth, as could 'practical problem-solving through manipulation of materials'. The prominence of each of these areas is subject to the whims of educational fashion; for example, in the 1960s the area of personal growth was deemed to be of greatest importance, especially in the UK, whereas current trends indicate the prominence of visual literacy. The *de facto* future of art education lies in the hearts, hands and minds of specialist teachers of art and design. It makes sense, then, to ask new 'trainees' about their views – what they consider to be important now and what they think will be of importance in the future with regard to the orientation of art education. In the summer of 2003 I gave a questionnaire to a group of trainee teachers of art and design in their final term from three different institutions [89]. They were asked to rank, from the list of eight aims for art education given above, the aims that they considered to be most important and least important, both currently and in the future. The students' predictions for the future were based on their own personal view as determined by the way they perceived trends.

Table 3:

Mean average ranking of aims, as determined by PGCE students

Average Ranking of Aims

The highest bars indicate the lowest priority. For example, 'understanding of inner world' was given the lowest priority for the future, while 'problem-solving' was given the highest priority for the present.

The questionnaire survey on aims for art education was concerned with individual students' perceptions; there were no significant differences in attitudes between the three institutions. Of the eight aims listed above, and in Table 3, 'facilitating judgements about the made environment' was given the lowest priority by the largest number of respondents (34%); this was in relation to their present priorities. For future priorities, 'understanding of one's inner world, of feeling and imagination' was considered to be the lowest by the largest number. The aim of 'understanding of the visual world – perceptual training' was rated as currently being second in importance to 'practical problem-solving through manipulation of materials', while the respondents overall tended to predict that 'knowledge and understanding of the cultural heritage of others' would be more important (second to 'problem-solving') in the future. The aim of facilitating 'problem-solving through manipulation of materials' activities seems therefore to be consistently ranked as being of the highest priority. The

greatest variability between what was felt now to be of importance and what respondents overall predicted for the future was with regard to ' knowledge and understanding of the cultural heritage of others'. This was given first priority by nearly a quarter (23.4%) of the respondents for the future, while for the present, less than one twentieth (4.3%) rated it as being the highest priority. This appears to indicate that beginning teachers' perceptions of what is important in art education is likely to move away from concerns with feeling and individual expression towards a concern for understanding visual form from a range of different cultures. The most important aim, however, remains that of 'problem-solving through manipulation of materials. The key aspect here, found from follow-up interviews, is the 'manipulation of materials' rather than the 'problem-solving' aspect.

Much of what has been written about art in education appears to be from a modernist 'fine art' perspective. Certainly classroom practice seems to have this bias – it is extremely common to see painting and drawing with an emphasis on a mixture of expressionist and formalist approaches. This is perhaps surprising given the range of background (i.e. undergraduate) disciplines that characterise many specialist teachers of art. It is not so surprising when we witness the school art orthodoxies that so many beginning art teachers slip into at an early stage in their careers.

In order to examine the range of degree specialisms that teachers of art bring to the profession, I took a sample from two different institutions responsible for the post-graduate training of art teachers for the years 2000 to 2004 [90]. I found that fine art (including painting, sculpture and printmaking) accounted for 52 out of 163 students' degree specialisms (32%). Design on the other hand (including photography, silversmithing and jewellery, three dimensional design, graphic design, interior design and fashion design) accounted for 69 of the degree specialisms. If we include ceramic and glass (11) plus textile design (22), this gives us 102, with history of art (plus other non-studio subjects such as anthropology) at ten making the total of 163. So on this sample we can see that while fine art is the largest single contributor, less than one third of those training to be teachers of art are from fine art backgrounds. I would suggest that the principal activity which appears to bind these degree backgrounds together is drawing – a skill which ironically has been downplayed in fine art course in recent years. The corollary of this is that aims for art education that have a 'fine art' bias are inappropriate and a more skills-based approach, perhaps with a greater emphasis upon drawing, would be more in keeping with the aptitudes and interests of specialist teachers of art.

In his 1982 publication *Art Education – a Strategy for Course Design,* Maurice Barrett lists 21 'worthwhile outcomes' for art education [91]. These outcomes, which are put in terms of general educational aims, describe the role of art in achieving certain desirable outcomes. Eight of the 21 are concerned

with what we can describe as 'making activities': for example, 'to develop the ability to organise marks, shapes and forms so that they communicate or demonstrate our response to what has been observed'. These making activities are variously concerned with recording, expressing and communicating through exploring, organising and manipulating visual form. There is an explicit connection, made in Barrett's list of worthwhile aims, between self and society, as in, for example, 'to be able to realise personal uniqueness in a community or in society as a whole, so that the pupil can learn from and contribute to society'. Other values are also made explicit – the importance of 'personal uniqueness' and 'self-reliance' and the importance of being able to express personal feelings in a 'world shared with others'. The subject of art itself is given somewhat less attention, but given the historical and cultural context of Barrett's book, figures more prominently than one might expect, with reference to understanding 'the dynamics of visual form'. There is also a nod to art's role in cognition: 'art should be recognised as a form of thinking able to sustain creative ideas and provide a framework for judgement'. Problem-solving and the development of visual perception, combined with sensitivity to the made environment, are evident. The complete list of Barrett's 21 'worthwhile outcomes' is well worth looking at and can be found in Appendix III. It is also worth noting that the heads of art departments who were surveyed at that time (the late 1970s) appeared to rate the development of perceptual skills, imagination and expressive skills – all associated with 'making' – more highly than developing understanding of cultural forms. There appears to be little significant difference between the views of art teachers of the 1970s and those of trainee teachers of art some 30 years later, despite the considerable cultural changes that have occurred. Perhaps the reason for this lies not so much in teachers' conservatism as with a perennial and abiding concern for creative self-expression.

Concluding remarks for Section One

In this Section I have outlined broad areas for justifying art in young people's lives and have suggested that most of the stated aims for art in education can be summarised under three headings of social utility, personal growth and visual literacy but that these are not mutually exclusive. Of particular importance, I feel, is the notion, highlighted by Herbert Read, of the basic unit of society being the individual and it is individuals' capacity for expression, their use of intuition and imagination and their pleasure in making that contribute to a healthy society.

I have given a brief overview of the nature of art and its place in education. It is acknowledged that the concept of art is too fuzzy and too contested to be of much value; it is also a concept that can be understood at different levels of complexity and abstractness. However, learning in art cannot be discussed in

any meaningful way without reference to concept learning. I take the view that learning in art is fundamentally developmental and is an interaction between a logic core acquired through maturation and interaction with the environment; thus understanding is, of course, unique to each individual. While outlining a view of artistic development that is said to be universal, I emphasise the importance of environmental factors and note that higher levels of development cannot be attained without appropriate teaching.

I note that most of the research in learning in art focuses upon learners' interaction with and response to art objects made by others – there is a dearth of studies looking at the development of practical studio skills beyond childhood. While this book does not fill that gap, it does focus upon the importance of making as opposed to responding, the latter being a development that I have described as being associated with a move away from learner-centred to subject-centred approaches in art education. Subject-centred approaches are in turn associated with issues of accountability and the measurement of performance – performance of individual learners, teachers, schools and school districts.

Most rationales for art education emphasise, among other things, the role of art-making in developing individuals' self-esteem and a sense of identity. They point to the value of facilitating expression and imagination that can promote creativity. This in turn helps ensure that human society remains dynamic and is able to confront and tackle new problems as they arise. art-making is, however, an intensely personal activity for the most part, especially in industrialised societies, and provides an opportunity for meaning-making and self-reflection. It is therefore important to pay attention to personal accounts of the part that art-related activity has played in people's lives. To this end the following section is devoted to individuals' perspectives on their own art learning.

Notes and references for Section One

[1] Authorities include Collingwood, R.G. (1938) *The Principles of Art*. Oxford: Oxford University Press. Raymond Williams noted that the terms creative and imaginative have become associated with the word art as a means of classification since 1880 – see Williams, R. (1983) *Keywords*. London: Flamingo, p. 43.

[2] Black, M. (1973) 'Notes on Design Education in Great Britain', in D.W. Piper (ed.) *Readings in Art and Design Education* Book 1 – After Hornsey. London: Davis-Poynter. The quotation is from p. 34.

[3] DES (1992) *Art in the National Curriculum*. London: DES, p. 3.

[4] DfEE (2000) *Art and Design*. London: DfEE/QCA, p. 14.

[5] There is also, in the English school curriculum, an association between design and technology. This association of design with technology is of interest etymologically, in that 'technology' is associated closely with 'art', the Greek root from which it is derived being 'tekhne', meaning an art or craft; in the modern Greek curriculum, art (when it appears – very rarely) is known as 'kalotekhne', or fine art. Williams notes that 'technology' was used from the 17th century to 'describe a systematic study of the arts . . . or the terminology of a particular art' Williams, op. cit. p. 315.

[6] A seminal work is 'The Culture Industry: Enlightenment as Mass Deception' originally written as an essay by Max Hormheimer and Theodore Adorno, translated into English in 1972. Of particular interest in this paper is their assertion that, despite the notion of individuality as a bourgeois concept, the artist as an individual has a crucial role to perform in challenging the 'commodity society'.

[7] Recent statistics from OFSTED, the British government's office for 'standards in education', reveal that 211,724 school students opted to take the GCSE examination in art; this can be compared with 56,742 students opting for music in 2003/4.

[8] Prentice, R. (2002) *An investigation into Art and Design Education Components of courses of Primary Initial Teacher Education*. A survey commissioned by the QCA, published by the University of London Institute of Education. The quotation is from p. 5.

[9] This notion has been put forward by Paul Duncum – See Duncum, P. & Bracey, T. (eds.) (2001) *On Knowing – Art and Visual Culture*. Christchurch, NZ: Canterbury University Press. See also the chapters by Howard Hollands ('Ways of Not Seeing: Education, Art and Visual Culture') and Darren Newbury ('Changing Practices: Art Education and Popular Visual Culture') in Hickman, R. (ed.) (2004, 2nd ed.) *Art Education 11-18: Meaning, Purpose and Direction*. London: Continuum. There is also an interesting chapter on theme parks by Nick Stanley in Hickman, R. (ed.) (2005) *Critical Studies in Art and Design Education*. Bristol: Intellect.

[10] Graham Chalmers in Duncum, P. & Bracey, T. (eds.) (2001) *On Knowing – Art and Visual Culture*. Christchurch, NZ: Canterbury University Press, p. 86.

[11] Elizabeth Garber. ibid.

[12] See Hickman, R., 'A Short History of Critical Studies in Art and Design Education', in R. Hickman (ed.) (2005) *Critical Studies in Art and Design Education*. Bristol: Intellect.

[13] Read, H. (1947) *Education Through Art*. London: Faber and Faber.

[14] Field, D. (1970) *Change in Art Education*. London: Routledge and Kegan Paul, p. 55.

[15] Barkan, M. (1962) 'Transition in Art Education: Changing Conceptions of Curriculum Content and Teaching.' *Art Education*, 15, 12-18.

[16] Bruner, J. (1960) *The Process of Education*. Cambridge: Harvard University Press.

[17] Barkan, M. (1966) 'Curriculum Problems in Art Education', in E.L. Mattil (ed.) *A Seminar in Art Education for Research and Curriculum Development* (USDE Co-operative Research Project No. V-002) (pp.240-55). University Park: Pennsylvania State University.

[18] Greer, W.D. (1984) 'Discipline-Based Art Education: Approaching Art as a Subject of Study'. *Studies in Art Education*, 25 (4), 212-18.

[19] Allison, B. (1982) 'Identifying the Core in Art and Design'. *Journal of Art and Design Education*, 1, (1), 59-66.

[20] Viola, W. (1936) *Child Art and Franz Cizek*. New York: Reynal and Hitchcock.

[21] Kellogg, R. and Odell, S. (1967) *The Psychology of Children's Art*. London: Random House.

[22] See Wilson, B. and Wilson, M. (1977) 'An Iconoclastic View of the Imagery Sources of Young People'. *Art Education*, 30 (1), 5-15. A more recent account by Brent Wilson of his views on child art after Modernism can be found in the section on 'Learning in the Visual Arts', E. Eisner and M. Day (eds.) (2004) *Handbook of Research and Policy in Art Education*. Other researchers have found what they believe to be cultural distinctions in children's artistic development but these tend to be superficial. See, for example, note 24.

[23] Originally published in 1947. I have drawn upon the fifth edition of this book: Lowenfeld, V. and Lambert Brittain, W. (5th ed., 1970) *Creative and Mental Growth*. London: Collier Macmillan. It is an indication of the importance of this publication that it has run to several more editions.

[24] Masami Toku's work, published in *Visual Arts Research*, was titled 'Cross-Cultural Analysis of Artistic Development: Drawing by Japanese and U.S. Children'. In this paper Toku maintains that the universal tendency of artistic development is limited to the years before children are exposed to cultural and educational influences. In a study that compared several hundred drawings by American and Japanese children given a specific theme ('Me and my friends playing in the school yard'), the most telling difference between the two groups appeared to be the preponderance of cartoon-style drawings amongst the older Japanese children. There appeared to be no evidence to suggest that

children of both cultures did not conform to the standard model of artistic development. It is interesting to note that the pictures I have chosen to illustrate typical features of the middle figurative schematic stage happen to be Japanese. In the examples given, I have protected the identity of the children concerned and have given my own titles to the pictures.

[25] Cox, M. (1998) 'Drawings of People by Australian Aboriginal Children: The Inter-mixing of Cultural Styles', in the *Journal of Art and Design Education*, 17 (1), pp. 71-9. The paper draws upon research conducted by Dr Edith Bavin of La Trobe University.

[26] Kindler, A. (1999) 'From Endpoints to Repertoires: A Challenge to Art Education', in *Studies in Art Education*, 40, Summer 1999. See also Kindler's contribution to 'Learning in the Visual Arts' in E. Eisner and M. Day (eds.) (2004), op. cit.

[27] Eisner, E. (1969) *Teaching Art to the Young: A Curriculum Development Project in Art Education*. Stanford: School of Education, Stanford University.

[28] Bruner referred to three stages of intellectual growth – enactive, iconic and symbolic. In Bruner's enactive phase of intellectual growth, thought and action are interrelated; the iconic phase is characterised by thought being governed by perception of concrete phenomena, while the symbolic phase is characterised by language use. Bruner, J. (1966) *Towards a Theory of Instruction*. Cambridge: Harvard University Press.

[29] Hickey, D. (1975) *The Development and Testing of a Matrix of Perceptual and Cognitive Abilities in Art Appreciation, Children and Adolescents*. Unpub. Ph.D. Thesis: University of Indiana, Minneapolis.

[30] Feldman, E.B. (1970) *Becoming Human Through Art*. Englewood Cliffs: Prentice-Hall. Feldman's strategy has been widely used in subsequent research but has been criticised for being too reliant on formal analysis of artworks rather than students' responses and for its lack of attention to contextual factors. See, for example, George Geahigan's contribution to Wolff, T.F. and Geahigan, G. (1997) *Art Criticism and Education*. Chicago: University of Illinois Press.

[31] Piaget's classic text *The Origins of Intelligence in Children* is often cited. Piaget, J. (1952) *The Origins of Intelligence in Children*. New York: International University Press.

[32] Project Zero was founded in 1967 as an interdisciplinary collaborative enterprise by Nelson Goodman, who provided the philosophical basis for the work. Goodman was among the first to propose that visual images as well as words can operate as symbol systems and that being literate means being

visually literate, in terms of being able to decode certain symbol systems, in addition to being able to read and write. This means that art can be seen as a form of enquiry. The web site for Project Zero is: http//www. pzweb.harvard.edu. See Goodman, N. (1978) *Ways of Worldmaking*. Indianapolis: Hackett.

[33] For example: Gardner, H. (1973) *The Arts and Human Development*. New York: Wiley; Gardner, H. (1980) *Artful Scribbles: The Significance of Children's Drawings*. New York: Basic Books; Gardner, H. (1982) *Art, Mind and Brain: A Cognitive Approach to Creativity*. New York: Basic Books; Gardner, H. (1990) *Art Education and Human Development*. (Occasional Paper 3). The Getty Center for Education in the Arts; Gardner, H. and Perkins, D. (eds.) (1989) *Art, Mind and Education*. Urbana: University of Illinois Press.

[34] Rosentiel, A., Morison, P., Silverman, J. and Gardner, H. (1978) 'Critical Judgement: A Developmental Study'. *Journal of Aesthetic Education*, 12, 95-197.

[35] Gardner. H. (1973) op.cit. p.76

[36] ibid. p. 45

[37] Gardner, H., Winner, E. and Kircher, M. (1975) Children's Conceptions of the Arts. *Journal of Aesthetic Education*, 9, (3), 60-7.

[38] Hickman, R. (2000) Adolescents' Concepts of the Concept 'Art'. *Journal of Aesthetic Education* (Spring 2000) 107-12.

[39] Wolf, D. (1988) 'The growth of three aesthetic stances: What developmental psychology suggests about discipline based art education.' *Issues in Discipline Based Art Education: Strengthening the Stance, Extending the Horizons*. (Proceedings of Seminar held at Cincinnati, Ohio, May 21-4, 1987). Los Angeles: The Getty Center for Education in the Arts.

[40] Parsons, M. (1987) *How We Understand Art: A Cognitive Developmental Account of Aesthetic Experience*. New York: Cambridge University Press.

[41] ibid. p.22.

[42] ibid.

[43] ibid. p.23.

[44] Kohlberg, L. (1981) *Essays on Moral Development*, vols. 1 and 2. San Francisco: Harper and Row.

[45] Goldsmith, L.T. and Feldman, D.H. (1988) 'Aesthetic Judgement: Changes in People and Changes in Domains' [commentary on Parsons (1987) *How We Understand Art*]. *Journal of Aesthetic Education*, 22, (4), 85-92. The quotation

is from p. 86.

[46] Feldman, D. (1980) *Beyond Universals in Cognitive Development*. New Jersey: Abley.

[47] Parsons based his theory on interviews with people in and around Salt Lake City who 'do not represent a careful sample of any population' (Parsons, 1987, op. cit. p. 18).

[48] Pariser, D. (1988) Review of Michael Parsons' *How We Understand Art*, in *Journal of Aesthetic Education*, 22 (4), 93-102.

[49] Hickman (2000), op. cit.

[50] Bruner, J., Goodnow, J., and Austin, G. (1956) *A Study of Thinking*. London: John Wiley.

[51] Peel, E.A. (1971) *The Nature of Adolescent Judgement*. London: Staples Press.

[52] Klausmeier, D., Ghatala, E. and Frayer, D. (eds.) (1974) *Conceptual Learning and Development: A Cognitive View*. New York: Academic Press. The quotation is from p. 4.

[53] Schaefer, G. (1979) 'Concept Formation in Biology: The concept "Growth"'. *European Journal of Science Education*, 24, (1), 87-101.

[54] Bolton, N. (1977) *Concept Formation*. Oxford: Pergamon.

[55] Clark, H.H., and Clark, E.V. (1977) *Psychology and Language*. New York: Harcourt Brace Jovanovich.

[56] Bolton, N. (1991) 'Cognitivism: A Phenomenological Critique', in A. Still and A. Costall (eds.) (1991) *Against Cognitivism: Alternative Foundations for Cognitive Psychology*. London: Harvester. See also Markova in the same book. Markova examined the Platonic/Cartesian notion of fixed universals, contrasting this with the Hegelian view that universals correspond to 'concepts that are the product of human evolution' (p. 81) and asserted that there are no universal concepts which are ontological entities existing independently of the human mind. Markova, I. 'The Concepts of the Universal in the Cartesian and Hegelian Frameworks', in N. Bolton (1991) ibid.

[57] Gilbert, J.K. and Watts, D.M. (1983) 'Concepts, Misconceptions and Alternative Conceptions: Changing Perspectives in Science Education'. *Studies in Science Education*, (10) 61-98.

[58] Koroskik, J.S., Short, G., Stravopoulos, C. and Fortin, S. (1992) 'Frameworks for Understanding Art: The Function of Comparative Art Contexts and Verbal Cues'. *Studies in Art Education*, 33, (3), 154-64.

[59] Perkins, D. (1992) *The Intelligent Eye – Learning to Think by Looking at Art*. Santa Monica: Getty.

[60] Perkins, op.cit. p. 5. I use the term 'interacting' here quite carefully, as Perkins only refers to engaging with others' art forms. When I asked him about the cognitive value of making art, in a seminar, he was unforthcoming.

[61] Parsons, M. (1987) *How We Understand Art: A Cognitive Development Account of Aesthetic Experience*. New York: Cambridge University Press.

[62] Smith, R.A. (1992) 'Building a Sense of Art in Today's World'. *Studies in Art Education*, 33 (2) pp. 71-85. The quotation is from p. 82.

[63] ibid. p. 74.

[64] I use the term 'stage' to indicate the broad, generalised developmental steps. I also use the term 'phase' to refer to parts of a stage and 'levels' for parts of a phase. This, of course, implies that such divisions exist; in reality they do not, but they do offer a useful theoretical model for discussing artistic development.

[65] Efland, A. (1990) *A History of Art Education*. New York: Teachers College Press.

[66] Reid, L.A. (1986) *Ways of Understanding and Education*. London: University of London Institute of Education.

[67] Arnheim, R. (1989) *Thoughts on Art Education*, Occasional Paper No. 2, Getty Center for the Arts, Santa Monica, p. 55.

[68] Steers, J. (1997) 'Ten Questions about the Future of Art Education', *Australian Art Education*, nos. 1 and 2, pp 9 – 20. This paper was updated as version 6 and presented at the 'ACTA' conference, Melbourne, Australia, 23 May 1998. For an account of how 'reconstructionist' ideas in art education can be translated into classroom practice, see: Clark, R. (1998). 'Doors and Mirrors in Art Education: Constructing the Postmodernist Classroom', in *Art Education*, 51, (6), pp. 6-11.

[69] Read, H. (1943) *Education Through Art*. London: Faber and Faber, p. 202.

[70] ibid. p. 221.

[71] These goals are paraphrased from the Hong Kong Government's Curriculum Development Council (2000) *Key Learning Area: Arts Education*, pp 12-13.

[72] Kenneth Lansing wrote in 1971, for a largely American audience, about general educational aims and the role of art in education. He identified a number of features that may be considered to be characteristic of 'the educated person'; he outlined the role which art could play in developing such characteristics.

Lansing wrote that the production and appreciation of art requires aesthetic sensitivity and therefore people who are educated in art are better equipped to make informed purchasing decisions. Lansing K. (1971) *Art, Artists and Art Education*. New York: McGraw-Hill. See Appendix II for a fuller account of Lansing's thoughts on the relationship of the 'educated person' to art.

[73] Efland, A. (2002) *Art and Cognition – Integrating the Visual Arts in the Curriculum*. New York: Teachers College Press.

[74] Dorn, C.M. (1999) *Mind in Art: Cognitive Foundations in Art Education*. Mahwah, NJ: Lawrence Erlbaum; Eisner, E. (2002) *The Arts and the Creation of Mind*. London: Yale University Press.

[75] Efland, A. (2002) op. cit. pp 48-9. The 'zone of proximal development' is the difference between the level of solved tasked that can be performed with guidance from a teacher (or other adult) and the level of independently solved tasks; it is the place where the learner and the teacher meet.

[76] ibid. pp.154-5

[77] ibid. p.153, emphasis in original.

[78] Eisner, E. (2002) op. cit. note 58, p. 35.

[79] Hall, J. (2nd ed., 2004) 'The Spiritual in Art', in R. Hickman (ed.) *Art Education 11-18: Meaning, Purpose and Direction*. London: Continuum.

[80] Hargreaves, D.H. (1983) 'The Teaching of Art and the Art of Teaching', in M. Hammersley and A. Hargreaves (eds.) *Curriculum Practice: Some Sociological Case Studies*. London: Falmer. (p. 131). See also Sikes, Patricia J. (1987) 'A Kind of Oasis: Art Rooms and Art Teachers in Secondary Schools', in Tickle, L., (ed) (1987) *The Arts in Education – Some Research Studies*, p. 143, Beckenham: Croom Helm.

[81] Hargreaves, op.cit.

[82] DFEE (2000) op.cit.

[83] ibid.

[84] ibid.

[85] ibid.

[86] Hickman, R. (1999) 'Rationales for Teaching Art – An International Perspective', in *Proceedings of the 38th World Congress of the International Society for Education through Art*, Brisbane, 1999 [electronic publication].

[87] Harvey, L. and Blackwell, A. (1999) *Destinations & Reflections: Careers of British Art, Craft and Design Graduates*. Birmingham: Centre for Research

into Quality, UCE.

[88] ibid. p. 4.

[89] The three institutions were University of Cambridge, University of Exeter and University of London Institute of Education. These institutions were opportunity samples but also selected on the basis of having consistently received the highest praise for their art education programmes from government inspectors. A synthesis of the survey results can be found at Appendix V. A complete breakdown of responses is available from the author.

[90] The sample was from two universities over a three-year period, giving a total number of specialist trainee art teachers of 163.

[91] Barrett, M (1982) *Art Education – A Strategy for Course Design*, London: Heinemann.

Conversations and reflections – some 'mini case-studies'

Introduction

Notions about the nature of art and published aims for art education, as identified in the previous section, are often written by academics and educational administrators (albeit occasionally in consultation with practitioners). As a kind of foil to this, it seems reasonable to go directly to the producers and consumers of art and art education to find out what motivated them to produce, and continue to produce, artwork. Over the past 25 years I have had conversations with hundreds of young people about their artwork and since 1999 I have had more focused discussions (in some cases semi-formal interviews) with older, established artists and school students about their attitude towards their own art-making – why they do it and what they get out of it [1]. The 'mini case studies' that I have included here are those that show the range of respondents with whom I talked. Most of them also provided me with some written accounts, which I feel add to their veracity.

In a conversation with an artist at the outset of this project, I asked him directly why he made art. His immediate response was, 'I don't think you would like what I would say', presumably (as I did not pursue it at that time) because it was for reasons that were not idealised, profound or romantic. I presume this because of my own motives for making art. These are outlined below.

Some autobiographical reflections

I have kept my account as straightforward as I could, avoiding too much theorising and simply recalling incidents that might have had an effect upon me in terms of being an artist.

My earliest memories of a desire to make art are from my first year of compulsory schooling, at age five. I saw the results of older children working with clay; the clay models seemed to be so sophisticated when compared to using Plasticine, or compared with trying to make castles out of sand on the beach. I did not get to work with clay for another ten years, by which time I had established myself as a drawer and painter and became frustrated with what I felt, at the time, to be the constraints of 3-D material. The significant point in my artistic development came at the age of nine when I received a gold star for a drawing that I had done of a caracal; I had copied it from a picture card collected from 'PG Tips' tea packets (I think the series was

'African Wildlife'). Like most boys of that age, I collected things; from age seven to early adolescence I collected fossils as well as picture cards of wildlife. This helped give me a life-long interest in the natural world: bird watching, identifying wild flowers, insects and other aspects of nature.

With the award of my first gold star, I felt that I had been given a reason for drawing other than the simple delight in drawing itself: I was going to be recognised as an achieving individual. I looked daily at the rows of gold stars against pupils' names on the classroom wall and worked towards gaining as many as possible. This extrinsic motivation did not detract from the intrinsic rewards gained from drawing, rather, it added another dimension, which encouraged me to do more and better. This encouragement was fostered in my secondary school, which I entered at age eleven. At that time I was entering competitions, such as the village fete where the art show was always in a humid marquee smelling of hay, alongside the immaculate chrysanthemums and enormous root vegetables of local horticulturists. I won first prize for my drawing of 'A Prehistoric Scene' (see Figure 2a). Further motivation was engendered by way of my art teacher's assessment system. My art teacher at secondary school was a painter, trained, I believe, at London University's Slade. He liked thick paint. The standard art lesson of the day (this being the early 1960s) consisted of the art teacher chalking up three titles on the blackboard (I recall 'The Volcanoes are Erupting', 'A Vivid Dream' and 'Witches on Broomsticks'). After completing a painting (suitably impastoed) each pupil would line up at the teacher's desk to receive a grade out of ten, or perhaps to receive some critical appraisal ('make the paint more thick'). My goal of course was to get top marks – getting ten out of ten became a priority, more so when I and one or two of my peers who were 'good at art' consistently achieved the magic ten. I remember being quite dismayed at receiving 'only' nine on one occasion; this was for an ambitious attempt to portray a tropical rain forest from above. I think the nine was meant to stop me from being complacent; this extrinsic motivation introduced an element of competition and provided a further incentive. I assume that this competitive element did not act as a motivating factor to less successful classmates.

The school as a whole was fairly brutish, despite the best efforts of some teachers, and the ethos was not really conducive to reflection and learning. Pupils assaulted teachers, teachers assaulted pupils, pupils assaulted each other; I did not witness teachers assaulting other teachers however.

In my professional life, I had subscribed to the notion that art competitions were inherently a bad thing; this was despite the clear fact that my own progress in art was facilitated by the encouragement I received from winning. And here's the issue: had I not won anything at all and received no commendation, would I

have been discouraged? I think not, in that I have had enough lack of acclaim subsequent to these early triumphs to put off (perhaps a more sensitive soul) an aspiring artist for life. Many art teachers in schools and colleges actively promote students' entry into competitions; others actively discourage it. Some government departments and national associations have clearly stated policies discouraging participation in art competitions; the Australian Institute of Art Education, for example, has had a long- term policy against art competitions for a variety of sound educational reasons. These reasons include the fact that they encourage and reward the few at the expense of the majority and that they apply adult values to children's achievements. There is also a basic philosophical objection along the lines of 'art is about sharing and communication, and competitions (especially those promoted by commercial interests) are at variance with this'. I must confess that I have not personally witnessed children being damaged by participating in art competitions but I suspect such sentiments are akin to those expressed by supporters of the cane and the birch – 'it never did me any harm' (when it clearly has).

My parents encouraged me, in their own way, not so much through praise but through the purchase of art materials, in my case, oil paints and an easel. My first attempts with these more sophisticated materials resulted in a spectacularly unsuccessful painting of a bird – a trogon I believe – from the PG Tips 'Tropical Birds' series. I was nevertheless deemed to be 'good at art' and by the age of twelve had decided that I wanted to be an artist (as an aside, I should say that I flirted with the idea of becoming a palaeontologist. However, when, in my first interview with a careers advisor I said that I intended to be an artist, the response was 'have you thought about taking up leather tanning?' a response which can be seen to be less bizarre when it is known that this was the local industry). By late adolescence I had decided that I was in fact already an artist and, having assimilated most of the myths associated with that calling, could behave in as obnoxious a way as time and limited resources would permit. All manner of un- or anti-social activities could be put down to either artistic temperament or challenging the accepted status quo (this included nearly burning down the community centre as an artistic act while using flames as a vehicle for artistic expression). I delighted in the idea that 'anything could be art' and was especially taken by aspects of Dada, which I discovered through what I have since found to be the usual adolescent interest in surrealism. Liberated from the rigours of representational drawing, I experimented with collage, montage and 'happenings'. With a group of friends I distributed blank pieces of paper and held placards saying 'vote nasty snatch' during election rallies – all good fun and suitably artistic to my mind at that time.

As an adolescent I assimilated the usual stereotypes about art and artists and was developing a sense of identity that revolved around this. I joined the Young Communist Party, much to the consternation of parents and teachers, and read

whatever anarchist literature I could. I had vague ideas about Paris being a place where artists should go and hitchhiked there as soon as I was old enough to get a passport. I wandered down to the Seine and found a suitably Bohemian group of people to engage with, but didn't do any art. I later hitchhiked to Florence with a friend, Tony – a brilliant linguist – and saw lots of interesting architecture; I wanted to see the ceiling of the Sistine chapel but hadn't done my homework which would have informed me that I should have been in Rome, not Florence. I wasn't particularly moved by any of the art I saw, but I was enthralled by the landscapes I encountered: the Alps by moonlight stands out in my memory, as does the fact that I was suspended from school for, ironically, 'unauthorised absence'.

After gaining my Advanced level qualifications at school, I went to a local art college for my 'Foundation' year. This was an eye opener in that I was taught things about art, not just encouraged to be artistic, but actually taught how to do things: photography (my report at that time says 'Richard seems to be confused by this subject'), etching, aluminium casting and other creative processes which I didn't know about. I became more technically skilled in drawing, and also developed studio skills in other areas, such as printmaking and ceramics. But this was not enough. I felt a real need to explore my inner world and to understand my relationship with nature and my aesthetic response to it. I read *The Outsider* by the then young author Colin Wilson and was particularly struck by his description of Ramakrishna's aesthetic experience with a flock of cranes:

> *I was walking along a narrow path separating the paddy fields, eating some puffed rice, which I was carrying in a basket. Looking up at the sky, I saw a beautiful, sombre thundercloud. As it spread rapidly over the whole sky, a flight of snow-white cranes flew overhead in front of it. It presented such a beautiful contrast that my mind wandered to far off regions. Lost to outward sense, I fell down, and the puffed rice was scattered in all directions. Some people found me . . . and carried me home* [2].

I now find this amusing – the idea of being overcome by beauty and falling in a faint to the ground – but as an adolescent, the association of the aesthetic with the mystical appealed to me, and contributed to my developing ideas about intense involvement with both art and nature. I read Aldous Huxley's *Doors of Perception* and was intrigued by his account of mescaline-induced heightened perception:

> *I was looking at my furniture, not as the utilitarian who has to sit on chairs... but as the pure aesthete whose concern is only with forms.*

He goes on to describe the legs of a chair:

How miraculous their tubularity, how supernatural their polished smoothness! [3].

Huxley's assessment of his experience centred on the idea of transcendence of the ego, identifying with the essence of objects by becoming his own essence:

This participation in the manifest glory of things left no room, so to speak, for the ordinary, the necessary concerns of human existence, above all for concerns involving persons. For persons are selves, and, in one respect at least, I was a Not-self, simultaneously perceiving the being and Not-self of the things around me [4].

I include these quotations because they encapsulated my own experiences with freshly gathered 'magic mushrooms'. As an idealistic teenager, such things were influential in my understanding of not only my inner self, but also my perception of the natural world. I saw trees as if for the first time – glowing, breathing and above all more real than anything I had experienced before, as if my eyes had been opened and my mind cleansed of all preconceptions. I was a rather earnest young man.

After four years at art school, I emerged as a fully-fledged artist, allegedly. Rebelling against the apparently superficial nature of the work of some of my peers, I immersed myself in representational drawing of beetles, birds and flowers. Around me, novelty appeared to be the key to success and I associated conceptual art with my fairly shallow understandings as a school student of Duchamp and the manifestations of Dada. A key tutor at the time was Victor Burgin who has gone on to achieve considerable acclaim as a conceptual artist. I was, however, unmoved by my peers' preoccupation with visual puns. These included, for example, broken wooden school rules fixed on a board with the caption 'Rules are Made to be Broken'; I even did my own piece for fun: a large alarm bell which I found in a skip, attached to a board with the title 'An Alarming Piece of Art'; there was also 'Bulbs in Flower' – light bulbs planted in plaster in a flowerpot. I eschewed the sub-genre of encasing small animals in resin and posing naked on stage as a living sculpture. I even rejected writing out the punctuation marks of Sartre's 'Being and Nothingness', in favour of finding meaning through contemplation of nature and attempting to gain understanding about the world through drawing.

The anti-vocational ethos of my degree course compounded my antipathy towards meaningful work and I was able to survive for a while 'being an artist' while not actually making a living from it. At that point I developed an urge to make art, not the kind of urge that I dimly remember from childhood, but an urge to make art because that is what I did; it was my identity.

I have often felt a slight unease with much of what has been written about art and art education in that I have not been able to relate it to my own personal experiences of art and art-making. I have seen my own practice, as a student of art and as a producer of art, as being parallel with, but separate from, my work as an art educator. During my early years as a schoolteacher I painted alongside my pupils in the classroom. I found this to be fulfilling as well as pedagogically useful, in that a suitable studio atmosphere was created and solutions to technical problems could be shared and explained with direct reference to my artwork. However, I had developed a certain ambivalence towards art production; my degree training, after all, was in the realm of conceptual art and I was inducted into the notion that there are too many art objects in the world already (a notion not dissimilar to that of married couples making an ethical decision not to have children because the world is overpopulated). I even went through a phase (some ten years after finishing art school) of giving my sketches and ideas to someone else to paint – I had a whole exhibition of paintings that were basically spray-painted by my local garage. But, although I was working close to my intellectual ideal, that is, of the idea being more important than the product, I had a feeling that there might be a missing dimension to my artwork.

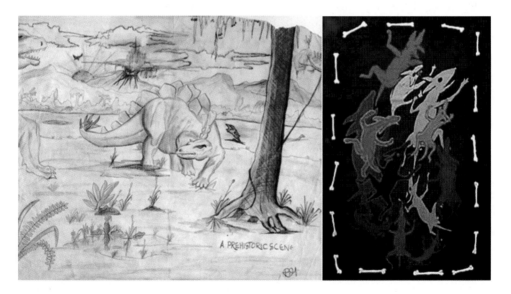

Figure 2: Work by the author.
(Left) 2a: *A Prehistoric Scene* by R.D. Hickman, age 11.
Pencil on paper, 42x30 cm.
(Right) 2b: *(My Shirt is Alive With) Several Clambering Doggies of Inappropriate Hue* by R.D. Hickman, age 43. Acrylic on board, 50x77 cm.

The feeling of being an artist is for me a more fundamental feeling than that of being an academic, teacher, husband, brother, father, consumer or ne'er-do-well; perhaps this is as a result of cultural conditioning in a time when individuality matters and when art remains cloaked in Romantic mythology. Nevertheless, there is something very strong about one's identity as an artist. It is almost as strong as one's ethnicity or religious affiliation, except that a group of artists gathered together in one place would not result in a harmonious coming together of like minds. Is showing one's artwork to others, particularly critical others, an essential part of art-making? For me, it has been important, in terms of my identity as an artist, to place my artwork in the public domain. However, the really important thing is the desire to draw and paint in response to what I see and feel and imagine, exhibiting is a side issue, and so I can empathise with people who work on the periphery of the art world (such as art teachers) and consider themselves to be artists: it is a question of essential identity; art is not only a way of knowing, but also a way of being. In considering the relationship between my identity as an artist and the artworks I produce I ask: Would it matter if my artworks were destroyed? I recall a commonly used phrase from art school days – 'the statement has been made', meaning something like 'now that I have expressed my ideas through my work, no more needs to be said and the work is of no value beyond the ideas expressed', with the implication that the idea behind the artwork is far more important than the artwork itself. I still subscribe to that notion to some extent but feel that the artwork, as the vehicle for carrying ideas, is of value.

Now in my fifth decade of producing artwork, I feel liberated from the constraints of pleasing teachers, parents and gallery owners. I do not have to make a living from selling my paintings and can simply do as I wish with regard to art. To me, my work has become richer and more complex than in earlier years (although others might see it as cruder and simpler); I have more concern for meaning than technique (see Figure 2b).

It would seem that, in my personal history to date, there are several incidents that provided some extrinsic motivation for me. These can be summarised as praise (from peers, parents and teachers), together with the recognition of a skill and reward (in the form of 'gold stars', prizes and money from sales of paintings at exhibitions). Less tangible reward, from the pleasure derived from the actual act of making, ought to be seen as intrinsic. It is this aspect that is of interest here. I would argue that human beings are inherently predisposed to making; whether or not this means *art-making* depends, as is often the case, upon one's definition of art. I was undoubtedly influenced by things I read, as can be seen in my accounts of my response to the writings of Aldous Huxley and Colin Wilson in late adolescence. One thing that continued to evolve throughout my development as an artist was (and continues to be) my relationship with and regard for the natural world.

On reflection, I can see that questions of identity are more important than I had realised. The paintings and drawings and prints that I have produced over the past 40 years look as if they have been done by different people, reflecting different self-images and a range of influences and concerns. I have even adopted pseudonyms for different groups of artworks: my dark and sinister ones are by Richard De'Ath; my hard edge ones are by R.D. Edge; R. Davis produces detailed illustrations, while Ricky Mavro goes for all-black paintings. The work produced by Dick Barker (the most prolific) is based on another alter ego, a kind of manic dog, which in itself has different doggy characters. Issues of identity and related concerns are evident in many of the short accounts that follow.

People talking about their art-making

Bill, a plumber

I never had any formal teaching in art, not even at school, but I always did it, because people told me I was good at it. I did drawings mostly and I still like to draw when I have a break, like on holiday. It's like I need to do it. I used to do it because it was the only thing I was good at but now I do it, now that I'm better at it, for other people – I like to give things I have drawn or made away as presents.

Bill's short statement reveals two fairly obvious but important issues: that one gets better at things, in this case drawing, through practice and that this kind of activity can give people self-esteem when they find other things difficult. There is also the implicit notion that artwork is special in some way (it would be rare to see someone giving away a mathematical formula as a gift).

Roberta, a school student

Roberta is the youngest of five sisters, some of whom were active producers of art. I met Roberta when she was 16 whilst visiting an artworker, Kaye. Kaye was employed by the Local Education Authority to teach art to young people who were excluded from, or who could not cope with, mainstream schooling. Roberta was unusual in this respect in that she had attended a private boarding school and found it to be too restricting and repressive. She was first turned on to art at primary school, where she had a teacher who happened to be an art specialist: 'he was very enthusiastic, very camp and fun . . . willing to accept a lot of things'. Her teacher took the class to exhibitions and enthused about other artists' work. On our first meeting Roberta was copying from a reproduction of a painting by Jean-Michel Basquiat because she 'liked the artist's lifestyle'. She had a strong urge to express herself freely through art-

making and does a lot of independent (i.e. not related to school) artwork: 'I am far more pleased when I do work on my own which I haven't been given.' She likes to do 'massive pictures' and employs various media. She particularly enjoys using charcoal and the expressive gestural marks that it affords. For Roberta, both the process of art-making and seeing the end product is enjoyable; she finds the physical act of self expression through art-making cathartic and she misses it when she is not actively engaged in it. It is also a vehicle by which she records life events, a kind of visual journal 'to remind me of things'.

I had hoped to follow up Roberta's progress but in true Romantic artist fashion, she ran away from home to an unknown destination in Africa.

Amy and other special people

Figure 3: Amy's work.
3a (Left): *Fierce Dragons.*
3b (Right): *Chipper had a dog.*

Amy was 14 when I first met her at a special school. She produced remarkable narratives in the form of highly illustrated stories which she made up.
 She wrote the following:

Why I love art. One thing – it shows my talents. It's easy and I love it when it is published. And doing books to remember my dead friends, relatives and pets. An elderly neighbour of mine opened an art gallery in Cambridge. But he passed away 2 years ago. He was interested in me and used to watch me draw. I also like doing pictures to cheer people up.

Amy told me that she started drawing when she was 'about four'; she won an art competition in year five and has continued to produce artwork frequently and regularly. She says, 'I would be sad and bored if I couldn't draw.' She likes

very much to show off her work and enjoys praise. She says that she likes to 'express ideas' and she feels very attached to the work – there is a preciousness about it; her drawings are precise and neat. They are very linear and are reminiscent of comic cartoons, although their content is certainly not comic. She appears to have been influenced stylistically by Walt Disney animated cartoons, of which she has a collection that she views frequently. Her drawings, often in the form of books, appear to be extensions of her world and tend to feature young girls as the main character; there is always some reference to death, a theme with which she seems to have a detached interest (rather than an obsession). The book format that Amy has adopted helps structure her ideas and gives an overall coherence to her creative work. Each has a beginning (including a title page) and a clear conclusion; the sense of completion and resolution inherent in this format helps give Amy a real feeling of pride, fulfilment and satisfaction (see Figure 3).

Art for Amy is a channel for her creative imagination. It is a vehicle for constructing a fantasy world that enhances reality and adds another dimension to it, a world where any identity can be assumed and any situation can be created. The parallel real world of the actual created objects also helps give a sense of identity – the feeling of being more 'important' because one has control of external events, through making.

I met other art makers through my contact with this particular school. Joseph produced work that I found to be genuine, authentic responses to his surroundings; it was refreshingly spontaneous. Joseph enjoys all kinds of creative activities, including music and dancing. I was so struck by the quality of his artwork, which was displayed for his GCSE examination [a national examination at age 16 for school students in England and Wales], that I offered to buy some of it. Joseph was happy to part with his work and felt pleased that it was valued. He and his parents settled for a compact disc recording by 'Shaggy' in return for his sketchbook. Joseph has Down's Syndrome; Amelia, his talented and vivacious teacher, provided the right environment for him to flower [5].

Another of Amelia's pupils, Amy's class mate Kathie, was interested in my presence in the classroom and told me that she liked drawing and painting things too. In her case, she said she liked the actual process of making things and didn't feel particularly attached to the end product. Kathie said that she wanted to be a caterer so that she could make cakes and decorate them.

In a similar way, another informant, Jackie, a professional costume and prosthetics maker, said that she liked the process of art-making more than the satisfaction of seeing the end result. However, she likes the end product to be useful and said, 'It's nice to get a response.' She took a non-vocational degree because she simply liked making things. She said to me, 'I always done artwork, for as long as I can remember.' She used to draw after (primary) school at a friend's house and enjoyed the social element, as her friends enjoyed drawing

too. She was praised by her teachers but her main inspiration came from her mother, who was an active artist. As an adult, she continues to derive enormous pleasure from creating things: 'I get this urge and I have to make something – my friend wanted a nodding dog for her car, so I used that as an excuse to make one.' She is not especially attached to her creations; for example, she had to burn all the costumes she had made up to a certain point because of bed bugs 'and I didn't mind too much . . . I like doing what I do *because* it's less personal'.

Stephen

Stephen's work on the other hand is intensely personal. He is attached to the outcomes of his creative activity and is not particularly interested in exhibiting. Those artworks that he has sold (through a prestigious London gallery) he has expressed a desire to buy back. Born in 1951, Stephen has been a practising artist to the exclusion of all else. He wrote, in a letter to me:

For as long as I can remember, I have always felt detached from reality and harboured a reluctance to involve myself in the normal workings of life, through no fault of my own. I would liken the sensation to that of being permanently incarcerated in a telephone box whilst struggling to communicate with the world outside. And so I became a gloomy observer of life, where onomatopoeic riddles formed in my head, imparting something interesting in an otherwise uninteresting world. Thus, I was almost subconsciously conjuring what I would later call my 'atmospheres'. Looking back to my first decade, music was nearer to my intuition than the visual arts. Then, at the age of twelve, I discovered, and fell in love with, oil paint. The mere smell of the stuff somehow made me feel very important; for the first time in my life, I felt as if I counted. However, whilst others attended football matches and youth clubs, I would be buried in some gallery or walking anywhere, to let ideas flow. Walking has, to this day, been a wonderful friend and vital for my art. My solitary nature is, of course, absolutely suited to the solitary-ness of painting. I am sure this is true for many artists. I also believe that my natural pessimism is a vital catalyst in my creative process. Out of a state of despondency grows something to challenge normality, something where pessimism has been supplanted by a shining optimism: the finished work.

One thing that stands out in Stephen's account is the role that making art can play in developing self identity and self-esteem; it can impart a feeling of being or of doing something of value or importance. Art is also a kind of lifeline, a link between one's inner world and the world of others. As with other respondents, such as Amy, Stephen is involved in a quite intense way in a kind of world-making which is intrinsically linked to finding a place for oneself in a potentially hostile world (see Figure 4).

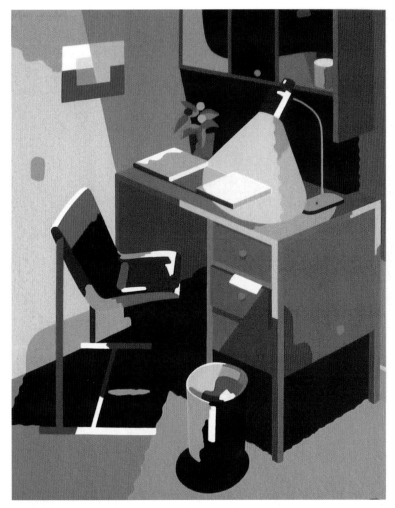

Figure 4: *Desk with Lamp* by Stephen Duncalf, 1981.
Enamel on board 29x37 cm.

Alex

Alex graduated from Chelsea School of Art and some of her work had been shown on national television as an example of good quality contemporary art emerging from higher education. She sent me the following account:

Figure 5: *Around the Heights* by Alex Butler, 2000. Still from video.

When I refer to myself as an artist and talk about my 'work' I feel faintly embarrassed and distinctly fraudulent. I do not feel like an artist – it's more of an aspiration of mine to one day become an artist. I'm not sure what qualifies one as an artist, but I feel sure I'm not there yet. The way I live my life and the

way I go about my work does not feel like artistic endeavour to me. When people ask me what I do, it doesn't occur to me to say I'm an artist; I always refer to the paid work I'm involved in. And if I do say 'artist', I feel a bit sheepish and hope I'm not asked about my 'work'. I am making work presently, and all the time, always, but I'm not often gripped by it like proper artists always seem to be. I will always put eating, sleeping, 'Coronation Street' and people first. In fact I think I put everything first. So it doesn't seem worth talking about. But in truth it's always at the back of mind, interfering with my attempts to have a happy, carefree life. I think of nothing else, really, in a quiet way. And I am an artist. And one day I hope to make great things.

I make art because there's nothing else to do. I cannot do anything else; I would prefer to be a pop star but it seems unlikely to happen. They say the things I make are very good, which pleases me enormously. I have always fantasised about being praised and being expert at something; when I was awarded a 1st for my Degree it came true for the first time ever. I like this. I make art for a little glory.

I have always had too many thoughts and thought about everything too deeply, they say. I always felt separate from my friends because I was thinking all the time. My mind has forever been heavy with ideas about death and grief. Death has me tangled in a permanent state of shock; I still don't believe it. Making art is an attempt to come to terms with it and to try and put it in order. I need to explore as many of its facets as possible to help me cope. I wonder about things. People are amazing. I want to get into people's heads to see what's going on. Creating characters, scenarios, images, stories is a way of going places I have never been. Invariably I travel into people's sadnesses and griefs. If we didn't all have to die I wouldn't have to be an artist. I make art because of death.

I attempt the sublime. I am desperate for the sublime. I want to be jolted out of the restrictions of my mind, to glimpse at truth. Art is a relatively safe place to stare at death – I don't have the stomach for skydiving or for heroin. All I require of art is that it strives for the sublime. I have contempt for all artists who do not realise the seriousness of their task. When I embark on a piece of work, whatever the subject or media, my fundamental desire is to affect the sublime in myself and in my viewer. There is no other end as far as I am concerned. To experience the sublime is to glimpse at Truth – to gaze into the abyss: death. Truth is death. I make art because I believe in the search for Truth.

I make art to connect. I make art because I want to connect with other people. I love other people. Art's just communication. I know the things I make work about are universal concerns, and I for one want to talk about them. It's very important to connect with other people. My biggest shot at happiness is other people.

It is clear from Alex's commentary that art is fundamentally important for her. Through art she gains a sense of identity and self-esteem. What is also clear is that for her it is not a form of therapy in the usual sense of the word; it is more of a burden than a hobby. Art is for her, however, a way of handling the big issues of life. She refers to some of the great universal themes that have attracted artists, such as death and the search for the sublime, in a personal way, not as something remote from everyday life (see Figure 5).

Carole and Violet

Carole and Violet are daughters of old friends of mine. I knew that they were creative individuals and had been bought up in a home environment that facilitated this; I well remember staying with them one Christmas in Copenhagen when many hours were spent with the two girls making 'marbled' paper. I visited them at their home in Sydney and talked to them about their art-making activities. Violet, who was eleven when she talked to me, told me that she 'liked making things' and felt inspired to make art by reading about things. For example, she read in her favourite book about a girl who gets a doll's house for her birthday and so Violet decided that she should make one:

Once I made a doll's house out of cardboard and it got very frustrating because it wouldn't stick . . . I had a definite idea of how I wanted it to be . . . I was pleased with the way it looked when I had finished it; I felt proud. Bindy [the cat] destroyed it by jumping on it and I was very annoyed.

Carole is two years older than Violet and has gained entry to a school that selects on the basis of creative talent. She told me that she does a lot of art-making and, like her sister, gets encouragement from her parents:

My uncle's an artist and he did a lot of art with me when I was really little; this helped me get into it. But I like art a lot and going to art museums and picking my favourite work. I was top in my class in art . . . it's a good feeling from making something beautiful – to get that feeling of accomplishment – I dunno – it's weird.

As with her sister, but unlike some art college graduates, Carole is attached to her work: 'I would be very upset if my work was destroyed, because it takes a long time.' She derives a sense of meaning and purpose from making things beautiful or making beautiful things.

Charles

Charles was in year 10 (aged 15) at the time of our discussion. I was interested to talk with him as he was someone who produced a lot of artwork outside

school. He had opted to study art for public examination but did not appear to be enjoying it. The kind of work that he did at home was quite different from that produced in school. At first he was reluctant to show me his home art, as he thought that I might not value it, but became increasingly enthusiastic about it when I showed interest. He did not want to write down any of his thoughts on the subject and so this account is based on notes that I took at the time.

Charles felt that there should be more time given to art in school and that the present allocation was not enough to 'really get involved'. He didn't like his work being graded, mainly because he felt that his teachers didn't really know what he was trying to achieve; he felt that he needed more time to think about his work (without being 'told off for wasting time') and more time to discuss with his teachers and, particularly, to get advice about how to 'make things look better'. I asked him about what kinds of things he thinks should be taught in art lessons. He was quite unequivocal in his reply:

They should teach us how to get certain effects in our drawings – how to make things look realistic . . . I would like to learn how to make sculptures and use video. There are lots of things I want to learn about.

He was not so sure about learning about artists and designers: 'If it helps you in your own work – yes, but it's mainly a waste of time.' He conceded, however, that he liked to look at examples of 'graffiti art' and cartoons. He intimated that he did his own 'graffiti art' on walls outside school. Charles quite liked school ('to be with my mates') but found that some of the lessons were frustrating because 'everybody messes about'.

Tara

Tara spends most of her spare time drawing. She is apparently popular at school but chooses to do artwork in the school art room rather than socialise with others elsewhere. At the time of my talks with her she was in the first year of secondary school (in eastern England), aged twelve. She likes to copy pictures from magazines, usually of models and female singers. She is most satisfied with her work when the results look 'cool'. She is concerned to get things 'to look right' and sometimes gets frustrated when she cannot duplicate a realistic image. The work she does in art lessons is different in both content and process. I asked her about the lessons in art that she enjoyed most. She replied:

I liked it when [the art teacher] showed us how to draw people and people's faces – proportions and things like that. That was good. I don't like it when we look at all the abstract stuff and we have to do something like it. I hate it when I get a bad mark – it makes me want to give up altogether.

I have included Tara's account because it is a clear example of the kind of issues that are said to concern young people at this stage in their lives with regard to art. She is concerned with representation and idealised imagery; her criteria for judging the merit of artworks include beauty and skill. She is one of many who expressed to me dissatisfaction with the way artwork was assessed in school.

Bella

Bella, at the time of my initial chat with her about her art-making, was an artist in residence, having graduated in theology some years before. She sent me the following account of her artistic life:

As a toddler I dug a hole in our garden and got into it. I pretended I was a plant growing from a seed and when I reached full height I took off my clothes in recognition of autumn. I encouraged others to do the same and was often engrossed in imaginary games with my long-suffering brothers who became visitors at my dinner parties, fathers, children in a classroom or soldiers. Being a middle child I was the one who instigated. I created worlds that mirrored life and loved it when people entered these worlds. It was the sharing of my whims that motivated my desire to play and later to be an artist. In terms of being a fine artist as opposed to a musician or actress, painting and drawing seemed to me the most natural form of expression. At your fingertips you could create worlds, introduce mood, colour, entertain and be utterly absorbed. As a child I would regularly watch my mother working on a collage at the kitchen table and at prep school I remember being praised for an accurate drawing of Africa that we copied from an atlas. This encouraged me to recognise a talent that took off at secondary school where I was happier.

I find it difficult to know why we fundamentally are the way we are. We inherit traits from parents and the wider family and we are affected by our environment and circumstances. As to why I make art, all I can say is that I always have. At four years old my godfather gave me an enormous china collection of small animals and figurines. I spent hours arranging the collection making backdrops and creating themes depending on the season or an interest. This gave me immense satisfaction and I would always have a formal showing of my finished arrangement. From this early stage I developed a sense that for me creativity was about narrative and drama, an idea I carried through into my GCSE and A-level work. Here I made 3-D ceramic follies and paper pop-ups of cities and cathedrals. I wanted the viewer to have to peer and discover, be enriched and entertained by the things I found incredible. Being at school in the countryside I remember feeling sick with excitement at the lights of London and the wet pavements after rain. I loved the rhythm of rooftops and lights on in windows at night. It was the drama and atmosphere of it I found interesting.

During my foundation course I became burnt out and felt stale. My work became more introspective and minimal, extremely melancholic and tortured; I found beauty in wastelands and desolate beaches (I still do). I felt increasingly that I needed new horizons and challenges so that I could recharge myself. I went to Australia and studied theology at Leeds; both experiences were all absorbing and rich, providing me with structure and a broadened mind. Now my work centres around the needs of people and my spiritual understanding and journey. I find it difficult to produce work for no purpose. I believe that art is a powerful tool that can be used to communicate at deep levels . . . It amazed me how, when completing a mural in a local care home, people seemed to open up and soften, flowers were brought in and a new gardening scene fell into place without my instigation, directors started to think about how they could creatively refurbish other homes around the county. It was as if the art gave them permission to be themselves and care more creatively . . .

So returning to why I make art. I love it, I need to share what I find interesting about life and use it as a tool to communicate and challenge. I paint for a reason and find galleries often deathly and clinical. I find it incredible how the arts have a huge part to play in building community and breaking down barriers. I hope to explore this further.

As with others, Bella is concerned with creating meaning and significance. She has done this in the form of 'arranging' things aesthetically from an early age and has responded positively to praise. Her art-making has developed from creating order through to self-discovery and a turning outwards, with a concern for art as a tool for the growth and consolation of others.

Liz, a beginning teacher of art

What attracted me to involve myself in Art was the influence of an older brother who was very skilled in the subject and discovering my own natural ability. As children we had private Art lessons for a while and whilst at secondary school it was definitely my main focus. I can only ever remember wanting to pursue a career that involved Art and Design. The opportunities of professional or financial success in comparison to other fields was never really considered. The subject always allowed me to be creative and passionate. I hold enjoyment and satisfaction as much more important than being involved in a career that just becomes a means to an end, no matter how lucrative.

Liz exemplifies the kind of person who apparently has 'natural ability' which is nurtured and then becomes more skilful and wants to help others in the same way.

Art has provided her with 'enjoyment and satisfaction' and in this way has become an essential part of her life.

Mark, a student

It sounds cheesy I know, but the reason that I am studying and have studied and am still involved in art is because of good teaching and genuine encouragement. My upper school teacher gave me faith in my ability and made me want to excel and to prove to him, myself and everyone else all that I am capable of. This gave me massive self-esteem. Of course I have always enjoyed art and have always produced art in some way, shape or form. In this respect I think that creativity is in some way written into your DNA. This is not to say that it is necessarily hereditary as no one else in my family is artistic (though some may argue that they have not had the opportunity to be so) though I do feel that it has to be part of your personal make up, a part of who you are as art is a subject which is very close to the heart.

Mark's statement exemplifies the view that potential for creativity may well be innate but the important thing is how this is nurtured through providing opportunities for art activities and encouragement. It is interesting to see how art is seen as inextricably linked to creativity.

Nancy, a photographer

My mother is Austrian. I have a creative family background in terms of art and music. My Austrian relatives are all teachers in these two subjects. My grandma was a pianist, one uncle is a music teacher and concert performer, one auntie is an art teacher and web page designer, other three uncles are teachers. My mother is extremely musical and a teacher for autistic children. My father is English. His whole family for generations has been involved with scouting and outdoor instructing one way or another. My grandma teaches stain glass workshops . . . I think I originally made art because I could. Because it was an activity my family would engage with me together. It was cheap and easy for my mum to arrange – paper and crayons.
Now when I make art it is because I want to. The art I produce can evoke different feelings. I get a great sense of calm whilst water colouring a coastal scene or a buzz inside of me when using acrylics on big boards . . . I feel useful and proud that I achieved something of value that day of making.
. . . the fact that I have made something of visual quality that others and myself enjoy looking at really makes me smile inside.
If I started tomorrow doing an art painting . . . my whole heart and soul would be consumed until the end. I wouldn't be able to think of anything else. I love

the originality and the claim you can say – I did that. It is my work. I find decisions hard to make . . . But when I am making art, the decisions of what looks best, what to do, how, editing, cropping, just come naturally. It is a pleasure and exciting making these decisions. Not a burden. I love feeling satisfied that what I am producing is good. And it is flattering hearing praise towards it for it is my own work.

My art teachers became role models. I would want to go in the art room to produce more work/experiments/sheets just to paint/draw to be around them and the other five girls like me. I loved the conversations with the art teachers and they would spend hours of lunch times trying to mark but instead chatting to us whilst working. Miss E and Mrs S even became friends to a degree as I used to write to them occasionally from various stages I'm at. Yet I always thought they were professional. Conversations were always on artwork/ or issues in the news, never personal. Other teachers crossing this boundary lost my respect completely. These two teachers were interested in me and my work – and others, and I sensed that. This intensity made me want to put more effort into my work and achieve higher.

I guess I seek self-satisfaction too. I mean I make Christmas cards, birthday cards by printing or photography or watercolour pics scanned in . . . I don't need to hear the thanks anymore. I just love doing it for others.

Nancy highlights the importance of environment and upbringing in developing an interest and ability in art. In particular, she draws attention to the importance of positive and genuine encouragement by teachers and the value of an agreeable creative working environment where learners are treated as individuals. Nancy draws attention to her love of doing things for others. I would suggest that empathy and the ability to put oneself in another's place is characteristic of creative and imaginative people.

Margaret

Margaret is an academic specialising in theology. She makes art, sings and plays the viola.

Art is to resolve pain; it's only available when and if you can't avoid suffering something. That's why it's connected to passio [passion] that also means passion as in Christ, as in suffering, etc. I'm not sure I actually think there's much point to it other than that, though there probably is. I can't disconnect pain from it though. I see it like a Sartre-ish thing . . . Art exists to shatter those imaginations that suppose that to be reality . . . Art is illiterate, indeterminate, haywire, chaotic and clumsy . . . when your own heart is by definition, full of nothingness, threatens, illegitimises and condemns . . . this is when you make art.

In this statement Margaret makes a case for the value of art as a form of therapy, a cure or at least a channel for existential angst. The therapeutic aspects of art-making activities described here are more profound than simply seeing art as a leisure activity that calms the mind.

Linda, a student, specialising in ceramics

I am someone who feels the need to create things in order to understand the world around me. These things communicate my feelings and response to the world I live in. Art is the only thing I have found that satisfies this desire to create.

When I was young I loved to do anything that created an image of some sort, particularly if it involved a story or a dragon. This has stayed with me, and I am still drawn to creating stories and dragons. I always knew that I wanted to be an artist, for it has always been the thing that gives me the most understanding and fulfilment of my life. So studying art at school just seemed the natural thing to do.

For me Art is part friend, therapy, communication and possession. Sometimes I just want to create something that I find beautiful, and that has meaning to me personally, as some sort of record of part of my life. Other times my motivation comes from strong feelings or emotions that just have to be vented. Though in truth there are numerous reasons for my creating, it always comes back to art being a personal response to the world I perceive and live in. Art is the way I have chosen to respond.

Linda talks of the 'need to create' and mentions the importance of expressing feelings. She sees art as both therapeutic and as a vehicle for communication but most of all it provides a personal and individual way of making meaning.

Li Hong

Li Hong is a PhD student, whose family moved when he was very young from Hong Kong to North America.

I am a painter who writes and a writer who paints. My interdisciplinary interests extend beyond the arts and include the social sciences (particularly psychology), music, philosophy and cultural studies. One reason for my diverse (yet very related) concerns is that my family and I moved when I was very young from one distinct culture to another. Perhaps I never felt the need to be any one particular person and indeed it was probably a matter of survival to develop the capacity for adaptability. This might be why I did well in many different school subjects and why I needed to develop internally (or

put another way, from the inside out), rather than adopt any one particular way of being (in terms of cultural identity, or from the outside in).

Li Hong's background raises issues of identity and his creative pursuits go some way towards addressing these. art-making is seen here to be a way of developing a strong sense of self.

Dave, a student

My interest and involvement in Art was probably initially thanks to a visually rich childhood – I spent a lot of time (most of it reluctantly) going round exhibitions with my parents and I was always very interested in what my Dad was painting at home. At school the art room was a bit of a refuge for me, and I didn't really seem to like school . . . as my work became more personal I found making art very cathartic. I have a need to express problems and thoughts, and different people do it in different ways – I like to paint and draw. That's not to say that I'm only motivated by this. I also get a lot of pleasure from the process of making a piece of art – maybe you could compare it to the feeling you get from listening to a moving piece of music – that adrenaline rush you get when something works visually.

Dave owes his original interest in art to his upbringing and this is sustained by his love of the artistic process itself. He uses art as a medium to express ideas and sees it as a way of purging emotions.

Anthony

Anthony is a successful artist, with his work in national collections and other public collections in the UK and elsewhere. He has been a professional artist for over 40 years. I interviewed him in his studio and recorded his responses [6]. When asked about why he makes paintings, he replied: 'I make them in fact to celebrate my humanity.' He speaks of how art can provide a kind of refuge:

I used to enjoy the Art Department because it was a refuge from rough things like too much sport and too much standing around in the wet on a rainy day playing football – or run or do things like that. It was a refuge from a broken marriage. My parents' marriage broke up round about this time, and when I was happy painting my pictures I didn't have to worry too much about what my mum and dad were up to.

Art for Anthony is also tied up with the compulsion to create meaning:

Yes, I mean I can't envisage a day without making things. Without making

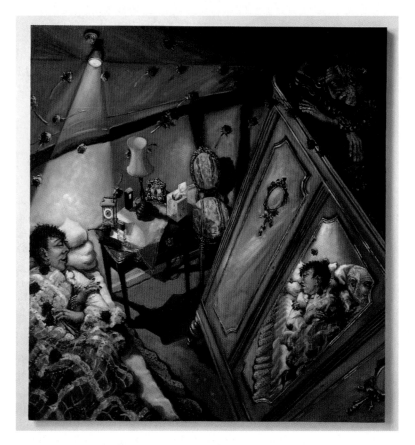

Figure 6: *The 40th Wedding Anniversary (version II)* by Anthony Green RA, 2004. Oil on MDF, 96.5x104 cm.

things to celebrate the concept of the family unit, which is the thing I've concentrated on all through my 40 years as a professional. Because I use it as a metaphor for society.

He acknowledges learning from other artists, being inspired by their work:

Art has sustained me all through my professional life. And when I've needed inspiration I've turned to my elders and betters. I've turned to van Gogh's letters or I've turned to the writings of art historians. And Vincent van Gogh still is my super hero.

Anthony has been painting all his life and can see the personal development in his art. Although his paintings are largely domestic narratives, profound universal themes are present:

> *[My art is] richer, it's deeper, it's multi-layered now. It's attacking on all sorts of fronts . . . it's dealing with a very complicated subject, which is the stuff of life itself. It's dealing with birth, marriage, death.*

John

John is an art teacher who is an active painter and has a love of all kinds of visual form.

> *I have a very early memory (three years old) of having a strong, almost obsessive preference for certain colours, notably deep crimsons, navy blue and violets, and a loathing for pastel shades. I very much enjoyed arranging objects sequentially according to size, tone and hue. These arrangements became increasingly complex and with hindsight the considerations were a form of compositional aesthetic. I was a fairly solitary child and most of my game-playing involved games of imagination. These increasingly involved props. I clearly remember arranging toy soldiers in the gnarled roots of a tree that in my imagination became a rugged landscape. It was an easy step to transpose this imaginative activity into drawing. Most of my early drawings were of knights in armour and soldiers in historical costumes similar to my toys. I enjoyed this fantasy world of drawing and disliked most other academic activities. I was often praised for the high quality of my drawing and painting. As the drawing was fun I did more of it, I got better at it, I gained confidence in it and the gulf between that and the other subjects increased.*
>
> *By the age of 12 or 13 I was already defining my own identity as artist rather than a scientist or literary individual. In some ways this was a position that was encouraged by my parents who had a strong bias towards the humanities and were also particularly interested in the European artistic traditions.*
>
> *My art teacher used to set me these puzzles where he'd put out postcards of different paintings and I had to identify them. This became a bit of a party piece and I was very good at recognising details and could tell which painting it came from.*

John's account is an interesting example of one way in which an interest and an ability in art unfolds: a predisposition for arranging things which became increasingly sophisticated; opportunities taken to exercise the imagination; drawing as a medium for extending and developing the imagination; getting better at drawing through practice and therefore gaining confidence and self-esteem.

Figure 7: *Rust* by John Laven, 1999. Oil on canvas, 42x30 cm.

Libby

Libby is a sculptor who was brought up in a family that, in various ways, worked within 'the world of art'.

My father is an illustrator, graphic designer, woodcarver etc. (I think this may have prevented me from seeing art and artists as having to be pigeonholed and having a particular specialism). Some uncles and aunts are fine artists, teachers and printers and older cousins went to art college and became textile artists and product designers. Art in no way seemed distant and mysterious to me but I remember school friends finding it all a little unusual.

Our house always had a ready supply of materials for making things. Mum was an avid collector of old bottle tops, magazines, yoghurt pots etc. etc. etc. etc. etc. !!! and dad often brought waste materials home from the London Weekend Television graphic studio in which he worked.

We were always encouraged to be doing things, whether that meant making camps, playing imaginary games or making and painting. Art was encouraged but never forced upon us. I remember always being told by my parents that

they would rather we were 'all-rounders' than excelled in one narrow field. A significant formative experience occurred when I was about nine years old. It was coming up to Christmas and my primary school had launched a Christmas hat competition. I knew that I didn't want to make a cliché crepe paper design and spent some time thinking over what I could do that would be really different and hit on the idea of a (slightly ironic) Christmas pudding that would look real and make people think I'd just stuck a real one on my head! I got up very early on a Sunday morning and went quietly down to the utility room whilst everyone else was sleeping. I remember working on the floor and being very physically involved in the process of making this hat. I mixed up plaster of Paris and poured it over a medium-sized mixing bowl. Obviously it just ran down the side and formed a puddle all over the floor. I waited a while for the plaster to begin to go off and found that it could then be scooped up and pressed onto the sides of the bowl, having sufficient strength to hold its own weight. I remember the excitement of having solved the problem myself and the satisfaction of achieving an effect that was much better suited to the texture of a Christmas pud. Once given a coat of two different brown paints and dotted with black marker pen, it looked fairly convincing. Remembering that when plaster that has just been mixed it runs easily, I mixed another batch, added some of my mum's yellow food colouring, waited for it to start to thicken slightly and then just poured a little over the top to create the illusion of custard, into which I stuck a sprig of plastic holly I'd snatched hurriedly from the dining room table. I remember the adrenalin rush of having to work and think quickly, the pleasure of discovering that materials could be used in more ways than 'just what it says on the tin' and the intensity of having completely lost myself in my own world. I remember the sense of pride in what I have achieved and especially the congratulations given by my parents – just before they saw what a horrific mess I'd made of the utility room!

Art at secondary school was terrible. It was seen as no more than a relaxing thing for the girls to release them from the strain of the real subjects. There was no teaching – nothing. Sometimes we'd be asked to 'draw an imaginary picture of a jumble sale', other times it was drawing hydrangeas (these grew just outside the staff room) and sometimes when she'd forgotten to pick the hydrangeas, we'd have to draw our feet because she knew we'd all have brought a pair along with us!

I have always found the need to be working with my hands to make things, but not necessarily just 'ART'. It could be sandcastles on the beach, DIY, quilts, necklaces . . . anything. Almost a driving need, like a greed to produce things. Getting things made means that you no longer have to store them as ideas in your head – makes more space! Adventure and problem-solving – not always knowing what the outcome will be.

Libby's account contains many things that are echoes of previous accounts, even the phrase 'adrenaline rush' as applied to the pleasure associated with the act of art-making. She is clearly one who has come to art through her home background rather than encouragement at school; art at school she describes as 'terrible'. She describes key moments in her life when creating something of significance (regardless of whether we call it art) is of real importance; she refers to the 'driving need' to make things (which includes sandcastles, quilts and necklaces) and the value of engaging in activities which do not have a pre-specified outcome.

Figure 8: *Slate* by Libby Tribe. Sculpted slate, approx. 35 cm diameter.

Jade, a photographer
Jade is a photographer who started to teach but gave it up because she did not feel that the school environment was suited to creative activity.

Born to unusual parents (a Bluebell girl and circus clown), I was a feral and often 'underprivileged' child. I desperately wanted to fit in with my peers – something I would never achieve. The art room became a haven, my solace, and encouraged by my art teachers I spent every possible moment there.

I took confidence in my teachers' and mother's belief that I was special, talent, 'a born artist.' For as long as I can remember, and while I missed the first years of school, my mum and I have drawn, painted and created together. She has never stopped developing her creative work that has taken many forms including military uniform design and novelty cake-making. She was also a teacher for a short time, and in some respect, I have followed in her footsteps – and continually experimented with new media.

As an adolescent my need to fit in was replaced by a desire to rebel, stand out, circle the differences. I was driven by my fury and sense of injustice in education. I attended a rather rough secondary school, where expectation of pupils was low – particularly those from the 'estate', something I would again witness to my dismay later as a teacher. My anger found expression in art and still does.

I have, to some extent, opted out – of conventional art practices and 'normal' life. No career, no house, no car and no TV. I have decided that life/art should be more meaningful to me. I often wonder what might go through my mind, what regrets I might have on my deathbed. I won't wish I'd achieved more material wealth or respectability. I will think of those whom I have known, loved, inspired. I will be glad that I made art and love with my life in a world that can be so utterly wonderful and beautiful – and yet is not for most. People seem not to question, 'Why do I do this every day?'

I am not precious about my work and have little to boast in terms of portfolio. I destroy much of what I create or give it away. The actual making is the important bit for me. The process can be exciting, cathartic, fun, a turn-on and sometimes a chore. But the absolute need to create always remains – I think it is all that differentiates us from any other living creature.

Jade's account reveals what has often been in the popular imagination – the association of art with the idiosyncratic, the unconventional and the rebellious. She was encouraged by parents and art teachers and has come to see the process of art-making as a way of expressing emotions and she values its cathartic effects. It is clear that art is associated in her mind with questions of real personal meaning and is a way of confronting profound issues such as what it means to be human.

Concluding remarks for Section Two
In the statements that appear in this section, certain concepts emerge and re-emerge, concepts such as creativity, identity, self-esteem, expression,

individuality and imagination. Several of the respondents also put forward the idea of art as a kind of refuge – the art room in school is referred to as an oasis or haven, a place that is different from the rest of the school. The impact of school and schooling is quite significant, both in terms of encouragement and providing the right environment to grow aesthetically, but also, it should be noted, in terms of its potential to de-motivate. Issues of intrinsic and extrinsic motivation were raised, for instance with regard to praise and encouragement. The school art curriculum is touched upon in terms of highlighting the importance of practical studio activities, with one respondent, Charles, complaining that in his experience, school does not facilitate his desire to make art; he wants to learn 'basic skills' in art but is not taught them. He is taught about other artists and values this but only in terms of how it impinges upon his own making. The role of other artists and engaging with the artwork of others is considered by many of the respondents and is seen largely as an aid to making and in the development of one's own understanding of the world.

Several statements refer to the urge to make art – an inner compulsion or desire to express and communicate pictorially. Libby spoke of a 'driving need to produce things'; others, such as Anthony, spoke of the compulsion to create meaning. Both Jade and Linda spoke of the 'need to create', while others referred to an 'urge' to make, to give significance to something. Elsewhere in my interview with Anthony, he talked of the need to 'just keep going':

> You just keep going until you can't do it anymore. I know all the stories about Renoir who had the brushes strapped to the stumps of his arthritic hands and kind of sloshing it on. You just, you just do it because you have to. There are so many things in you that you want to do.

There is some evidence of a developmental pattern in the lives of the more mature respondents: an early endeavour to acquire technical skill and a striving for realism in representing the world, moving through creating meaning for oneself and towards more universal themes. There is a move away from attempting to understand oneself towards understanding the world, a development from creating order through to self-discovery and a turning outwards, with a concern for art as a tool for the growth and consolation of others. Art is seen as a way of coming to terms with life – 'a relatively safe place to stare at death'. It was seen by one respondent as a way of dealing with profound impersonal issues in a personal way.

Margaret was one of many who saw art activities as a kind of therapy: 'Art is made when you are full of nothingness.' Roberta finds the physical act of expressive art-making cathartic and this in itself was seen as a kind of therapy. Art was seen by several as providing a vent for strong emotions or as a vehicle for expression. For some, technical skill in the handling of materials and in

construction or modelling appears to be valued. In particular, pleasure derived from the actual act of making and creating was reported – physical involvement in the medium. This was enhanced by the sense of pride in making something and finishing it, giving fulfilment and satisfaction. The place of beauty, or at least a concern for making things 'look right', was also cited as being important by some, particular the younger respondents.

There are some common characteristics amongst these informants, all of whom were actively involved in art-making of some kind. Many of the people with whom I spoke had what we can call a 'creative' family environment; they also received parental support, praise from teachers and general encouragement from peers. They were motivated by encouragement and positive feedback as well as by the intrinsic value of their creative activities. Many also reported an early interest in making things and in drawing, from about five years of age or even earlier – some saying that they 'always' made art: arranging and making things. Being good at representational drawing was cited as a starting point for a more generalised interest in art. There were also references to being aesthetically aware and aroused by visual form in both nature and art, they were visually alert and noticed things, especially pleasing arrangements and curious juxtapositions. They all seem to have a strong sense of self and many spoke of the importance of art-making as a way of establishing identity.

Noel Barber's book *Conversations with Painters* [7] is a record of conversations with ten successful British painters. It reveals painters' views on their work and what drives them to produce it, in some cases against considerable difficulties. One feature of mature artists' reflections on their work is the conviction that their art has evolved and continues to develop. Barber reported that Sydney Nolan firmly believed in the importance of change as one gets older; Graham Sutherland is quoted as saying one continues to refine one's work. Much of what has been reported in this section features in these and other artists' testimonies, in particular, the almost obsessive need to create, in the case of Barber's artists, through painting. This single mindedness, displayed, for example, by L.S. Lowry, is characteristic of most successful people, whatever their field, but what is interesting here is that even quite ordinary people become highly focused and feel a strong desire to create something of aesthetic significance.

Notes and references for Section Two

[1] I used several methods of gaining and recording information, depending upon the circumstances. In many cases, I simply asked basic questions, such as 'Do you like making things? Why?' I checked the veracity of my notes with the informants later. In other cases, I did semi-formal interviews that were

recorded and transcribed. The prompt questions used during the semi-formal interviews with school students can be found at Appendix IV. In the case of respondents who showed a particular interest in my investigations, I asked them to put down their thoughts and e-mail them to me; some of these appear in this section, verbatim. All of these statements, whether written, transcribed from recordings or received as e-mail correspondence, are inset in italics.

[2] Wilson, C. (1956) *The Outsider*. London: Gollancz. The quotation about Ramakrishna is from p. 252.

[3] Huxley, A. (1954) *The Doors of Perception*. London: Chatto and Windus, p. 20.

[4] ibid. p. 31.

[5] Joseph's work of the skeleton of a Kudu is on the back cover.

[6] The interview with Anthony Green RA took place on 18 February 2004. The complete transcript of this interview is available from the author.

[7] Barber, N. (1964) *Conversations with Painters*. London: Collins.

Issues in art and learning

Introduction

This section explores some of the issues and concerns arising from talking with people who are actively involved in making art. Over the past few years, whenever I encountered people who were active in art-making, I asked a simple question: 'Why do you make art?' The respondents' accounts that I chose to include in Section Two are representative of the wide range of ages and aptitudes that I have encountered. One thing that struck me is that people spoke more readily about their influences, like school, rather than art itself. No one said that they were turned on to art by seeing a wonderful artwork in a gallery; all, however, referred to an inner desire to draw, paint or make things. It can be seen that the accounts (which I have called 'mini case studies') have several features in common. These include a concern for what I consider to be topics that are frequently, if not traditionally, associated with art: creativity, imagination, expression and identity. Adults, such as parents and teachers, were seen by many as important in giving encouragement and support to foster artistic pursuits during the respondents' early years. School art lessons were also cited by many as important in nurturing art activities; some respondents, however, felt that their art lessons were counterproductive in facilitating meaningful art experience. This section examines the concerns and issues highlighted by the respondents, including the apparent mismatch between schooling and individual creative expression.

The artistic personality

The question whether artists are born or made is a controversial and contested topic but nevertheless, or perhaps because of this, it merits some attention. Anthropologist Donald Brown compiled a list of what he claims to be universal human attributes [1]; this list, which covers a wide range of behaviours, has attracted both derision and genuine interest. Steven Pinker, Professor of Psychology at Harvard University, has seen value in it and cites it in full, adding:

> *Child psychologists no longer believe that the world of the infant is a blooming, buzzing confusion, because they have found signs of the basic categories of mind . . . Archaeologists and palaeontologists have found that prehistoric humans were not brutish troglodytes but exercised their minds with art, ritual, trade, violence, co-operation, technology, and symbols. And primatologists have shown that our hairy relatives are not like lab rats waiting to be conditioned but are outfitted with many complex faculties that used to be*

considered uniquely human, including concepts, a spatial sense, tool use, jealousy, parental love, reciprocity, peacemaking, and differences between sexes. With so many mental abilities appearing in all human cultures, in children before they have acquired cultures, and in creatures that have little or no culture, the mind no longer looks like a formless lump pounded into shape by culture [2].

On the other hand, John Dupré, Professor of Philosophy at Exeter University, dismisses the items on Brown's list as eccentric [3]. Certainly there are some curious inclusions, such as gossip and hairstyles, but Dupre is more concerned with what he perceives as sinister aspects of 'this misguided project', asserting that it is 'politically dangerous'. His principal objection appears to be that scientific theories such as those expounded by evolutionary psychologists can have a negative effect upon attitudes, particularly in perpetuating racial and gender stereotypes. What he fails to consider carefully, however, are the subtle, complex and multifarious interactions between the mind and its environment; modern evolutionary psychologists do not deny the crucial importance of cultural and environmental factors in determining human nature, only stress the significance of inherited characteristics that have been previously downplayed.

Of interest here in Donald Brown's list of universals are inclusions relating to the aesthetic and the poetic; there are, however, no obvious references to art-making. This could be due to the fact that art is such a fuzzy concept that its basic characteristics are hard to discern. As we have seen, not only is art difficult to define conceptually, it also covers a wide range of human activities and so it is unlikely that there is one universal characteristic that can be associated with popular conceptions of art. In answer to the question 'Is there an artistic intelligence?' Howard Gardner, in his book *Intelligence Reframed,* answers that there is not, 'strictly speaking', but that other identified intelligences can be utilised artistically. These include the metaphorical and expressive use of language and the aesthetic exploitation of spatial intelligence. Gardner states that 'whether an intelligence is deployed for aesthetic purposes represents personal and cultural decisions' [4]. Gardner's theory of multiple intelligences is well known and continues to be developed. In his original publication of 1983 seven 'intelligences' were identified [5] but now there are others to be added to the list: a 'naturalistic' intelligence and, perhaps, a 'spiritual' and even 'existential' intelligence. Each of these might have some impact upon people's propensity for making, understanding and appreciating art. Naturalistic intelligence refers to, among other things, the capacity to *notice* – the ability to discern subtle changes in hue and tone, for example, and to identify patterns and relationships. Spiritual intelligence is drawn upon when considering the more profound aspects of art-making and appreciating; it is essential for

grasping and communicating in visual form about, for instance, existential truths, as well as 'awe and wonder'. I contend that what appears to be a curious omission – the lack of any specifically identified *artistic* intelligence is because of the diverse and eclectic nature of both art and those who practise it. Artists draw upon the full range of intelligences to a greater or lesser degree; when engaging in practical art activities there is perhaps an emphasis upon spatial and naturalistic intelligence, but others, such as mathematical and musical intelligence might also be drawn upon. Some art forms, especially in contemporary art, will also display strong elements of linguistic intelligence.

Regarding particular talents, it is likely that a broad spectrum of factors contribute to artistic giftedness, both environmental and developmental. Ability in art is also likely to combine specific cognitive abilities with affective qualities, such as empathy and sensitivity, and dispositions such as motivation and interest. My argument is that what some might term 'exceptional talent' or 'giftedness' in art is largely culturally determined, while the desire and potential for art-making is innate. Moreover, the abilities to appreciate visual form (among the sighted), to have a concept of beauty and to value it are all intrinsic to human makeup. What is wonderful in nature is not that there is some divine hand that has made the world beautiful with sunsets, rainbows, waterfalls and the like, but that we have the capacity to perceive these things as beautiful. Art objects – things made significant by human hand – are made to be the focus of our aesthetic attention by having a pleasing and/or arresting form and are often complex enough in various ways to incite that other important characteristic in people: curiosity. Without curiosity, there would be little opportunity for technological advancement and so we can see the evolutionary benefits of an innate sense of curiosity and capacity for inventiveness. Curiosity is fundamental to learning and it is this faculty that needs to be exercised if we are to live lives that are rich, significant and meaningful.

It is axiomatic that individuals differ; what stimulate some people will bore others; one way of working might appeal to some and not others. I come now to the issue of different styles of learning and how they might impinge upon learning in art. As noted in Section One, Viktor Lowenfeld [6] referred to the need to cater for both the 'visual' learner, who strives towards naturalism in art-making, and the 'haptic' child who is concerned primarily with expression but people are, of course, far more complex than that.

Research on learning styles, for example, has indicated that there are (at least) four different ones. Our perceptions of experience range from the intuitive to the logical and all the permutations in between. The processes through which individuals begin to develop this experience for understanding can range from active experimentation to reflective observation. Engaging in art-making can enable all individuals to learn in a meaningful and powerful way by facilitating all kinds of learning styles including doing, watching, thinking

and feeling. David Kolb [7] identified four distinct learning styles: accommodating, converging, diverging and assimilating. He attributed particular characteristics to each style; I have isolated those that might have an impact upon learning in art as follows:

Accommodators enjoy change and variety; they are willing to take risks (therefore not too bothered about getting things wrong) and look for excitement and hidden possibilities. On the more negative side, they tend not to plan work and avoid checking and reworking.

Divergers are characteristically imaginative thinkers who draw upon their own personal experiences. They like social interaction and group work. However, they tend to work in short bursts of energy and are easily distracted.

Convergers apply their ideas in a practical way and enjoy solving problems. They like finding out how things work and to try them out in a systematic way. They tend not to be too concerned with the presentation of their work. They have a very practical approach to learning and need to know the practical relevance of tasks given.

Assimilators also like to try things out and they are good at 'tinkering' with things. They are precise and feel happiest when working towards one solution. They work well alone and are not easily distracted; they do not feel as comfortable in group discussion as does, for example, the diverger. They also differ markedly from the diverger by being reluctant to try anything new, doing things in a set way, being overcautious and trusting logic rather than feelings.

It is useful here to distinguish between a 'style' and an 'intelligence'; put simply, a learning style is a chosen way in which an intelligence is used. Gardner tackles this issue, citing the work of Harvey Silver, saying that people with strengths in particular intelligences must 'still decide how to exploit these strengths' [8]. Using the example of people with strength in spatial intelligence, we could say that those who are accommodators might produce, for example, a piece of sculpture through trial and error, perhaps working with others, while a converger might work steadfastly and methodically alone, focusing on producing a piece of work which exemplifies the best solution to a given problem. Other researchers [9] have identified what have become known as 'learning modalities' that refers to strengths in particular senses or, more specifically, sensory channels relating to the ways through which different people process information via their sense of sight, hearing and touch. These modalities are known as visual, auditory and kinaesthetic. *Auditory* learners remember what they hear and say, often needing to talk through new learning.

They tend not to be good with written directions and, not surprisingly, are distracted by noise. *Visual* learners remember better when things are written down, particularly when illustrated with graphs or pictures, but they find verbal activities difficult and prefer information in visual form. *Kinaesthetic* learners like to work though problems physically and remember what they do when they practically experience it; they often lose interest when not actively involved. Again, although it can be seen that a modality is similar to a style, it differs from an intelligence. The former is a general approach to a range of stimuli, the latter is a more fundamental capacity which is used for specific purposes. Gardner uses the following example:

> *Someone gifted with linguistic intelligence might decide to write poetry or screenplays, engage in debates, master foreign languages, or enter crossword puzzle contests. Perhaps the decision about how to use one's favoured intelligences reflects one's preferred style. Thus, for example, introverted people would be more likely to write poetry or do crossword puzzles, whereas extroverted ones would be drawn to public speaking, debating or television talk shows* [10].

It should be noted that one is unlikely to find a person who operates in just one particular way regardless of circumstances. Most people in a learning situation will draw upon several approaches, and depending upon the circumstances, will tend to prefer one way of processing information over another. Of course, learning styles and different kinds of intelligence impinge upon the way that people relate to the world throughout their lives, not just in educational institutions. Indeed, it is a problem that most institutions – including schools – operate as though there were only one kind of intelligence and one way of utilising it. A related problem is the tendency for institutions to label people and so we have instances of schools that have adopted a 'learning styles' approach to the curriculum, labelling pupils as 'kinaesthetic learners' because they appear to enjoy PE and dislike mathematics.

The diverse and complex nature of art allows the full range of learning dispositions to be accommodated. Those who might be considered to be artistically gifted might display maturity in any of the diverse skills associated with art: representation; sensitivity to colour relationships; the ability to see the whole in relation to its parts; manual dexterity; eye, hand, brain coordination; visual discrimination with the ability to distinguish between subtle qualities of form and numerous other skills. Although working with art can involve, for example, both individualised reflective activity and practical group work, there exists a body of published work on the nature of the artistic personality and a significant body of research based on the musical temperament. Anthony Kemp, for example, has made extensive use of psychometric testing and has

found that the musical temperament is characterised by particular traits that are shared with 'other creative types'. These traits include high levels of sensitivity, imagination and intuition, as well as the general tendency towards introversion. However, Kemp noted that other attributes of creative personalities include a certain 'boldness' arising from 'considerable inner strength' as well as a propensity for independence [11].

We are born with a capacity for acquiring skills in making and the capacity to appreciate visual form. Different intelligences can come together in certain people, which, given the appropriate environment, can result in someone being particularly skilled, gifted or even a 'genius'. Different styles and modes of learning result in the range of different kinds of artists and approaches to art-making. Skills in both the handling of media and growth in understanding of (for example) pictorial representation develop in a particular way, in definable stages; some progress rapidly through the stages, regardless of instruction, but will inevitably need guidance and coaching to achieve higher levels of competence. All other things being equal, everyone is capable of learning skills in handling materials and tools, and of developing sensitivity to visual form.

The 'mini case-studies' of Section Two cover a wide range of people, from mature successful artists to children with learning difficulties. There are extroverts, introverts, people who are garrulous and others taciturn. Some are from deprived backgrounds, others privileged; some with excellent opportunities for art in school and elsewhere, others with more limited opportunities. What they have in common is a need to create and a sense of fulfilment, a sense of identity and self-worth from the act of creating art. They are sensitive to their environment and most appear to have a heightened capacity for empathy. Whether these traits are simply related to the predispositions towards art-making or traits that develop as a result of art-making activities is debatable. It is nevertheless likely that engaging in art-making activities will have certain effects upon the character of the maker; these might include, among other things, greater self-esteem and perhaps sensitivity to others – characteristics which I consider to be desirable and therefore worth developing.

Creating aesthetic significance

I have outlined a case for suggesting that everyone, that is every human being, has an innate capacity and desire for making art. However, because of art's conceptual slipperiness and the fact that it is so dependant upon culture, such a suggestion needs qualifying by taking a very broad definition of what is meant by making art. Amongst the people I have talked with about their creative endeavours are many who do not consider themselves to be artists but exhibit all of the tendencies which artists often display: a passionate desire to create something that looks good and feels right – something which has particular

significance, whether it be a birthday cake, a garden or a hairstyle. In such activities, intuition, expression, skill and a consideration of aesthetic form – all attributes of artistic activity – are considered important. What everyone needs is the opportunity to create, and when the occasion calls for it, to create something of aesthetic significance, that is, something that has meaning for the person who created it.

The term that I prefer, then, is 'creating aesthetic significance'. 'Creating' because of that word's association with creativity and inventiveness, concepts that have a particular resonance when talking about human development; 'aesthetic', because we are concerned here with the senses, while 'significance' is associated with meaning and 'signs' that are highly expressive and invite attention. I am not aware of any culture in the history of humankind that does not create aesthetic significance. If an individual person has not demonstrated the ability or desire to create something of aesthetic significance it is because of lack of opportunity. The urge to create aesthetic significance is facilitated through art; where there are no opportunities to engage in art-making activities, the urge is manifested in other ways, not always positive.

Some commentators on art education continue to belittle the importance of creative self-expression and its value in promoting outcomes that are self-evidently valuable, such as heightened self-esteem. For example, Donovan R. Walling, in his book *Rethinking How Art is Taught*, asserts that a focus on creative self-expression promotes:

> *. . . a shallow view of art as almost wholly self-referential and self-serving and thus ignores the larger purposes of art . . .The young artists (and these are all children and adolescents) in most elementary and secondary schools more often experience critiques of their work that are confined to the use of line or shape or colour, without reference to how the work relates to the art being presented by professional artists working in or against the prevailing aesthetic* [12].

Walling places himself firmly within the 'discipline-based' camp, claiming that the production of art by young people cannot be 'fully successful' without reference to the disciplines of aesthetics, art history and art criticism. To me, this makes sense only if we value art more than people. The young people in our schools are not 'young artists', who are concerned with art's 'larger purposes'; they are individuals trying to make sense of themselves and the world around them, sometimes through art activities. The problem here is in imposing upon young people a whole body of (contested) knowledge at an inappropriate time in their development. It is, of course, important for young people to know about and understand the incredibly diverse nature of visual culture but not at the expense of depriving them of opportunities for creative self-expression. Older

students, those who have refined their technical skills and are relatively secure in their sense of self, can be directed to the work of other artists and designers and be given appropriate critical tools but the choice of what is to be the focus of attention is always going to be problematic.

Walling cites Henry Giroux, who stresses the importance of attending to the needs of the individual. Giroux is quoted as saying that educators must ensure that students are given opportunities

> *to develop the critical capacity to challenge and to transform existing social and political forms, rather than simply adapt to them [and] providing students with the skills they will need to locate themselves in history, to find their own voices, and to provide the convictions and compassion necessary for exercising civic courage, taking risks, and furthering the habits, customs, and social relations that are essential for democratic forms* [13].

I suspect that Giroux, known for his rejection of 'grand narratives' or single visions, would not wish to impose any particular art canon onto students, especially if it were at the expense of under-represented individuals' choices. Art as a subject in schools is well placed to develop students' critical capacities, to enable them to 'find their own voice' and to encourage risk-taking and the will to challenge norms. It has been found [14] that practical arts activities are an ideal, in many cases perhaps the only, way for students to find their voice. I have argued elsewhere [15] that the significant contribution that an education in art can make to society is not so much as a 'civilising' force in the sense of conforming to accepted notions of civil behaviour as a way of 'educating for transgression'. One potent myth of modernism is the personification of the artist as transgressor and outsider; many, perhaps even most, western artists are not generally known for their socially responsible behaviour. It could be said, however, that they have made useful contributions to society because of their willingness to transgress social mores and engage in the politics of dissent. If we promote creative expression through art we are also promoting 'creative behaviour', which, by its very nature, can often be challenging. The 'artist as rebel' may well be a tired stereotype but, like most stereotypes, has its roots in some reality; the person educated to experiment, accept mistakes, try new ways of looking at and inventing things will also be someone who questions the *status quo* and contributes to the dynamism of society. I contend that these things can be achieved through active engagement in the production of art, in a supportive environment that encourages self-reflection. It is not democratic to impose a particular canon; if people are to find their own voice, they need to be given practical opportunities for creative self-expression.

Elsewhere in his book Walling considers the question 'How will individual students be encouraged or empowered to construct meaning based on their

own pursuit of art knowledge?' and answers it by saying:

Attention to individual student needs, interests, and abilities is essential to developing standards in which students will invest themselves, not merely their time [16].

However, Walling, as have so many others, appears to have taken on uncritically the 'discipline-based' approach – learning *about* art, which essentially entails valuing the subject rather than the learner. While apparently eschewing a learner-centred approach – learning *through* art – Walling advocates that attention be given to the needs of individual students by adopting a constructivist approach to art teaching. Constructivism in this context is an approach that is developmental and based upon the learner constructing knowledge and understanding by assimilating new information (for example from a teacher) and synthesising it. A higher level of understanding is thereby gained through this new information taking its place within the learner's existing knowledge structure. The issue here is the apparent lack of congruence between the desire to democratise teaching and learning by attending to the needs of individual learners, while learners' own preferences go unacknowledged – the teacher is placed in the position of knowledge-giver rather than as a facilitator of meaning-making. However, from a social-constructivist standpoint, the teacher can be seen as both facilitator and instructor.

I am not advocating a 'return' to the *laissez-faire* approach which characterised art education in previous years but I am saying that concerns associated with earlier models of teaching and learning remain of value. These concerns include imagination, expression, identity and creativity. However, young people need structure and guidance in their lives, and in order to help them create their own things of significance, they need to be taught the relevant skills at an appropriate time in their development.

Notes on imagination and expression

Imagination involves thought, thought which is not simply fantasy or the conjuring up of mental images of things not experienced but the actual construction of new realities. art-making can be seen as an effective conduit through which imagination can flow. There appears to be a link between one's capacity for empathy and the ability to think creatively; empathy is made possible by imagination. Furthermore, as Maxine Greene asserts

of all our cognitive capacities, imagination is the one that permits us to give credence to alternative realities. It allows us to break with the taken for granted, to set aside familiar distractions and definitions [17].

It is instructive to consider Greene's use of the term 'cognitive capacities' as this places imagination and its manifestation in art activities firmly within the realm of thinking – but it is a special kind of thinking that is involved, thinking which is often spontaneous and intuitive, thinking that arises from tacit knowledge and results in the coming together of diverse material.

In its early form this kind of thinking occurs during play. When playing, children use their imagination and often take on imaginary roles where they are acting out behaviour that is beyond their age. They do this in a way that is more focused than when they are given a task to do by an adult. One lesson for teachers here is that learning is best facilitated through creating a situation where people can learn at their own pace, doing things that are relevant to them. art-making activities, such as drawing, allow people to create their own worlds, worlds where they are in charge and where they feel free to invest meaning that is both significant and intensely personal. Many of the respondents featured in Section Two spoke of the need to create; related to this is the need to have hope and vision, to consider alternatives and to imagine possibilities.

'Self-expression' as a valid and worthwhile aspect of art activity has been sidelined in recent years. There are several reasons for this. One is that it is difficult to assess and does not fit easily into the assessment structures that have emerged over the past decade or so; this is associated with concern about 'standards' and the fear that a focus upon self-expression encourages an attitude amongst both teachers and learners which militates against 'standards'. Mike Bonnet, however, in his book on children's thinking, comments that:

Authentic self-expression is far more likely to be criticized for its austerity than because it is laissez-faire. Self-expression cannot be simply a matter of 'doing one's own thing' regardless of the consequences: authentic self-expression must involve acknowledging that one is the author of one's own actions, and it is this sense of personal responsibility that gives them their feeling of meaningfulness, a feeling that is lacking if one is simply carrying out someone else's instructions, or complying with what is normally expected [18].

The key word here of course, is *authentic*. This entails aiming for genuine individualised responses to learning, which in turn requires reflection and an environment that is supportive. This is particularly the case when we consider that in order to be authentically self-expressive, students need to be secure in their sense of self. Such security is related to issues of identity and self-esteem, and so any stated aims for the inclusion of art in the school curriculum – those of promoting self-esteem and developing a sense of identity – are inextricably linked to fostering a nurturing environment where self-expression is enabled. People need to feel that they are unique or at least valued. The need for much of contemporary youth to rebel against what is perceived as the values of an

older generation (while conforming to the norms of their peer group) can be seen to be a way of seeking an identity. Self-expression, while often maligned when advocated as a desirable end in itself, is an important aspect of growing up. If an individual is denied the opportunity for self-expression, then emotional growth is stunted and less socially acceptable forms of expression are sometimes pursued.

A more fundamental reason for the marginalizing of self-expression is the notion, held by many post-modern thinkers, that there is no such thing as the self and therefore any 'expression' of it is spurious. Post-modern thinking, or more accurately, post-structuralist thinking, revolves around the idea that there are no generalisations that can be made about human nature; indeed, there are no concepts of objectivity, reality or truth. There is no room in post-structuralism for any meaningful conception of the self, nor of art, therefore self-expression as an aspect of creating visual form becomes redundant. However, some authorities in the field, such as Dennis Atkinson, while dismissing as irrelevant developmental stages, together with what we might call 'traditional' notions of what constitutes artistic activity, offer interesting perspectives on the question of art-making, particularly drawing and the sense of self, from a post-structuralist standpoint. From such a position, both teachers and learners gain their identities within practices that are ideologically constructed; therefore any notion of innate ability is rejected. Atkinson draws attention to the work of John Matthews, who manages to reconcile constructivist theories of learning (which pay little attention to social influences) and social constructivist theories (which tend to deny the importance of individual agency) [19]. Atkinson goes on to advocate an art curriculum that is characterised by diversity, one that does not predetermine how an individual makes meaning in art. Such a curriculum values the individual but in Atkinson's approach a problem is highlighted in that modernist ideas about self-expression and uniqueness are social constructions, thus rendering meaningless any conception of individual expression. However, while self-expression and conceptions of identity are related to modernist ideas about the nature of art, this does not mean that in a post-modern world we eschew them; the value of an education through art-making lies in its concern for the individual, not in its concern for art.

There can be no doubt that many art teachers in schools continue to facilitate self-expression and that the general creative ethos characteristic of many art rooms (which Hargreaves remarked upon in the early 1980s) continues to flourish. Hargreaves noted, on the basis of those schools he visited, that 'art rooms allow for considerable choice, autonomy and opportunity for self-expression' and saw the art room as a kind of 'retreat' [20]. The idea of the art room as a 'kind of oasis' has been reported by several commentators, notably Patricia Sikes. Sikes maintains that art rooms often have a different atmosphere

to the rest of the school, noting that art teachers talk about cultivating and fostering a climate which is conducive to creativity and self-expression both in terms of producing work and of enabling students to relax and be themselves [21].

She found that the art teachers with whom she worked saw art principally as a means of self-expression and a source of personal achievement. The art teachers tended to see themselves in the main as facilitators, perceiving their job to be concerned with drawing out or facilitating the expression of students' inner capabilities, which, she argues, contrasts with the aim shared by the teachers of other subjects she worked with, whose principal aim was to transmit knowledge. Sikes concludes that among other outcomes 'art teachers set out to encourage self-respect and a positive self-concept' and that 'they encourage individuality' [22].

Identity

Many of the respondents' accounts in Section Two refer to issues associated with individuality – self-esteem, identity and self-confidence. It seems that people who are actively involved in making and other creative pursuits often derive heightened self-esteem and self-confidence from their activities; there is a lot of evidence to support this. Harland *et al*, for example, in their in-depth research into the effects of arts education, found that:

> *Many pupils testify to a significant enhancement in various forms of self-confidence through engagement in the arts. Moreover, particularly striking in some [of the pupils' accounts of their learning] were the unsolicited references pupils made to the transference of these gains in self-confidence to other arenas and contexts* [23].

They also found, from the testimonies of many teachers and students, that self-worth, self-esteem and sense of achievement were raised through engagement in arts activities. They cautioned, however, that such effects were not automatic, depending to a great extent upon the skills of the teachers concerned. Self-expression often has a cathartic dimension to it but there are therapeutic aspects to art-making that go beyond providing a duct for the purging of emotions. Some testify, for example, to the sense of calm that is derived from concentrated art activity; some compare their mental state while drawing to that achieved during meditation. Peter Steinhart suggests that certain kinds of brain activity found in meditating yogis, such as increased alpha and theta wave activity (said to be associated with creativity and imagination), and beta waves (said to be associated with concentrated attention), are found in among artists when they are drawing [24].

The notion that teachers should be individuals (rather than curriculum delivery operatives) and that it is expected that they treat their students as individuals (rather than a uniform mass of empty vessels) is taken up in the following quotation from Anthony Green, commenting on the singularity of art teachers in his experience:

The attitudes of the teaching staff are usually slightly different to the head of . . . physics or science or the housemasters. They sort of seem to be, they seem to have a kind of different take on life. They seem to laugh quite a lot in the art department and crack jokes. And life's kind of funny and they do nudes and they look inside seashells and they kind of, it's like Mission Impossible realised in the art department. It's just lovely [see note 6, Section Two].

I am not simply resurrecting stereotypes here but reasserting the importance of the individual student and the difference that teachers can make if they are enthusiastic about their subject and value students in a way that is reflected in the ambience of the teaching space. Successful art teachers and the way that many create a special learning atmosphere can be seen as models for others.

A few words on creativity

Firstly a word about the concept of creativity itself – something that is notoriously difficult to define; nevertheless, there is what has become a standard definition, now in common currency:

Imaginative activity fashioned so as to produce outcomes that are both original and of value [25].

And so we have the concepts of imagination and originality coming to the fore, together with the suggestion of practical activity. It is easy to see, given this definition, why creativity continues to be associated with art-making. The concept of creativity, like the concept of art, is notoriously slippery but, like art, we are able to identify two observable phenomena, namely creative behaviour and the objects that arise as a result of creative action.

In an exhaustive and comprehensive review of the empirical studies on artistic personality, Gregory Feist found that:

In sum, the personality of the creative artist suggests a person who is imaginative, open to new ideas, drives [sic]*, neurotic, affectively labile, but for the most part, asocial, and at times even anti-social* [26].

While it is undoubtedly the case that 'creative personalities' exist and that they display particular and special qualities, I would also suggest that the ability

to be creative is quintessentially human and such ability is common to all. Creative activity is characterised by being imaginative, purposeful and original and is concerned with quality or value. We can assume, therefore, that the results of such activity would display elements of imagination and originality and would have some utility (in the broadest sense) that is of value. The level of utility and the nature of the value or quality of the outcomes of creative behaviour are to some extent determined by the individual but in the case of gifted individuals, these things would be determined by society at large. Regarding developmental aspects of creativity, Gardner makes the point that:

> *It takes about a decade for people to master a domain and up to an additional decade for them to fashion work that is creative enough to alter that domain* [27].

And so it can be seen that while the potential to be creative is common to all, only a few are able, through hard work and judicious interaction with the environment, to be creative enough to make a difference outside their personal domain.

The association of art activities with creativity was given a boost during the period when child-centred progressive education was gaining ground, with the publication of *Creative and Mental Growth* and also Victor D'Amico's *Creative Teaching in Art*, first published in 1942. Since that time, most of the research into creativity has focused outside the field of art practice. Nevertheless, it is still an association that appears to be fixed in the public imagination. Many of the respondents reported in Section Two mentioned 'creating', 'the creative process' or 'creativity' when referring to their involvement with art. If someone refers to 'the creative subjects' disciplines, I believe we can safely assume that they are referring to arts subjects, not sciences or even humanities, despite years of research and publications that have highlighted the fact that creative activity is not and never has been within the sole remit of art. The concept of creativity is, of course, associated with a process, not a subject; however, the processes that many art teachers encourage and engage with do indeed facilitate creative behaviour.

Problem-solving in the context of art can refer to simple, concrete activities when working with diverse materials – how to fit an octagonal peg into a hexagonal hole. It can also refer to more mercurial phenomena. Speculative and intuitive factors are involved in problem-solving and it is in this respect, as well as the practical aspect of art-making, that makes art practice an important activity in fostering problem-solving. In art, people often try to assert their individuality and see rule-breaking as a desirable goal. Art practice facilitates the kind of thinking which in turn leads to intuitive leaps; thinking 'artistically' is essentially non-verbal and is therefore not tied down to the logical structures

of everyday thought processes.

In Section One I outlined different aims for art education, suggesting that some had more social utility than others. Politicians from different parts of the world at different times have advocated creativity as an answer to various perceived shortcomings in the educational system. Promoting 'creativity' is a theme that occurs from time to time in governments' visions for education, alongside a range of apparently desirable humanistic goals that might benefit not only the individual but also society as a whole. Whilst working in Singapore in the early 1990s, I was struck by the plethora of incentives and general discussion surrounding the topic of creativity (I also supervised two Masters' degree dissertations which focused on the subject). It seemed quite ironic for a government not known for its liberal philosophy (jail and caning for vandals, $10,000 fine for feeding the jungle monkeys, unspecified punishment for chewing gum anywhere . . .) to promote this most humanistic of human traits. To my mind, it seemed odd that a state that has an international reputation for excessive social control should promote creativity but in Singapore it is claimed that this is something that the country should embrace. Having achieved economic success, art has been seen as the way to promote creativity and, presumably, the risk taking and breaking of boundaries associated with it. Tay Eng Soon, the senior Minister of State for Education in 1990 said: 'Creativity is icing on the cake . . . What does creativity mean in operational terms, practical terms in the classroom? Well, Art is an obvious example, free expression . . .' [28]. It remains to be seen whether this attitude filters through to other areas of that government's policies. When the British Labour government in its second term of office and confident of its power sought in a similar way to promote creativity, my suspicions were aroused. This was a government, notorious for its desire to control, wanting also to control creativity.

If, as I have suggested, we are all born with the capacity to be creative and with a desire to make and enquire, we might assume that all people are creative all of the time, which of course is not the case. What, for instance, happens to the natural curiosity of children? The eminent writer on all things creative, Csikszentmilhalyi, notes:

Each of us is born with two contradictory sets of instructions: a conservative tendency, made up of instincts for self-preservation, self-aggrandizement, and saving energy, and an expansive tendency made up of instincts for exploring, for enjoying novelty and risk – the curiosity that leads to creativity belongs to this set. We need both of these programs. But whereas the first tendency requires little encouragement or support from outside to motivate behavior, the second can wilt if it is not cultivated. If too few opportunities for curiosity are available, if too many obstacles are placed in the way of risk and exploration, the motivation to engage in creative behavior is easily extinguished [29].

Creativity is an elusive thing – pursuing it is like catching butterflies or grabbing soap – when pursuing the object of one's desires it is better to create an appropriate situation and have it come to you. Many schools, by their very nature, do not generally fall into the category of appropriate situations for facilitating creativity. All young people have the potential to grow artistically; schools can facilitate that growth but, equally, they can inhibit it.

Art and schooling

Among the respondents who contributed to Section Two was Jade, a newly-qualified teacher of photography who after less than a year in schools has left to pursue more creative work. She wrote the following in an e-mail message:

My experiences to date have illustrated to me that much art teaching and schooling are actually anti-art, and moreover anti-education. School and creativity/ teaching and art-making are not comfortable bedfellows. Indeed the role of schools appears increasingly to be to manufacture mediocrity. We teach an edited, filtered version of the arts and art history to suit society's need to produce drones – not thinking individuals. I believe teaching and making art is about generosity, sharing of concepts and enthusiasm for the craft and for life, and seeing a student's victories as our own. However I have often witnessed in schools a competitiveness and reluctance to share skills and knowledge. Teachers fresh from college, full of lofty aspirations, are worn down by the education system, by their lack of power and by ingratitude. Teachers can subsequently become the worst dictatorial bullies. School is consequently a potentially miserable experience for pupils and teachers alike.

There is clearly something amiss in some, perhaps most, schools. The school art room was seen by many of the respondents cited in Section Two as an oasis or haven. This gives rise to the question: Are schools such appalling places that there is a need to seek refuge from them? I have asserted that everyone has the desire to 'create aesthetic significance' and that this desire is facilitated through art. It would seem that one of the characteristics that the respondents displayed is a sense of identity and self-esteem, derived from art-making activities. One conclusion which might be drawn from this is that those who are not actively involved in art-making have not gained such rewards. It could well be the case that schools, where most people's experience of art-making begins, at least in industrialised societies, are also responsible for de-motivating young people with regard to art – I once heard an art teacher, on greeting his enthusiastic new year seven students, remark in a self-mocking aside, 'We'll soon knock that out of them!'

Creative behaviour in the classroom is probably the last thing many teachers want. Studies of creative people tend to support the notion that creativity is

associated with social disruption. Creative people tend to challenge existing structures, delay closure rather than structure ideas and let new perceptions dictate their own structures rather than use existing models. The nature of schooling militates against all of these characteristics, with its emphasis on rules and maintenance of structures. Many teachers respond negatively to students who challenge the *status quo* in whatever form, even in art lessons.

Schools are often hierarchical institutions dominated by petty rules and breeding grounds for bullying behaviour. It is self-evident, then, that most schools do not welcome creative behaviour; indeed, most schools, as Harry Ree asserts, are not places well-suited to education in the arts. In the following quotation Ree talks about 'promotion of the arts', an enterprise that 'aims to develop imagination, sensitivity, inventiveness and delight, and works largely and most effectively through the feelings'. He goes on to assert that:

> *Schools, for several understandable reasons, are not geared to work through the feelings – the very opposite. They are designed to impart information, to reward exactitude, to inculcate skills and sometimes to develop curiosity. They are then expected to test the outcomes of their teaching and give numerical evidence for the success or failure of themselves or their pupils* [30].

But let us not take a grown-up's view of it. What about the clients – the pupils? The following is from a letter to the *Independent* newspaper, from a 15-year-old attending a London school:

> *It's not my hormones or a phase, school sucks! It is obsessed with league tables and what can be put on the front of the latest, perfectly photographed prospectus . . . I understand that we have to know maths but sometimes wonder what its practical uses are given the multitude of hypothetical questions with hypothetical answers. English and science are no better. I have a particular gripe with English because it has so much promise but all of the creativity has been squeezed out of it by the iron grasp of the league tables . . . Creativity is little more than a poster or some half-hearted drawings done on the last day of term* [31].

A response the following week from a 13-year-old girl attending a Manchester school:

> *School does more than just suck it reeks of that thing which every student in the world dreads – boredom . . . For example geography is so boring that I would sleep through it if I could. I'm not blaming the teacher . . . it's the system she has to stick to* [32].

Later in that year, under the headline 'OFSTED's silent witness', a school student wrote a short column in the educational press criticising the inspection process saying, 'You are the only real inspector of your own education' [33]. In each of these cases apparently intelligent but disaffected students cite the principal reason for their disaffection as 'the system' or the need for the school to be competing in league tables. Elliot Eisner draws attention to the tendency for schools to be monitored and measured, to 'assuage our anxiety' about their performance; this entails prescribing content and procedures and measuring their consequences, 'to create an efficient system that will help us achieve, without any surprise or eventfulness the aims that we seek' [34]. He contrasts this with experience of the aesthetic:

Efficiency is largely a virtue of the tasks we don't like to do; few of us like to eat a great meal efficiently or to participate in a wonderful conversation efficiently, or indeed to make love efficiently. What we enjoy the most we linger over. A school system designed with an overriding commitment to efficiency may produce outcomes that have little enduring quality. Children, like the rest of us, seldom voluntarily pursue activities for which they receive little or no satisfaction. Experiencing the aesthetic in the context of intellectual and artistic work is a source of pleasure that predicts best what students are likely to do when they can do whatever they would like to do [35].

Efficiency and the tendency to want to measure drive out those subtle aspects of life and learning that are not easily measured.

As far as education through schooling is concerned, the nature of schools needs to be radically different from those with which many of us are familiar. I have spent a lot of time in schools – as an examiner, as an inspector, as a student teacher supervisor, as a concerned adult, as a teacher and as a pupil. I have also spent time in many different kinds of schools, state and private, catering for different ages and ability ranges. I have spent time in schools in Africa, Asia, Australasia, North America and Europe. I am saying all of this because I want to give a little credibility to what I say next: I don't like them. I don't like them because the overwhelming majority are elitist, hierarchical, undemocratic, and in many cases, brutish. Now, isn't it strange that institutions that are supposedly dedicated to learning, to preparing young people for a meaningful, purposeful, enriching and creative place in society should be perceived in this way? I feel that it is no exaggeration to say that many have more in common with prisons than with, for example, theatres or art studios (even though most schools incorporate these into their fabric). Many, perhaps most teachers try very hard to overcome the deadening ethos of their schools but have an uphill struggle against enormous odds to create an environment where purposeful and joyous learning can occur. Among other things, we want students who emerge from

over a decade of compulsory schooling to be numerate, literate, articulate, socially competent, technologically able and tolerant. We also need them to be able to communicate in graphic form, to be aesthetically sensitive (why do we put up with so much ugliness in many of our cities?), to be able to work cooperatively and to discriminate between what is meaningful to them as human beings and what is not.

I have found that many teachers, particularly art teachers, feel that 'creating an ambience' is of value [36]. Other researchers, such as Patricia Sikes, quoted above, have referred to the art room in many secondary schools as special and different from the rest of the school. However, Michele Tallack makes the point quite forcefully that such attitudes can lead to the isolation of art from other curricular areas and, in particular, deprive students of a balanced view of the place of art in the world [37]. My view is that, on the assumption that we have schools as they are conceived at present, the 'rest of the school' should become more like the art room.

The notion that the learning environment is of central importance to aesthetic growth has been around for at least 50 years. Herbert Read, for example, writing in the early 1940s, advocated:

> *the use of textile hangings, the exhibition of pictures and sculpture, the dresses of the children and the teachers, the display of flowers, the absence of stridency and undue haste . . . But it should always be remembered that the school is a workshop and not a museum, a centre of creative activity and not an academy of learning* [38].

Read was writing here of education in general, of the need for schools as a whole to facilitate creative growth through freedom of movement and exposure to interesting and beautiful things; it should be noted that Read also advocated the removal of barriers, both physical and mental, from between subject areas. The more relaxed the atmosphere of the art room, and its associated freedoms, is sometimes cited by pupils as a reason why they like art lessons and a positive factor in deciding to carry on with art at a higher level.

If we accept, as I have argued, that making art, or at the very least, the desire to create something significant, is an essential prerequisite of being human, then young people need to be in environments that promote this. All too often young people are actually prevented from developing in this way through the very structures that are put in place to facilitate growth. This perception is common enough to find its way into modern fiction and is satirised in television and in magazines. John Fardell's cartoon strip in *Viz*, 'Desert Island Teacher', features a secondary school teacher, Brian Chalkwright, who is shipwrecked on a desolate rock in the middle of the Atlantic but 'resolves not to let this mishap affect his professional commitment'. He does this by erecting signs (such as

'staff toilets') around the rock and barking out instructions to limpets and other unfortunate marine organisms:

> *Come on limpets . . . face the front and settle down. Just because it's the second last day of term doesn't mean we don't maintain discipline and order. No, you can't bring in games tomorrow! Tomorrow is a school day like any other. Where do you think you're going, crab? Get back to your desk!* [39].

Mr Chalkwright is shown falling asleep and dreaming of being a 'master teacher who can bring young minds to life' as in the frames below:

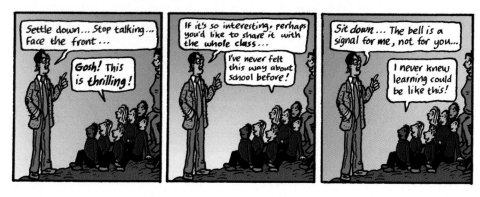

Figure 9: *Desert Island Teacher.* © John Fardell, 2004. *Viz*, no. 141, December 2004, p. 43.

In Annie Proulx's award-winning novel *The Shipping News* there is a depressingly familiar account of the kind of 'creativity' that can be found in many schools:

> *The school came in sight. Bunny stood at the bottom of the steps holding a sheet of paper. Quoyle dreaded the things she brought from school that she showed him with her lip stuck out: bits of pasta glued on construction paper to form a face, pipe cleaners twisted into flowers, crayoned houses with quadrate windows, brown trees with broccoli heads never seen in Newfoundland. School iconography, he thought.*
> *'That's how Miss Grandy says to do it.'*
> *'But Bunny, did you ever see a brown tree?'*

and later:

> *Sunshine felt hot under Quoyle's hand. He looked at her drawing. At the top,*

a shape with cactus ears and spiral tail. The legs shot down to the bottom of the page. 'It's a monkey with its legs stretched out,' said Sunshine. Quoyle kissed the hot temple, aware of the crouching forces that would press her to draw broccoli trees with brown bark [40].

The 'crouching forces' are the oppressive ethos of school, personified by the likes of 'Miss Grandy', which stifle rather than nurture creativity, imagination and intuition.

Elsewhere, one can find evidence of schools' dispiriting ethos and the natural inclination of schooling to be normative:

Alex hated school. 'I just don't think I liked conforming, and school's not equipped for dealing with individuals is it?' She looks down, then sullenly up. And suddenly it's Kevin the teenager. 'I had all these feelings and views, like I wanted to get my nose pierced and have my shirt out, and I couldn't understand 'cos like it's not affecting my work – but it was [rolls eyes] such a big deal. And I was only interested in what I was good at, like sport, art, drama.'

The above is part of an interview with the winner of BBC's 'Fame Academy', Alex Parks, reproduced in *The Independent Magazine* [41]. Even when teachers are trying to create an environment where creativity can flower, there can be other problems, such as trying to maintain a balance between teaching and facilitating or simply telling students that they are individuals who should be creative without actually teaching anything. The following is from Libby, one of the respondents included in Section Two:

My new teacher did a strange thing at the very start of our very first lesson together which at the time I thought was weird and a bit pointless, but soon after realised what an excellent lesson it'd been. She gave us each a sheet of plain A4 paper and casually asked us to fold it in two. Naturally we had all (with the exception of Jo F – who to this day is as eccentric as one can be) folded the paper neatly into two to form two A5 areas. The teacher, almost angrily, said, 'if you learn nothing else in the next two years, learn this – there are an infinite number of ways a piece of paper can be folded into two. You are individuals. None of you are the same. I don't expect to see you doing the same as one another again – understood?' It must be said that from that point on we learnt nothing from our teacher, but gained unquantifiable amounts of motivation, insight, encouragement and inspiration from one another. My A-level art group were an exceptional bunch of individuals who you'd have to meet to believe. Everyone was 100% immersed in what they did, be it making films, to bondage suits of armour, forging five pound notes, composing music,

mathematically calculating how many plastic coffee cups would need to be cut in a particular way to create spherical designs as intricate as snowflakes, carving gravestones, gaining access to surgeon's museums, etc. Very little work went on in class. Everyone did their own thing at home and came into lessons to talk about it or show it to one another.

The telling thing here is that most of the learning and involvement in creating things occurred outside school; school was principally a meeting place.

The 'good' art teacher, however – and there are many, probably a disproportionate number – displays all of the characteristics of excellence in teaching generally. There are many reasons for this, not least the level of commitment and enthusiasm that are typical of art teachers. Other factors include the nature of the learning environment; many art rooms are organised in such a way as to create an ethos that facilitates creativity and independent learning. School students in such active learning environments operate as makers rather than as pupils; this gives them autonomy, control and, ultimately, some degree of empowerment. Good art teachers are also experts in resource-based learning; it is common for art and design teachers to make effective use of outside agencies, such as museums, galleries and professional artists in residence. Of particular value is the approach to assessment adopted by many good art teachers, which is often formative and learner-centred; this issue is discussed more fully in Section Four.

Maxine Greene argues for classrooms to be 'nurturing and thoughtful', declaring that:

It may only be when we think of humane and liberating classrooms in which every learner is recognised and sustained in his or her struggle to learn how to learn that we can perceive the insufficiency of bureaucratized, uncaring schools [42].

Greene contrasts seeing 'small', that is from a lofty, dehumanised perspective, and seeing 'large', focusing on individual people and their individual needs. All too often schools are viewed 'small', with the emphasis on bureaucratic 'efficiency' – the result is disaffected and disengaged individuals whose potential is stifled with an all-pervading boredom. Seeing young learners as 'human resources' in institutions that are designed to supply the labour market with its 'raw materials' does nothing for the personal growth of those learners.

Schools need to be seen as genuine centres of the community, with adults learning alongside children. They have a special part to play in facilitating the urge to create; community arts initiatives are particularly worthwhile in this context and there have been some successes, even in apparently less

enlightened times. The Owatonna Art Project in Minnesota, for example, was a successful community art project funded by central government in America in the 1930s. The project was intended to create art activities based upon the aesthetic interests of the community. This involved such things as visually interesting window displays in commercial areas as well as promoting home decoration. Projects such as this highlight the importance of creating aesthetic significance for the community as well as the individual and take away the association of art with 'high culture'.

It is worth noting, as did Harry Ree, that the Greek word *skoli* – from which we derive the word school – means leisure; Ree goes on to say that 'in a civilised society leisure involves working for love' [43]. This might seem to be dangerously close to William Morris' utopian vision where honest manufacturing work was a 'joy to the maker and the user' [44] but nevertheless highlights the notion that places of learning should be places with opportunities for discovery and reflection and be places of excitement rather than boredom. 'Working for love' is the essence of being 'amateur', someone who does things for love, not pay. It is unfortunate that 'amateur' has come to have negative connotations and that being 'amateur' is synonymous with being unskilled.

In the UK and elsewhere there are government initiatives to encourage specialist schools, including 'art schools'. These are not the traditional art colleges of Further and Higher Education but are an attempt to capitalise upon what is perceived as a strength in certain secondary schools. So what could be the role of traditional specialist schools of art? Roy Ascott, author, television presenter and academic, ponders this question in an article for the *Times Higher Education Supplement*:

Students find the stimulus for change, transformation and enterprise on the streets rather than in the studio, in the clubs rather than in the seminar, on the net rather than in the museum. Art schools for the most part are housed in old modernist or Victorian buildings designed for other kinds of practice and older sensibilities [45].

Ascott outlined his vision for the future of art schools that is based not on the unique discipline of art but on 'transdisciplinary networks' based on an alliance between arts subjects and the sciences. Such thinking is inevitable when the concept of art as a discrete subject has become so diffuse as to be rendered non-existent. If we consider art to be concerned with practical skills, then art schools do indeed have a fundamental role to play in society, in showing the way forward, by modelling environments where all – not just a few privileged art students – can develop their creative and imaginative faculties.

The ethos of traditional art schools, where students can grow in a sympathetic and creative environment and where imagination is encouraged, is in stark contrast to the oppressive and sterile atmosphere that can characterise many schools. Imagination in particular suffers in environments where easily quantifiable achievements are valued over those which are less tangible but nevertheless valuable. I would like to end this section with a quotation from Dan Nadaner that I feel is relevant here:

> *The imagination, like art, has value by virtue of its own unique character and the history of its functioning across human cultures. Education too, as schooling, has its own character (image: a typical classroom), but it is hard to see it functioning very well without the exercise of the imagination. The imagination makes thought more personal and gives the individual a more authentic kind of participation in his or her environment. Personal images of feelings and problems might stand up well to the totality and impenetrability of media images, but they need a chance to be developed first, and to make this possible the educational system has much work to do* [46].

Concluding remarks for Section Three

In this section I have examined briefly the major topics that arose from the accounts that made up Section Two. Two main strands have emerged: the nature of artistic learning and the place of schools in accommodating this. In this section I have discussed the nature of the artistic personality and how this develops. I noted that there is no identified artistic intelligence and that this is because of the diverse nature of both art and its practitioners. In practice, the artistic personality draws upon a range of intelligences, in particular spatial and naturalistic intelligence, but the diverse and complex nature of art allows the full range of learning dispositions to be accommodated. I put forward the notion that we as humans have a fundamental urge to create aesthetic significance and that this can be given a focus through art-making.

Some concepts that have become associated with art-making were examined in this section, such as imagination and self-expression. I asserted that imagination involves thought that is not simply fantasy but the actual construction of new realities. Further to this, I put forward the idea that *authentic* self-expression entails genuine individualised responses to learning. In order to be authentically self-expressive, students need to be secure in their sense of self but while self-esteem and a sense of achievement are said to be raised through engagement in arts activities, most schools are not well suited to this. In particular, creative behaviour, which is encouraged by many art teachers who often try to encourage and facilitate creativity, does not fit well within the structures and systems which typify schools.

It would appear that in order to encourage creative growth the general

learning environment should be based on practice found in successful art rooms. By 'successful' I do not refer to the number of high grades attained in formal examinations but to the less easily measurable achievements of happiness and sense of self. The next section outlines a case for seeing art activities as essential aspects of human nature and for a learner-centred approach to learning in art that has at its heart the happiness of the individual learner.

Notes and references for Section Three

[1] Brown, D.E. (1991) *Universals*. New York: McGraw-Hill.

[2] Pinker, S. (2002) *The Blank Slate – The Modern Denial of Human Nature*. London: Penguin.

[3] Dupre, John. 'On Human Nature'. humanaffairs.sk/dupre.pdf, accessed 10 July 2004.

[4] Gardner, H. (1999) *Intelligence Reframed: Multiple Intelligences for the 21st Century*. New York: Basic Books. See p. 109.

[5] Gardner, H. (1983) *Frames of Mind: The Theory of Multiple Intelligences*. New York: Basic Books.

[6] Lowenfeld, V. (1947) *Creative and Mental Growth*. New York: Macmillan.

[7] Kolb, D. (1984) *Experiential Learning*. Englewood Cliffs: Prentice-Hall.

[8] Gardner (1999) op. cit. p. 84.

[9] For example: Barbe, W.B. and Swassing, R.H. (1979) *Teaching Through Modality Strengths: Concepts and Practices*. Columbus, OH: Zaner-Blosser.

[10] Gardner (1999) op. cit. p. 85.

[11] Kemp, A. (1996) *The Musical Temperament: Psychology and Personality of Musicians*. Oxford: Oxford University Press. See p. 66.

[12] Walling, D.R. (2000) *Rethinking How Art is Taught: A Critical Convergence*. Thousand Oaks, CA: Corwin. See p. 25.

[13] The quotation is from p. 690 of Giroux, H. (1996) 'Towards a Postmodern Pedagogy', in L. Cahoone (ed.). *From Modernism to Post Modernism: An Anthology*. Cambridge, MA: Blackwell.

[14] See, for example, Finney, J., R. Hickman, M. Morrison, B. Nicholl and J. Ruddock (2005) *Rebuilding Pupils' Engagement through the Arts*. Cambridge: Pearson.

[15] Hickman, R. (2003) 'The Role of Art and Design in Citizenship Education', in L. Burgess and N. Addison (eds.) *Issues in Art & Design Education*. London: RoutledgeFalmer.

[16] Walling, D.R. (2000) op. cit. p. 15.

[17] Greene, M. (1995) *Releasing the Imagination*. San Fransisco: Jossey-Bass, p.3.

[18] Bonnett, M. (1994) *Children's Thinking*. London: Cassell, p.110.

[19] Atkinson, D. (2002) *Art in Education: Identity and Practice.* London: Kluwer Academic Publishers. Atkinson cites Matthews: Matthews, J. (1999) *The Art of Childhood and Adolescence*. London: Falmer.

[20] Hargreaves, D.H. (1983) 'The Teaching of Art and the Art of Teaching', in M. Hammersley and A. Hargreaves (eds.) *Curriculum Practice: Some Sociological Case Studies.* London: Falmer, p.131.

[21] Sikes, Patricia J. (1987) 'A Kind of Oasis: Art Rooms and Art Teachers in Secondary Schools' in Tickle, L., (ed.) (1987) *The Arts in Education – Some Research Studies.* Beckenham: Croom Helm Ltd., p. 143.

[22] ibid. p. 162.

[23] Harland, J., K. Kinder, P. Lord, A. Stott, I. Schagen, J. Haynes with L. Cusworth, R. White and R. Paola (2000) *Arts Education in Secondary Schools: Effects and Effectiveness*. Slough, Berks: NFER. The evidence for their project was gained through four main programmes of data collection: in-depth case studies of five secondary schools; secondary data analysis of information gained from NFER's 'Quantitative Analysis for Self-Evaluation' project (QUASE); a year eleven survey of pupils and schools; interviews with employers and employees. The quotation is from p. 158.

[24] Steinhart, P. (2004) *The Undressed Art – Why We Draw.* New York: Alfred A. Knopf; p. 153.

[25] DFEE (1999) *All Our Futures: Creativity, Culture and Education*. A Report by the National Advisory Committee on Creative and Cultural Education [the NACCCE report]. Sudbury: DFEE publications.

[26] The review looked at six different personality traits (e.g. 'openness to experience' and 'nonconformity') among 118 different empirical studies. Feist, G. (1999) 'The Influence of Personality on Artistic and Scientific Creativity', in R. Sternberg (ed.) *Handbook of Creativity*. Cambridge: Cambridge University Press. The quotation is from p. 279.

[27] Gardner (1999) op. cit. p. 119.

[28] Tay Eng Soon (1989) Dialogue Session, reported in *Commentary* 8, (1 and 2), p. 26.

[29] Csikszentmilhalyi, M. (1996) *Creativity: Flow and the Psychology of Discovery and Invention*. New York: HarperCollins, p.11.

[30] Ree H. (1981) 'Education and the Arts: Are Schools the Enemy?' in M. Ross (ed.) *The Aesthetic Imperative*. Oxford: Pergamon. The quotation is from p. 93.

[31] Greene, Tom (2004, March 4) 'School sucks. The reason? Textbooks.' [Letter to the editor]. *The Independent*, comment page.

[32] Hopewell, Michelle. 'Boredom Sucks' (2004, March 11) [Letter to the editor]. *The Independent*, comment page.

[33] Kolasinkski, J. (2004, August 27) 'OFSTED's Silent Witness'. *The Times Educational Supplement*.

[34] Eisner, E. (2002). *The Arts and the Creation of Mind*. London: Yale University Press. See p. xiii.

[35] ibid.

[36] Hickman, R. (2001) 'Art Rooms and Art Teaching', in *Art Education,* January 2001, pp. 6-11.

[37] Tallack, M. (2000). 'Critical Studies: Values at the Heart of Education?' in R. Hickman (ed.) *Art Education 11-18: Meaning, Purpose and Direction*. London: Continuum. See also Sikes (1987), op. cit.

[38] Read, H. (1943) *Education Through Art*. London: Faber and Faber. p. 292. See also p. 11 for Read's view on the removal of physical barriers, which he saw as a metaphor for psychological barriers.

[39] Fardell, J. (2004) 'Desert Island Teacher', in *Viz* 141 (December 2004) p. 43.

[40] Proulx, E.A. (1993) *The Shipping News*. London: Fourth Estate. The quotations are from pp. 234 and 262. This award-winning novel has also been made into a highly acclaimed film of the same name.

[41] Glyn Brown, 'Super Slacker'. Interview of the winner of BBC's 'Fame Academy', Alex Parks.*The Independent Magazine,* 7 February 2004, p. 24.

[42] Greene, M. (1995) *Releasing the Imagination*. San Fransisco: Jossey-Bass, p. 5.

[43] Ree, H. (1981) op. cit. p. 99. Regarding Ree's reference to the etymology of the word 'school', we have here a wonderful opportunity for pedantry: in Greek, the word skol*i* (emphasis on the last syllable) means school, while sk*o*li (emphasis on the second syllable) means leisure, while skolianos can mean

both holiday and, perversely, to be sharply criticised.

[44] William Morris' famous line in full is: 'millions of those who now sit in darkness will be enlightened by an art made by the people and for the people, a joy to the maker and the user'. It was the flourishing end to an address entitled 'The Beauty of Life', delivered to the Birmingham School of Arts and School of Design on 19 February 1880. It was later published in a collection of essays under the title *Hopes and Fears for Art*.

[45] Ascott, R. (2004) 'Why I think the role of art schools is less clear now than in the 1960s', in *The Times Higher Education Supplement*, 18 June 2004, p.14.

[46] Nadaner, D. (1988) 'Visual Imagery, Imagination and Education', in K. Egan and D. Nadaner (eds.) *Imagination across the Curriculum*. Milton Keynes: Open University Press. The quotation is from p. 206.

Concluding chapter

Introduction

In this section, following on from the discussion in Section Three on whether artists are born or made, I discuss the notion of art as a fundamental human urge and review work done by psychologists on the nature of concepts and their acquisition.

In reconsidering the kind of schools that would facilitate learning in art, I put forward a developmental learner-centred approach, with an emphasis upon practical work. I advocate a curriculum that fosters individual differences and encourages expression and heuristic learning, while highlighting the need for teachers to coach and instruct in studio skills in an environment that is conducive to creativity and where students have a voice. The nature of the assessment process in such an environment is considered. In celebrating the success and achievements of the many thousands of art teachers in creating fertile environments for learning and growth, I advocate a remodelling of schools and schooling along the lines of the successful art room.

Art as a fundamental human urge

Claims about 'fundamentality' and 'human nature' have often been met with extreme resilience, particularly by western academics in the post-war years. In the light of new discoveries about human genetic makeup and access to advanced statistical analysis, such resistance is being thwarted. At the forefront of those who advocate a rejection of the 'blank slate' conception of human nature is the popular author and academic Steven Pinker. Pinker draws upon a number of established authorities, including those on the 'liberal left' to underscore his argument for the principal factors in determining human behaviour being inherited rather than cultural; in doing so, he goes gleefully against the grain of the received wisdom prevalent in academic circles. Among those cited is Noam Chomsky, who believes that humans are innately endowed with a drive for 'creative free expression' [1]. In advocating a biological rather than a socially constructed conception of art, Pinker cites the philosopher Denis Dutton's list of seven 'universal signatures' that can be associated with art [2]. The first of these is skill (in the use of media to represent the world or express ideas and feelings) which is universally admired; this can be related to other 'universal signatures', such as the existence of stylistic rules for art forms and art forms that provide a special focus for attention, appreciation and

interpretation. Other universal signatures, to continue with Dutton's term, include the faculty of imagination and the human capacity for pleasure for its own sake. As a simple list, Dutton's universal signatures with regard to art are:

- Technical artistic skill
- Non-utilitarian pleasure
- Stylistic rules
- Appreciation and interpretation
- Imitation
- Special focus
- Imagination

There are, of course, several areas where people might disagree with a list such as this. Any claim to 'universality' is bound to be met with scepticism, especially by other experts; an obvious one to people working in the art world is the notion of 'imitation' having anything to do with art as it is currently conceived. Others might well argue that while acknowledging that 'imitationalism' as a theory of art is a cultural construct, the studied avoidance of it is a wilful, perhaps perverse denial of what has been a feature of human culture for millennia. Elsewhere, Dutton asserts that art forms are found everywhere, regardless of culture, and that its 'very universality . . . strongly suggests that it is connected with ancient psychological adaptations' [3]. By this he means adaptations from an evolutionary perspective, that is, developments that have become incorporated into the very essence of humanity. Dutton draws attention to the crucial factor in determining evolutionary adaptation being our preferences and dislikes. Dieticians remind us that our liking for sweet and fatty food can be traced back to our early ancestors when such foods were essential for survival; similarly, our revulsion of tainted food ensured an avoidance of disease. Dutton notes that characteristics associated with art-making can be expressed in the same way, such as our aesthetic responses to the environment – the aesthetic enjoyment of certain forms is also said to be a universal in particular living things [4].

I noted in Section Three that Howard Gardner, in his original book of 1983, identified seven discrete kinds of intelligence and subsequent to this he has added an eighth – 'naturalistic intelligence'. This particular intelligence appears to be strongly associated with creative responses to the environment. Peter Steinhart, in his book *The Undressed Art*, draws attention to the commonalities between artists, particularly those who draw, and naturalists:

They are both servants of their eyes. A naturalist learns to look intently at things, to listen to them, smell them, touch them, to wonder what they are made of, what they do, how they are like or not like each other, what they mean. I

was fascinated with birds, not with their miraculous ability to fly, but by the combination of their liveliness and accessibility on one hand and their precise and complicated detail on the other. Watching such things forces one also to wonder about their comings and goings and purposes in the world; to consider what is revealed and what is hidden and how the two accommodate each other. It seems to me now much like what an artist does, looking for form and line and color and texture to define the relationship between spirit and substance [5].

He goes on to say that one draws chiefly to advance one's understanding and that a drawing is a picture of that understanding. Steinhart puts forward the notion that the 'visualizing' which is an integral part of drawing, and which is a private activity involving the imagination, is a mode of thinking that has evolved alongside speech; he asserts that our ability to make mental images and to hold ideas in the form of symbols increases our ability to record and manipulate experience. An opposing view might be that all thought is linguistically based and that language determines perception – this is discussed below.

Concept learning re-visited

The tripartite nature of concepts described in Section One refers to what might be termed socially defined concepts. Vygotsky referred to these as 'scientific' concepts and differentiated them from 'spontaneous' pre-verbal concepts. Some researchers, looking into the cognitive development of hearing-impaired children have concluded that language facilitates intellectual development, providing readymade symbols that help to crystallise and focus thought [6]. It would seem that the formation of spontaneous concepts is not entirely dependent upon language but the attainment of 'scientific' concepts is closely associated with language development, as such concepts are often defined by cultural convention; 'scientific' concepts are developed in a particular cultural context and are conveyed verbally. Language and thought are interrelated but the part which visualisation of images plays is not clear-cut. There is no doubt that language influences cognitive development; for example, unfamiliar words can stimulate enquiry into their meanings, and dialogue in a learning context serves to direct and focus intellect. I would suggest that in addition to this, images and even feelings have a key role to play in the development of understanding.

Vygotsky maintained that thought has its own structure, and that, unlike words, does not consist of separate units. Words, however, in the form of 'inner speech', serve to orientate us mentally and are 'intimately and usefully connected' with thinking [7]. Vygotsky's work concentrated upon the social and cultural factors that might determine cognitive development; in this respect it differs from Piaget's. This is an important shift of emphasis as far as teachers

are concerned because the learning potential of students is considered rather than the learning status. What is missing in much of the learning and teaching that occurs in schools, however, is an acknowledgement of the importance, or even existence of, intuitive understanding and tacit knowing.

Assuming that language has an effect upon the way in which concepts are developed, it seems appropriate to ask whether the type of language spoken determines the nature of the concepts. This kind of question is addressed through the notion of linguistic determinism and linguistic relativity, encapsulated in what has become known as the 'Whorfian Hypothesis', after the linguist Benjamin Lee Whorf. Linguistic determinism refers to the idea that language determines cognition, while linguistic relativity refers to the idea that the determinism is relative to the particular language spoken. As a result of his investigations into Native American languages, Whorf concluded that his difficulty in finding direct translations from these languages into English was due to the fact that the world is conceived differently according to the structure of the language; moreover, the structure of the language is a cause of these different ways of conceiving and perceiving the world [8]. Whorf asserted that there is a tacit but obligatory agreement amongst speakers of the same language regarding the nature of reality and how the world is organised and classified. There are 'strong' and 'weak' versions of the Whorfian Hypothesis: the strong form holds that the language determines thought, while the weak form holds that the language may influence thought. The weaker form of the hypothesis appears to be more readily accepted among researchers in the field. Other research [9] has shown that the ease with which a colour can be labelled influences later recognition of it. Some cultures (such as that of the Hopi group of Native Americans studied by Whorf) pay greater attention to certain colour variations than others and this is reflected in their language. The notion that discrimination among colours is facilitated by colour labels is of interest in the context of art education, as it suggests that language can help students attend to certain visual attributes of an artwork.

The relationship between perception, cognition and language is an intriguing one; clearly, there is a relationship but the extent and nature of it is still open to debate. Concept labels in the form of words facilitate perceptual discrimination and help give form and focus to concepts. While language can often crystallise perception, by helping us to focus our attention, my own view is that aesthetic perception bypasses language; pure abstract thought is in my experience characteristic of both the art-making process and an intense engagement with aesthetic form. This is related to what we might call 'intuition', which I believe to be based largely on heightened perception: the connoisseur can distinguish things that appear the same but differ only in minute detail which are perceived almost instantly without recourse to language. This facility was referred to, perhaps somewhat disparagingly, by the

late Professor Brian Allison as 'whippet-fancying' but there is no doubt that such tacit knowledge exists and that it is employed as a matter of course among artists. An artist knows when an artwork is complete, when it 'feels right' – judgements such as this are made on the basis of juggling with perceptually acquired pre-verbal spontaneous concepts. We might not know the name of a colour but subliminally perceive it to be the exact hue to give an artwork formal coherence. However, in terms of learning, which is essentially a social activity in schools, verbal communication is crucial and can aid perception: if we can identify and name 'alizarin crimson' and 'madder carmine' for example, we are more likely to be able to perceive and differentiate them.

I have discussed the part that concepts play in art-making at some length because I want to draw attention to the fact that while art-making is a cognitive process it is not, or at least not entirely, dependent upon language and is something that is para-linguistic and therefore para-cultural. While divorcing art-making from linguistically based notions of cognition, I am affirming the central role of thinking in the creative process. What is being reasserted here is the central and singular role that creative activity (in the form of art-making) plays in human development.

To underline my conviction that aspects of behaviour that are associated with art-making have a biological rather than a purely cultural foundation, I point also to the fact that humans have a strong interest in creating narratives and an enjoyment of problem-solving – as exemplified in an obvious way by the popularity of puzzle magazines. There is also, of course, our abiding appreciation of made objects that demonstrate virtuosity. The appreciation of technical skill is pan-cultural; only the criteria for judgement differ between cultures.

The term 'creating aesthetic significance', introduced in Section Three, and the concept of this being a fundamental human trait is one that I have been considering for some time and I was gratified to find Ellen Dissanayake's term 'making special', which refers to a similar concept [10]. Dissayanake, like Dutton, refers to the fact that all human (and for that matter, animal) characteristics that are necessary for the continuation of the species are in some way enjoyable; this is my base line – that art-making is a natural human characteristic that has evolved as a result of nothing less than its importance in the preservation of the species. Dissayanake argues that art, or at least making special, is a fundamental evolutionary adaptation, such as fear of heights. Pinker, however, believes that art is a by-product of three other adaptations, namely the hunger for status, the aesthetic pleasure of experiencing adaptive environments and the ability to design artefacts to achieve desired ends [11]. Both views, of course, maintain that art is an essential part of human makeup.

It is clear from the accounts presented in Section Two that the personal nature of art-making activity is valued – it is important to individuals. So how

does an argument that is based on a consideration of the whole of the species impinge upon the activities of individual representatives of that species? Individual artists, who place their work in the public domain, are often concerned with universal themes, such as sex and death; but artists are not unique in this respect. It is commonplace for those traumatised by death or in anguish over love to compose poetry or in some way create something of aesthetic significance. The significance is, however, to the individual; the act of creating in these circumstances is usually private, there is no intention to put the poem, drawing or whatever into the public realm. I can best illustrate one aspect of this argument from immediate personal experience: During this period of writing, I decided to take a short break and go for a walk and explore a nearby mountain stream. After some time I came upon several small waterfalls and became fascinated with the play of light on the rocks and vegetation. I also saw threads of gossamer caught by the sun and shining bright turquoise, and some moss a brilliant golden-green. I had a real urge to capture this special place and, strangely, as I am no poet, felt compelled to describe the scene poetically, using extravagant descriptive language which, were I to relate this, would simply be a string of clichés. I felt no urge to share the scene through art or poetry but wanted simply to respond to it – to confer upon it some 'specialness' and to celebrate its existence and my aesthetic response to it. A dog, which was following me, responded to the place in the usual way, marking some territory; I had no desire to own the area, nor to capitalise upon it in any 'practical' way. My natural response was not to mark my territory but to celebrate my aesthetic experience by creating something that was significant to me – a poem, a song, a painting. It is in this respect that art is a necessity for human life. art-making responds to and reflects something other than itself that makes that life worth living. There are several themes that recur throughout human beings' pictorial history; in addition to this there are what I would consider to be universal concerns, one of which is beauty. The opening lines of Elaine Scarry's book *On Beauty* are apposite here:

> *What is the felt experience of cognition at the moment one stands in the presence of a beautiful boy or flower or bird? It seems to incite, even to require, the act of replication. Wittgenstein says that when the eye sees something beautiful, the hand wants to draw it.*
>
> *Beauty brings copies of itself into being. It makes us draw it, take photographs of it, or describe it to other people. Sometimes it gives rise to exact replication and at other times to resemblances and still other times to things whose connection to the original site of inspiration is unrecognizable* [12].

Here we can see an example of two aspects of human creativity that have

been sidelined since the rise of modernism: beauty and imitation. I suspect that the basic human desire to imitate and to relate to certain forms, colours and structures in a positive way will outlive the tenets of modernism and post-modernism. It seems to me perverse to deny that certain forms and colours, such as those found in nature, are universally admired. Such denials seem to be expounded in order to uphold an exaggerated notion of the importance of culture in determining human preferences and predispositions in art. As with appreciation of technical skill, appreciation of beauty, as a concept, is universal, while the criteria for judging what is beautiful are culturally determined.

The concept of art is less stable than many other concepts, as it is intrinsically bound up with the concepts of 'culture' and 'society' which themselves refer to amorphous and dynamic phenomena; it is not surprising therefore that both the concept and the practices of art are said to be culturally determined. June McFee saw art and culture as being dependent upon each other, in a kind of symbiotic relationship:

Art objectifies, enhances, differentiates, organises, communicates and gives continuity to culture. Culture gives art meaning and structure [13].

McFee argued that for art to be appreciated, it is necessary to understand the cultural criteria that 'brought it into being and that sanction it as an art form'; further to this, she stated that 'culture is maintained, transmitted and changed through art' and that one can come to appreciate a culture by understanding its art [14]. There are no conflicts apparent to me between McFee's anthropologically based notions as to the functions of art and the notion that art-making, or at least creating aesthetic significance, is innate.

It seems reasonable to claim that art cannot be understood outside human culture. As I have already suggested, the concept of art lies within people's minds; it does not reside within what people might call art objects. More fundamentally, to understand art or to know art we need to go further than understanding the culture from which it arose and identify art as an essential human, indeed biological, trait. In this respect, like Dissanayake, I am subscribing to what I call an 'essentialist' approach to understanding the place of art in human endeavour, that is, seeing art-making as a naturally occurring behaviour. If we see creating aesthetic significance – engaging in artistic activities – as an essential component of what it means to be human, then those of us who are not actively engaged in some kind of creative activity are not fulfilling our basic human needs, nor are we achieving our potential as individuals. If we follow a Darwinian line, we could also say that art-making behaviours are selected for because they lead to technological innovation, something that clearly distinguishes us from dogs. However, 'Darwinian' has too many other associations and so I am using the term 'essentialist' to convey

the idea that art-making (or at least creating aesthetic significance) is a human activity that is essential for health and ultimately the survival of the species. To quote Dutton:

> *If survival in life is a matter of dealing with an often inhospitable universe, and dealing with members of our own species, both friendly and unfriendly, there would be general benefit to be derived from imaginatively exercising the mind in order to prepare it for our next challenge. Puzzle-solving of all kinds, thinking through imagined alternative strategies to meet difficulties – these are at the heart of what the arts allow us to do* [15].

While I am arguing that creating significance through art-making is a fundamental human urge, I would also state that we need the right conditions for this 'urge' to be fulfilled in a way that benefits both the individual and society as a whole.

The art curriculum

If we take an essentialist view of art, then it seems reasonable to expect society to establish structures wherein people can engage in artistic activities and be coached in how to acquire, develop and refine making skills. The logical places for these kinds of activities are schools but not, as I have argued, as most are conceived at present.

Organising a curriculum that facilitates progression and growth makes perfect sense, as long as learners are not held back because they happen to be in a certain age group. If progression and growth in art does indeed involve acquiring, developing and refining practical studio skills, then it seems odd that much of the literature on artistic development contains no clear reference to art-making; the emphasis is upon responding to and appreciating artworks. It is not surprising, therefore, that much debate has been generated around basic issues such as the nature of the 'art' which is to be the focus of attention. It seems to me that both the post-modern and the western 'canonical' camps have forgotten, in their eagerness to defend a particular view of art and the place of art in society, the simple fact that people make art and that they have a natural desire to create aesthetic significance.

Debate about the kind of art (or whatever) that should be the focus of our attention should be secondary to concern for making. It seems that the interesting little fledgling known as critical studies has become the cuckoo in the nest [16]. This is not to say that there is no place for critical and contextual studies in art education; indeed, there is an urgent need for meaningful aesthetic appreciation to be an integral part of art education. I have often defended the notion that the study of art should be engaged in alongside the making of art. In some cases, on the basis that all people are consumers of art

craft and design but few are practising makers, I have even argued that knowledge and understanding of art, craft and design should take precedence over its production. After all, even a dog or a monkey can 'make' but only humans (appear to) have the capacity to understand the nature of that which is made (as an aside, dogs and monkeys can be trained, but only humans can [or appear to] be educated; it is not surprising that governments, ever mindful of the power of education, insist on referring to teacher training). However, I can all too easily imagine the glee with which budget holders greet the notion that art, craft and design can be taught without resort to messy and expensive materials and specialist equipment. Of course, making and understanding the process of making, as well as knowing about and understanding others' making, is part of a balanced education; we should not have one without the other. But if we take what I have termed an essentialist view, then it becomes clear that the physical act of production is fundamentally more important than appreciation – appreciation being in this instance shorthand for knowing about, understanding and being able to criticise, in an informed way, the various forms that the made world can take. Nevertheless, in the same way that all people have the potential to create, they have also the potential for aesthetic experience, in much the same way as, say, language. Aesthetic experience generates art; the urge to create aesthetic significance – to make art – is often in response to the specialness or significance of an experienced event. Such special events can, but need not be, elicited by art objects. If we want young people to be inspired into being creative, they should be encouraged to go to nightclubs or day trips to the coast rather than art galleries, as these are likely to be more relevant to the lives of young people than painting a pastiche of an image from the 19th century.

In the early 1980s I worked as a Senior Examiner for one of the English examination boards. One of my tasks was to set 'questions' for the painting examination. A particularly successful one at the time (in that it was very popular) was based on the idea of designing an item of clothing for a well-known artist (e.g. a tie for Van Gogh or a waistcoat for Matisse). Since then, some 20 years later, I am still seeing variations on that theme – all with depressingly predictable results and all confirming the established canon of 'famous painters'.

Maxine Greene talks of the need for people to be given opportunities to explore a range of media through practical making activities. People, she said:

> can be enabled to realize that one way of finding out what they are seeing, feeling, and imagining is to transmute it into some kind of content and to give that content form. Doing so, they may experience all sorts of sensuous openings. They may unexpectedly perceive patterns and structures they never knew existed in the surrounding world. They may discover all sorts of new perspectives as the curtains of inattentiveness pull apart. They may recognize

some of the ways in which consciousnesses touch and refract and engage with one another, the ways in which particular consciousnesses reach out and grasp the appearances of things [17].

She defines 'aesthetic education' as being concerned with fostering 'increasingly informed and involved encounters with art' and insists that it has its part to play in 'art education'. By 'aesthetic education', she means 'art appreciation', while her use of the term 'art education' refers to studio practice. She maintains that, as a means of stimulating the imaginative and perceptual faculties, making and appreciating are symbiotic:

We are fully present to art when we understand what is there to be noticed in the work at hand, release our imaginations to create orders in the field of what is perceived, and allow our feelings to inform and illuminate what is there to be realized. I would like to see one pedagogy that empowers students to create informing the pedagogy that empowers them to attend (and, perhaps, appreciate) and vice versa [18].

This sounds reasonable enough and I have some sympathy with this 'symbiotic' view. John Steers has warned, however, of taking for granted the notion that theory should always inform practice. Steers has characterised the work that comes out of school art rooms as often being 'formulaic, in subject, style and concept', based on a combination of working from observation and assessment-led 'domain-based' conceptions of the art curriculum [19]. He highlights the insular nature of school art and its lack of reference to, or relationship with, contemporary art and design activities, and asserts the need for art in schools to be concerned with real personal and social issues. While the notion that contemporary art and design activities are concerned with 'real personal and social issues' rather than with the vagaries of the art world is debateable, the principal argument that Steers is making is that art activities in schools should be meaningful, worthwhile and of relevance to the students. He makes the serious and profound point that the basis for art and design activities in schools

should be what it has always been – what it is to be human. The universal themes of birth, death, love, war, gender, disease, spirituality and identity can be re-examined in the context of our rich and varied post-modern, post-colonial, multi-ethnic and multi-faith society [20].

If we are concerned with inducting young people into the world of art with all of its manifold guises, then we should develop curricula that draw upon a range of visual forms from diverse cultures. But here is the problem: even if we

chose to focus upon, for all the years of compulsory schooling, just one art movement – let us say, that perennial favourite, impressionism – even then we could not do the subject justice in terms of contextual and critical study. So what about the rest of western art history? The art of ancient cultures from different parts of the globe? Contemporary art forms? Sculpture, architecture, textiles, photography, ceramics, graphic design? It is clear that there is not enough time in the school day (as it is currently conceived) to cover even a tiny fraction of what is out there; moreover, the issue as to what is selected is fraught with political and ideological difficulties. Are we asking too much of art teachers to be (in addition to studio practitioners) historians, aestheticians, sociologists and anthropologists?

There are three ways in which these problems can be dealt with. First, there needs to be clarity of aims for the teaching of art. These aims should, in my view, be concerned with addressing the fundamental need to create aesthetic significance – to make. They should be directly concerned with facilitating imaginative and expressive activities and with the acquisition of the necessary practical and conceptual skills. These aims are foremost, with the 'discipline' of art as a subject of study being incidental. Second, learning about art should be introduced progressively and incrementally – note that Greene talks about '*increasingly* informed and involved encounters' [my emphasis]. Third, we should be concerned with encouraging people to develop their own research and learning strategies and give them direction in criticism, so that they choose for themselves the visual forms which are to be the focus for their attention.

Art has different 'functions' at different stages of life: during early years, I would suggest that self-expression figures prominently; during adolescence, self-esteem and identity take priority, while at other stages in life, therapy and the desire to explore fundamental truths might take precedence. It is clear to me that different stages in life require different kinds of teaching. Reference to the developmental model described in Section One (see in particular Table 2) is relevant here. I have suggested that during the earliest stage, children are given guidance and instruction in the handling of materials and various media – from holding a crayon to (for example) intaglio printing – they are in other words actually taught. To some, this might seem obvious but we have several generations now of people who have not been taught how to draw well – how to express themselves in graphic form in a way that reflects what they want to express. The notion that inducting children into 'adult' conceptions of representational drawing is somehow undemocratic or is not taking into account the child's own symbol systems is misconstrued. Children and other learners get frustrated by not being able to represent what they see and, for that matter, what they feel; a truly learner-centred approach would not simply leave them to it, to work at their own pace, but would gradually induct, guide and support them. The second stage, which is concerned with perceptual training, is when drawing from observation comes to the fore.

On drawing

Learning how to do representational drawing has a long and distinguished place in education but fell out of favour in the post-war era of so-called 'free expression'; this is ironic as one of the very early exponents of child-centred education was Pestalozzi (born in Zurich in 1746), who gave prominence, in his progressive vision of education, to drawing – especially from observation, insisting that instruction must be based upon the learner's own experience:

> *A person who is in the habit of drawing, especially from nature, will easily perceive many circumstances which are commonly overlooked, and will form a much more correct impression even of such objects as he does not stop to examine minutely, than one who has never been taught to look upon what he sees with an intention of reproducing a likeness of it. The attention to the exact shape of the whole and the proportion of the parts, which is requisite for the taking of an adequate sketch, is converted into a habit, and becomes productive of both instruction and amusement* [21].

Pestalozzi is seen in this quotation to be highlighting the importance of perceptual education but it goes beyond that. Drawing helps us to think. It is well known, at least among educationalists, that teachers should encourage their students to talk themselves into understanding; the same can be said of drawing. Some commentators, notably Betty Edwards in her book *Drawing on the Right Side of the Brain*, have drawn attention to the different areas of the brain: the right hemisphere being spatially oriented and the left being linguistically oriented [22]. Edwards emphasises perception over knowledge, using exercises that, for example, focus on negative space for which the brain has no name, thus allowing percepts to remain uncluttered by concepts. However, the brain is far more complex than such a view implies and drawing requires a range of skills that draw upon different brain functions – storing and retrieving information, distinguishing figure from ground, refining psychomotor coordination etc. It is likely that there is some interplay between the hemispheres, with the left dealing with detail and the right with the whole; a skilled draughtsperson will have developed the connections between the two hemispheres rather than have simply developed the non-verbal 'artistic' right side. There is no doubt that some success is achieved by using Edwards' methods but there is more to drawing than simply being able to represent what one sees in a convincing way. Being 'able to draw' usually refers to the ability to accurately represent three dimensions on paper, with due regard to the western convention of linear perspective. This is one definition. The haptic drawer would no doubt be more satisfied with a drawing where expression dominated over 'accuracy'; the architect, using another drawing system – perhaps axonometric rather than linear perspective – would probably eschew expressive

considcrations altogether. Drawing fulfils different functions for different people in a range of different situations; what is important is that young people have the opportunity to develop their drawing ability and in so doing improve the quality of their thinking. Louis Arnaud Reid remarks that drawing:

improves the quality of observation and understanding. It teaches children to analyse objects: drawing can be involved with understanding one's feelings about things; it can be a means of re-organising ideas and responses, or of transforming them into new images. All this is very true and very important. Along with it can go spontaneity and joy of expression, altogether good; and anything that interferes with it, destructive [23].

Skill in drawing, however, is not simply acquired through maturation. The 'spontaneity and joy of expression' to which Reid refers can best be achieved when efforts are not frustrated through lack of skill and know-how. The necessary skill and know-how need to be taught. When people have learnt how to work effectively with art materials, they are then in a better position to explore the expressive potential of those materials and in doing so can gain a greater sense of self. At this point they can, through dialogue, be introduced to the range of visual forms (paintings, comic strips, architecture . . .) that might be of interest to them and be given the critical tools to be able to engage with and understand those visual forms; practical skills can then be refined in the light of this engagement with others' work.

The appreciation of visual form

I suspect that I am not alone in deriving pleasure from looking at things like chimney pots, flaking paint on doors and discarded items in the gutter. I should also add 'wasps rolling around drunk inside rotting apples', which I had observed while stealing apples from an orchard one year and was delighted to find that Thomas Hardy had noticed such things when I read *Return of the Native*. Louis Arnaud Reid draws attention to this aspect of visual education – that of noticing – by referring to one of Thomas Hardy's later poems:

When the Present has latched its postern behind my tremulous stay,
And the May moth flaps its glad green leaves like wings,
Delicate-filmed as new-spun silk, will the neighbours say
'He was a man who used to notice such things?' [24].

I put forward the notion that one of the aims for art education is, or ought to be, concerned with noticing. This is related to general aims relating to perceptual training and draws upon the facility described earlier within this section as 'naturalistic intelligence'. Visual education must surely concern itself

with drawing attention to the subtleties of the visual world, which includes the intriguing, the interesting, the arresting and the beautiful. I use the word 'beautiful' in the knowledge that it is considered by many to be passe, especially in a post-modern context where such things are considered undisputedly relative. However, as Clive Bell asserted, certain forms and relations of forms stir aesthetic emotions, and despite the apparent demise of formalism, there remains, I suspect, an appetite for traditional ideas of beauty and skill.

The problem for contemporary art education, as I have attempted to show, is that discredited ideas about 'the child as artist' and laissez-faire approaches to art teaching have been associated with modernism and, by further implication, Romanticism. Cherished beliefs about the importance of imagination and creative expression have consequently been downplayed in recent years in favour of more overtly 'cognitive' aspects of art-making and the contextual study of art. Most of the significant research and publications in art education are, as we have seen, concerned with engaging with, rather than producing, visual form.

Bancroft is one commentator who sees the relationship between some critical studies activities and practical work as problematic; the connections made between studio activity and the information given on 'art packs' particularly so:

A common practice is to relate activities, including practical artwork, to the subject matter of the image. This provides suggestions for students' engagement that descend to the random and the banal. What understanding can be gained when Uccello's 'St George and the Dragon' is reduced to such questions as 'What do dragons think about in their lonely, dark caves?' [25].

The issue raised here becomes redundant if art activities in schools are seen primarily in terms of developing imagination and facilitating expression. Bancroft's views can be seen to be set firmly within the 'learning about art' camp. If we see art activities, including engaging with art objects, as being worthwhile experiences in themselves, or taking a more instrumental view, as ways of stimulating our natural senses of curiosity and inventiveness, then conjecturing what dragons might think about is not as banal as it might appear. Further to this, I believe that one feature of creative behaviour is the ability to empathise. Asking people to put themselves into the place of another person, or in this case, a dragon, can facilitate 'empathetic understanding': a way of knowing intuitively about people and things outside of our own personal world.

Antony Gormley, who has achieved international recognition for his artwork, comments on Ucello's painting of *St George and the Dragon* in an interview, saying:

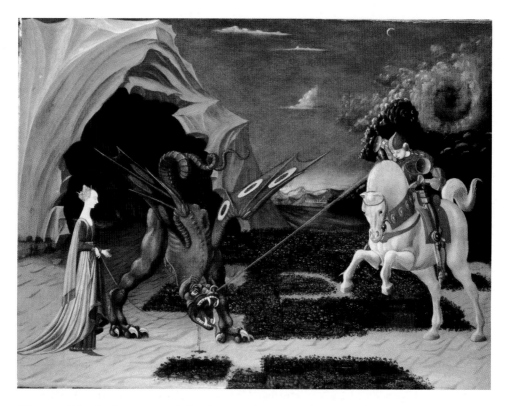

Figure 10: *St George and the Dragon* by Paolo Ucello, c. 1470. Oil on canvas, 55.6x74.2 cm (© National Gallery).

What in earth is going on here? Why is the young woman holding the dragon by a thread? Has St George got it wrong? Is he about to kill her beloved pet? The imagination of the viewer is sparked into relating the painting to personal memory and space. The liberation of creativity from the shackles of illustration and the declaration of the known is powerful fuel for the young mind. Ask them, 'What do you see, feel? What's the atmosphere? What does it smell like?' Open the doors further. Let them have space to listen to themselves, chart their own passage through visual experience. There's an enormous amount to be learned later about artists and the contexts the work comes from. First, be open, allow things to call across the space [26].

Here we can see the benefit of relating engagement with an artwork to students' own studio practice in a way that makes both meaningful to the learner. The appreciation of visual form in this way is not confined to those

objects that are deemed to be art. Such objects are made to be engaged with in this way, it is true, but scrap yards, demolition sites, shopping centres and amusement arcades also have much to offer. The cultural and social significance of such sites usually holds little fascination for the younger learner; I am talking here of the appreciation of formal relationships, in the same way as we learn to appreciate forms in nature – forms which young people often need to be shown and from which they derive pleasure. A focus upon visual culture from a post-modern perspective – looking at questions of power relationships, for example – is more appropriate for older students who have access to a range of specialist teachers. This is not to downplay the importance which adolescents attach to certain cultural forms but it is the job of the aesthetically aware adult to draw attention to aspects of the made and the natural environment which are in themselves intriguing, fascinating, curious and engaging.

To some the connection might seem tenuous but I feel that appreciation of visual form has a crucial part to play in citizenship. One way, perhaps the best way, to appreciate visual form is to create it and to develop empathy for materials. From very early in my own art education, I firmly believed in the social benefits of aesthetic education. I believed, for example, that if a person were visually trained and visually sensitive, then, for one thing, that person would not deface or pollute the environment (notwithstanding the value ascribed in some circles to 'graffiti art'). I am returning to that conviction and in doing so I am also resurrecting the notion of the civilizing effects of engaging with and making art. I say 'resurrecting' because the idea is very old, having its most eloquent expression in modern times in the work of Herbert Read, writing in the dark days of World War Two.

Assessing school art

I have been putting forward a case for art-making to be seen as a fundamental dimension of human life; I have also, in the light of my own experiences and those of my informants, painted a fairly grim picture of schools. At this point I want to look at something which is central to schooling and which has been a source of continuing frustration for many in the arts: assessment [27]. My ideas about the form and function of assessment have evolved in the past few years. In the past I was an advocate of formal assessment in art, for several reasons: it gave more status to the subject at a time when it was in need of it; it ensured that teachers had some idea about how well they were teaching; it helped learners know how well they were learning.

I intend to revisit some of the arguments of those who lost the battle against aspects of assessment in the arts and in doing so will criticise the trends which have occurred over the past two decades. My motivation for this was initiated by disquiet over the assessment system employed by some national examination boards in England. In the summer of 2001 I hosted an exhibition of examination

work for a 'special school'. The work was lively and varied and was a testament to the teaching skills of the art teacher concerned. The school students whose work was on show had a range of learning needs but had overcome many of their difficulties and had produced work which was well within the range of standards that would be expected for their age group. I was dismayed to learn, however, that they had been 'marked down' by the external assessor for the lack of written evidence of a knowledge and understanding of art. This was despite the obvious connections that had been made between certain artists' work (such as Rauschenberg and Matisse) and their own. I reflected upon this for some time and have come to the conclusion that it is not just the examination boards that are at fault here. They are, of course, responding to government directives but such directives (contrary to popular belief, perhaps) do not appear out of thin air.

There has been a steady shift in art education away from nurturing young people and facilitating their artistic and aesthetic development. This move has been towards scrutinising the products of young people's alleged learning in art and design, with an attendant emphasis on assessment and grading. Consequently, the kind of work that school students are increasingly expected to produce conforms to the requirements of a system which values work that is assessable.

The effect of examinations on perpetuating orthodoxies is well known among art teachers; I have no doubt that examination boards, regardless of their protestations to the contrary, reward 'safe' examination style school art [28]. The embryonic discipline of psychology provided a context for the notion of 'child art', where the child was seen as needing protection from adult influences. Such influences were seen as having the potential to pollute the children's imaginations and destroy each child's individuality. This context helped shape the development of movements in art, which in turn came to be associated with developments in art education. As the work of Marion Richardson [29] and other exponents of child art came to be equated with modernism in art, so the eclectic approaches to art education of the more recent past can be equated with post-modernism. Two notions that could be associated with the legacy of post-modern thinking and which impinge upon the assessment of art in schools are the beliefs that everyone can be an artist and that all visual phenomena are of equal worth. Although there is much that is problematic when these ideas are spelled out baldly in this way, they do offer some basis upon which one can develop a rationale for assessing the work which young people produce in art lessons.

I am focusing here on the assessment of students' development in art during their years at school, as opposed to assessing the value, worth or quality of art objects elsewhere. I am choosing my terms here carefully – at the outset I want to distinguish between assessing the objects that school students produce in

their school art lessons from any other kind of made objects. Louis Arnaud Reid cautions that we should not automatically label activities such as drawing, painting, potting, etc. as 'art'; if we accept this caution, as I do, then this clearly has implications for assessment practices. Assessment of art in schools is, at its best, assessment of items that look like art objects, as evidence of learning. I say 'at its best' meaning when the assessment is focused and judgement is uncluttered by other considerations such as aesthetic 'worth'. Confusion arises when teachers are simultaneously operating as if they were artists in studios, attempting to induct their students into the mysteries of art, while at the same time being teachers of art and design. As art teachers, they are normally expected to teach young people to know about and understand art in its various forms as well as teach them art skills and techniques. Teaching will necessarily entail assessing the extent to which the learners have learned these things, and by implication, the extent to which they as teachers have been successful. To do this the work produced by students in their art lessons needs to be viewed as evidence of the learning that has taken place. This, of course, has the potential to reduce the whole enterprise to a deadening, mechanical and joyless set of activities that have little to do with intuition, expression, vision and experimentation; words which I, for one, would normally associate with art.

Dennis Atkinson, commenting from a post-structuralist standpoint, makes the significant point that notions of ability 'do not refer to natural capacities but to ideological constructions' [30]. However, this does not preclude the existence of the kinds of developmental stages to which I have referred in Section One but it does highlight the issue of assessing children's work against adult norms, in particular conceptions of 'accuracy' in representation. Atkinson's vision of art teaching is encapsulated in his suggestion that we view art teaching

not as a transmission of ready-made knowledge and practice but rather as the creation of new conditions for learning [31].

If we take the view that 'anyone can be an artist' and that the potential to make art is an essential part of human makeup, then opportunities should be given which allow this potential to flower, so that each person can be fully human. Viewed from this point, that is of considering art-making to be a natural activity, to assess children's creative output in terms of a grade seems as bizarre as giving a gold star to a child for growing size eight feet. Moreover, in terms of being 'candidates for appreciation' [32], the visual items produced by children in school are all of equal worth – but this is turned on its head as soon as it is assessed and graded. This is not to say that learners do not need feedback; on the contrary, everyone values it but it must be couched in positive terms and not reduced to a simple grade.

There are many things that are un-assessable and those things should

perhaps remain un-assessed. Other people might reply that everything that exists exists in some quantity and can therefore be measured – I regard this assertion as irrelevant. Certainly, it would be possible to measure a rainbow [33] in terms of physics but to attempt to measure its aesthetic qualities or the level of aesthetic interest it generates is not just difficult, it is pointless. Elliot Eisner encapsulates this with an aphorism at the beginning of his chapter on the educational uses of assessment and evaluation in the arts in his book *The Arts and the Creation of Mind*: 'Not everything that matters can be measured, and not everything that is measured matters' [34].

John Finney, in writing about assessing what is important, comments that aesthetic learning needs to be:

experiential, physical, sensory, eventful, memorable and engage the whole personality of the learner. It will need to embrace the mysterious creative personality of the learner in making sense of feelings, attitudes, values and dispositions. If this is the case then, clearly, it is not appropriate to decide in advance what precisely will be learnt [35].

Finney here is referring to the pervasiveness of the 'objectives' model for teaching, whereby learning is pre-specified and criteria for assessment are linked directly to the stated objectives. In such a model, worthwhile learning that might emerge from a lesson is inevitably ignored; moreover, the identity of the learner as an individual is subsumed into the larger group. Some years ago I was conducting a workshop on assessment with student teachers of art. One of the tasks was to demonstrate a particular form of criterion referencing by comparing several different drawings against selected and graded standards [36]. One student refused to participate on the grounds that the exercise was destructive and left in tears. The student later wrote the following:

If teachers of arts are willing to undermine the value of individual response in this way, if they are not aware of the damaging effects such an activity can have on a child's confidence – who will be?

She continued, writing that assessing artwork in such a way was wrong because she 'knew it in [her] heart!' [37]. I know of some who upon hearing such an assertion would at first be puzzled and then reply: 'In which particular ventricle do you know this?' Although that student misinterpreted the point of the exercise, which was in part to show the inadequacies of such a method, a valid point was made. This particular attitude towards testing students' performance in art is encapsulated in the following quotation from Malcolm Ross:

A curriculum in the arts is, in the final analysis, a curriculum in love and in goodness, a curriculum in which freedom is not simply asserted but lived. What . . . are the tests of love, of goodness and of freedom?' [38].

If, as I have found, the most important aspects of art-making (at least for many young people and those actively concerned with art-making) are concerned with imagination, intuition, expression, how can these be assessed in any meaningful way? Indeed, it does not seem unreasonable to declare that they should not be assessed at all. However, evaluative feedback is necessary, so that students know how well they are doing; this occurs naturally in every learning situation where a teacher interacts in a positive way with learners. The important thing is to acknowledge that assessment needs to be negotiated. If criteria are considered to be necessary (to maintain 'standards'?) the community decides on criteria for assessment but we need to determine the size of the community. I would suggest that each learner's own criteria be used, which means that the community is a minimum of two people; the maximum being whatever practicable number the teacher and learner feel comfortable with. Essentially, the process should be formative and developmentally referenced [39], comparing students' present work with past performance and based on a portfolio of work, with the whole process being undertaken in a comfortable setting with familiar materials and cultural roles. The importance of individual development is taken up by Antony Gormley:

I loved the art room [at school] because the subject came out of me, not a book or an external monitoring system. It is about the evolution of the individual. The A and AS-level monitoring that goes on militates against expression and taking risks. Creativity and curiosity are at the centre of learning, and creativity is at the heart of a fulfilled life. It is weird that intelligence should be measured by the least intelligent method [40].

The added status which increased formal assessment via examination has given to art, together with a greater emphasis given to cognitive aspects, has been, for the most part, cautiously welcomed. However, the status afforded by formal assessment procedures such as public examinations is not worth the loss of the subject's heart and soul.

The art room as a model for schools and schooling

Students need to be treated as individuals and given a voice. Art activities, by their very nature, and especially when the focus is on expression and learning by discovery, facilitate individual learning and the development of identity. It follows, then, that those school art rooms that function well in this respect provide a fertile environment for facilitating growth. If we must have schools,

they should in my view be modelled on the best practice of successful art and design teachers.

Nel Noddings, who was (as Elliot Eisner currently is) a Lee Jacks Professor of Education at California's Stanford University, has put forward some interesting and worthwhile ideas in her book *Happiness and Education* [41]. She asserts that genuine dialogue rather than control should be a central feature of schools. She has, for example in her book *The Challenge to Care in Schools* [42], written about the development of structures in school that encourage caring relations. In particular, she decries the notion that curricula should be the same for everyone, regardless of individual differences. It is perhaps to be expected that curricula which are developed according to the needs of structures and systems rather than individuals would typically have to rely on coercion rather than cooperation in order to function successfully. Noddings highlights the absence of time in schools devoted to things that really matter to many adolescents: spiritual issues concerned with life and death, nature and religion. In *Happiness and Education* she maintains that happiness should be central to learning and that it is incumbent upon schools to facilitate happiness. She asks why the actual practice in schools is often clearly contradictory to their stated aims:

If, for example, we teach poetry in the hope that it will be a lifelong source of wisdom and delight, why do we bore students with endless analysis and an emphasis on technical vocabulary? Why do we tell children to do their best and then give them low grades when their best is not as good as that of others? Why, for that matter, do we give grades at all? [43].

I predict that in the not-too-distant future schools as most are presently structured will be as out of date as the workhouses of the 19th century and will probably be perceived in much the same way – fundamentally well-intentioned but dull, patriarchal, hierarchical and grim. There have been several attempts over the years in different places to promote and develop progressive learning institutions, placing an emphasis on community education, with adults learning alongside children, but the forces of conservatism have, for the most part, seen them wither.

I contend that everyone wants to create aesthetic significance in some way or other. Those people with whom I have talked and who pay particular attention to this in making art do it for several reasons. In the main these reasons are related to the aims for art education outlined in Section One and which can be grouped into social utility, visual literacy and personal growth. Of these, personal growth is likely to stand out as being of most relevance to the individual; individuals are more concerned with expressing their feelings, exploring the qualities of visual form, and invention than with, for example,

understanding and transmitting cultural heritage. People also make art as a way of challenging the status quo; the very nature of that loose set of ideas which constitutes the concept of art facilitates a wide range of approaches and media and is therefore a suitable vehicle for creative expression. Tom Barone in his book *Touching Eternity: The Enduring Outcomes of Teaching* [44], examines some basic issues concerning education by way of a qualitative study of a high school art teacher and the impact of his teaching on students. It is not surprising that an art teacher was chosen, as his subject encapsulates many of the 'enduring outcomes of teaching', outcomes which result from providing students with the opportunity to gain self-esteem through their art-making and by encouraging students to express themselves in their artwork. Barone also highlights how teachers can learn from their students. It is only in a learning environment characterised by mutual respect where individuals are valued that such meaningful two-way learning can occur.

Developmental psychologists have demonstrated that the higher levels of achievement in art cannot be attained through maturation or 'facilitation' alone. In order for people to realise their creative potential, they need to be taught. Teachers are important – they make a difference. However, schools need to be rather different kinds of places than many of them are at present. They need to be places where cooperative and creative working can flourish. I look forward to the day when all schools are genuine centres of the community, with adults learning alongside children and everyone's real needs are addressed in an environment that facilitates genuine personal growth.

Concluding remarks

Much contemporary art is concerned with social commentary and the primacy of idea over object. This has been promoted in some schools and colleges to the extent that there appears to be a need to reassert the role of 'traditional' art-making. This need is reflected in the rise of those who advocate a return to traditional ideas about the nature of art and art production [45]. The importance of imagination, perception and skill through making is being gradually reasserted [46]; passionate debate has appeared in academic journals and newsletters. There is an ongoing debate about the nature of art and the kind of work school students ought to be engaged with, exemplified by, for example, the letters to the editor of the newsletter of NSEAD [47].

For my part, I believe that the value of art lies in its potential to give new vision, to give aesthetic delight, to give a focus of interest that is complex and multi-layered and occasionally to startle or intrigue. Making art gives vent to an essential human capacity often, happily, for the benefit of others when done well. The value of art in education lies also in its potential to surprise, to break down barriers to thinking. Its very structures and working methods enable individuals to develop their understanding of themselves and the world around

them. Through making, experimenting with materials and critically engaging with a range of visual forms, people celebrate their humanity.

It is important for both students and teachers to be given a voice; many are brow-beaten by bureaucracy and pressured to 'perform' in a way which militates against creative thought and action. We need an educational environment where, in John Steers' words, 'risk-taking, personal enquiry and creative action' are promoted [48]. In order to fulfil our potential and to be able to create aesthetic significance in a confident way, we need to be taught. All learners can benefit from the flexible and multi-layered approach to teaching and learning that is characteristic of the best art teaching. Art education (or whatever we choose to call it) involves more than learning art skills and art concepts; engaging in art is a way of being and knowing, it is intensely personal and involves both public display and reflective introspection. People like creating; they value the sense of achievement inherent in this. Making art – creating aesthetic significance – is a universal human trait. This trait can be/is developed through instruction in techniques and through being in an appropriate environment. Some individuals will have a particular aptitude, an inherited predisposition, in, for example, the ability to see formal relationships; this aptitude might be associated with particular intelligences, such as spatial or naturalistic. Individuals, while having similar intelligences, might have differing learning styles. While all can be taught to be skilled in art-making, only a few will become highly skilled but even these will require the appropriate learning environment in order to develop fully. In such an environment students are valued and listened to – they are treated as individuals. The optimum learning environment is characterised by being visually stimulating, with diversity, rather than homogeneity, encouraged. I suggest that the teaching skills and the learning environment that characterise good art teaching provide an appropriate model for all learning. The singular contribution which participating in arts activities makes to young people's development lies in its capacity to provide a conduit for expression, thereby affirming identity.

Specialist teachers of art and design should be involved with the teaching of practical skills, to show how to make things stay together, how to paint, draw and print and how to use new technologies creatively. At the end of the period of compulsory education, all young people should be graphically able and visually sensitive – enough to draw convincingly, construct soundly and be able to appreciate when such things have been done well.

Learning about visual culture, while a worthwhile end in itself, should, in my view, of necessity be secondary to practical work in a school art room. However, other benefits of an education in art, such as perceptual discrimination, are facilitated through guided instruction in understanding the varieties of visual form that arise from different cultures. In the years of compulsory schooling [49] there will be some whose preferred learning style in the art room is best

accommodated through 'critical and contextual study'. In a truly democratic system, young people need to have a say in the kind of visual form that is to be the focus of attention; curriculum content needs to be negotiated, not imposed. When it is deemed necessary to assess students' artwork, the assessment process should be formative, negotiated and portfolio based. I see no reason why such a process cannot be used across the whole curriculum.

In this book I have attempted to marry new ideas with old. I have rejected some elements of post-modern thought in favour of traditional views on the nature of what is of value in visual form, such as skill in the manipulation of media. I have accepted that learning about art is fraught with problems about what is to be learned – what visual forms constitute the canon, if any – and have put forward the established idea of the primacy of studio practice and that in the main, critical and contextual study should be entered into primarily to inform young learners' own practical work. This is not because the study of visual form is not of value but that making should be prioritised, particularly in early adolescence. Moreover, I suggest that it is asking too much of teachers of art to be responsible for what in effect is media studies, aesthetics, art history and art criticism plus, for the adventurous, anthropology, psychology, philosophy. As Howard Gardner says

> *Art education is too important to be left to any one group, even that group designated as 'art educators'. Rather, art education needs to be a cooperative enterprise involving artists, teachers, administrators, researchers, and the students themselves* [50].

Not to mention anthropologists, psychologists, philosophers and the rest.

I have presented a case for the importance of practical art teaching and have suggested that a learner-centred approach be adopted. Such an approach should value imagination and expression and should take place in an environment where individuals are taught practical skills in the handling of materials and media and where learners are encouraged to develop their own sense of identity. These things are not new, but in the face of confusion about the role of art in people's lives and the form it might take, they need to be reasserted and woven into recent findings in developmental psychology and the nature of learning. The roots of learner-centred teaching go deeper than the 'free expression' era of the post-war period, finding their most eloquent early expression in the writings of Pestalozzi. Education has moved away from the idea of art for art's sake and romantic notions about the sanctity of art. I hope to have demonstrated that art is important for the psychological and social health of people and of society as a whole. Art, however, is not as important as the people whose lives it enhances.

As to why humans make art, I have argued that it is a natural desire and, like eating and sex, is (in its spontaneous and naturally occurring form) not only a pleasurable activity but also an activity which humans can feel compelled to do. I recently received a letter from a Cambridge art teacher who, knowing that I was looking into reasons for making art, asked his year eight (12 to 13 year olds) class the question 'why do we do art?' Their responses were almost entirely focused upon individual creative expression, although this one went a bit further:

Why do we do art?
• *To further our concentration and skills of imagination And make us look more closely into things*
• *It also teaches us to put ideas or things around us into a new physical form.*
• *We also do art to further our creative ideas and understanding of the world* [51].

Perhaps I might not have needed to do quite so much reading if I had consulted these children a year ago, although a year ago I suspect that they would have had different views. It probably comes down to the basic level of the schoolboys' joke about why dogs lick their balls . . . the answer, of course, being 'because they can'.

Notes and references for Section Four

[1] Chomsky, N. (1975) *Reflections on Language*. New York: Pantheon. Cited in Pinker, S. (2002) *The Blank Slate -The Modern Denial of Human Nature*. London: Penguin.

[2] Dutton, D. (2001) Aesthetic Universals, in B. Gaunt and D.M. Lopez (eds.) *The Routledge Companion to Aesthetics*. New York: Routledge.

[3] Dutton, D. (2003) Aesthetics and Evolutionary Psychology, in J. Levinson (ed.) *The Oxford Handbook for Aesthetics*. New York: Oxford University Press.

[4] This is known as 'biophilia', coined by Wilson in his book of the same name: Wilson, E.O. (1984) *Biophilia* Cambridge, Mass.: Harvard University Press.

[5] Steinhart, P. (2004) *The Undressed Art – Why we draw*. New York: Alfred A. Knopf, pp. 11-12.

[6] See, for example, Furth, H.G. (1966) *Thinking without Language: Psychological Implications of Deafness*. New York: The Free Press.

[7] Vygotsky, L.S. (1962). *Thought and Language*. New York: M.I.T. Press, p.133.

[8] Whorf, B.L. (1956), in J.B. Carroll (ed.) *Language, Thought and Reality*. New

York: Wiley.

[9] Lenneberg, E.H. (1961) 'Color Naming, Color Recognition, Color Discrimination: A Reappraisal'. *Perceptual and Motor Skills,* 12, 375-82.

[10] Dissanayake, E. (1995) *Homo Aestheticus. Where Art Comes From and Why*. London: University of Washington Press. In *Homo Aestheticus*, Dissanayake develops the argument she put forward in an earlier text (Dissayanake, E. (1988) *What is Art For?* Seattle: University of Washington Press), where she makes a case for viewing art from a 'species-centric' perspective.

[11] Pinker, S. (1997) *How the Mind Works*. New York: Norton. See Chapter 8.

[12] Scarry, E. (2000) *On Beauty – and Being Just*. London: Gerald Duckworth. The quotation is from p. 3 and is the opening paragraph.

[13] McFee, J.K. (1986) 'Cross-cultural inquiry into the social meaning of art: Implications for art education'. *Journal of Multi Cultural and Cross Cultural Research in Art Education*, 4, (1), 6-16. The quotation is from p. 7. For a fuller account of McFee's ideas, see McFee, J.K. (1978) 'Cultural Influences on Aesthetic Experience', in J. Condous, J. Howlett and J. Skull (eds.) (1980). *Arts in Cultural Diversity*. Sydney: Holt, Rinehart and Winston.

[14] ibid. pp. 7 and 8

[15] Dutton, D. (2003). The quotation is from section 4 on 'problem-solving and story-telling'.

[16] 'Critical and Contextual Studies' is the preferred term in the UK for those activities in art education that are not directly concerned with making; 'art appreciation' is another term but has fallen largely into disuse. In America, where 'Discipline Based Art Education' has taken root, the disciplines of aesthetics, art history and art criticism are named as the non- studio aspects of art education. In the English National Curriculum, 'Knowledge and Understanding' has become a 'catch-all' term to describe the non-practical element of the art and design curriculum.

[17] Greene, M. (1995) *Releasing the Imagination – Essays on Education, the Arts and Social Change*. San Francisco: Jossey-Bass. The quotation is from p. 137.

[18] ibid. p. 138.

[19] Steers, J. (2004) 'Art and Design', in J. White (2004) (ed.) *Rethinking the School Curriculum*. London: RoutledgeFalmer. The quotation is from p. 30.

[20] ibid. p. 41.

[21] This quotation is from 'a letter to Greaves, xxiv, 117' cited by a 19th-century Cambridge professor of education, Robert Quick, in *Essays on Educational*

Reformers published in London by Longmans in 1891 (the first edition being published in 1868), p. 368.

[22] Edwards, B. (1979) *Drawing on the Right Side of the Brain*. Los Angeles: J.P. Tarcher.

[23] Reid, L.A. (1986) *Ways of Understanding and Education*. London: University of London Institute of Education. The quotation is from p. 131.

[24] Reid quotes verses from *Afterwards* by Thomas Hardy, in L.A. Reid (1986) *Ways of Understanding and Education*. London: Heinemann, pp. 129-30.

[25] Bancroft, A. (2005) 'What Do Dragons Think About in their Dark Lonely Caves? or Critical Studies: The Importance of Knowledge', in R. Hickman (ed.) *Critical Studies in Art and Design Education*. Bristol: Intellect. Originally published in *JADE* 14 (1).

[26] Antony Gormley was interviewed by Jill Craven. The quotations are from the Times Educational Supplement *Friday* magazine, 4 October 2002, pp. 8-10.

[27] To clarify the terms I am using, it might be useful to distinguish between various terms that are associated with assessment, which is a 'parent concept', covering:

Evaluation – judging the value of; the process through which evidence is secured and judged with respect to its educational value;

Testing – one procedure through which some kinds of evidence are obtained; it secures a sample of a students' or group's behaviour or product through a mechanism – a 'test';

Examination refers to a formal process whereby a pupil's achievement over a specified period of time in a particular place is measured against stated criteria;

Measurements deals with a quantification of data;

Grading is the assignment of a symbol to a person's performance, often a letter (ABCDE) is used to indicate some level of performance, relative to some criteria;

Achievement refers to the overall accomplishment of a pupil, including personal factors;

Attainment refers to the standard or quality of work measured against set criteria.

[28] There is ongoing research focusing upon the effect of public examinations in art with regard to its potential for having a negative effect upon the kind of art curriculum that is delivered to students at younger ages. See the EPPI

(Evidence for Policy and Practice Information and Coordination) website http:// eppi.ioe.ac.uk for the first 'protocol': *The Impact of Formal Assessment on Secondary School Art & Design Education*, authored by Professor Rachel Mason *et al.*

[29] Richardson, M. (1948) *Art and the Child*. London: London University Press.

[30] Atkinson, D. (2002) *Art in Education: Identity and Practice*. London: Kluwer Academic Publishers. See p. 195.

[31] ibid.

[32] I have borrowed this term from the field of aesthetics; it was first used by George Dickie. Dickie, G. (1971) *Aesthetics: An Introduction*. Indianapolis: Bobbs-Merrill, p. 101.

[33] This is a reference to Eisner's early paper on assessment: E. Eisner (1971) 'How Can You Measure a Rainbow?' *Art Education*. 24 (5) NAEA.

[34] Eisner, E. (2002) *The Arts and the Creation of Mind*. London: Yale University Press.

[35] Finney, J. (2002) 'Assessing What is Important', in *Name – The National Association of Music Educators Magazine*, (2) 9, p. 9.

[36] Criterion referencing refers to a pupils' performance (usually as demonstrated by a particular product) and is assessed relative to a pre-specified objective. Criterion referencing assumes to some extent that there are clearly defined standards and that there exists bodies of skills/understandings, etc. which everyone accepts. Criterion referencing is directly linked to the behavioural objectives approach to learning in that objectives (and standards to be attained) are pre-specified. There are at least two other contexts that can be used for assessing pupils' progress and performance: (1) Norm referencing – a pupils' performance compared with the rest of the group to which the pupil belongs. Norm referencing has been the normal procedure for the distribution of grades in public examinations. This system makes it difficult to assess 'uniqueness' (and therefore creativity/originality/personal expression since it is concerned with examining those characteristics that are shared by all members of the group; (2) Developmental referencing – a pupils' present performance is compared with past performances. Developmental referencing (sometimes known as 'ipsative') is more learner-centred and perhaps more 'humanitarian'. It is concerned with individuals' growth and development; assessment is often made by 'negotiation' between teacher and taught and is linked to self-assessment. Developmental referencing re-inforces positive qualities.

[37] This particular student, Clare, subsequently became a very successful teacher.

[38] Ross, M. (1986) 'Against Assessment', in *Assessment in Arts Education*. Oxford: Pergamon.

[39] Formative assessment is usually continuous throughout the process of the learning activity. It is recognised by most art educators that formative assessment is preferable, as it is concerned with the process (rather than the product) while giving feedback on progress rather than assessing and grading a finished product in isolation from the producer. Summative assessment occurs at the end of a course of activity and therefore focuses on the finished product(s). It is often considered to be an inappropriate method for assessing the work of pupils who have engaged in loosely prescribed activities, where the outcomes are expected to be individual, personal and expressive.

[40] Gormley, op. cit. note 26.

[41] Noddings, N. (2003). *Happiness and Education*. Cambridge: Cambridge University Press.

[42] Noddings, N. (1992) *The Challenge to Care in Schools*. New York: Teachers College Press.

[43] Noddings, N. (2003) op. cit. p. 2.

[44] Barone, T. (2001) *Touching Eternity: The Enduring Outcomes of Teaching*. New York: Teachers College Press.

[45] See, for example, the on-line article by Khami, M. M. (2002) entitled 'Where's the Art in Today's Education'. This article criticises moves towards a 'visual culture' approach to teaching art and advocates a return to a more conservative approach. See http://www.aristos.org/whatart/arted-1.htm. Accessed April 2004.

[46] Stuart Richmond, for example, argued in 1998 that: 'the practice of art in education involves students in skill development, use of materials, and creative process'. Richmond, S. (1998) 'In Praise of Practice: A Defence of art-making in Education'. *Journal of Aesthetic Education*, 32, (2), 11-20; quotation from p. 11.

[47] See, for example, *A'N'D*, the newsletter of the National Society for Education in Art & Design (NSEAD), issues 10 and 11, 2004.

[48] Steers, J. (2004) op. cit., p. 40.

[49] The years of compulsory schooling in the UK are from age five to age sixteen. I feel that this is too many. On the condition that schools, as centres of the community, are open to all, day and night, with adults learning alongside

children, I believe that young people ought to be allowed to move into the world of work, apprenticeship or specialised study as they see fit, coming back into fulltime education at any point during their lifetime.

[50] Gardner, H. (1993) *Multiple intelligences: The Theory in Practice*. New York: Basic Books, p. 143.

[51] This quotation is from a pupil at Parkside School, Cambridge. His art teacher is Mr Richard Keys, who has recently received a glass commemorative vase from Cambridgeshire Local Education Authority to mark his long service.

Bibliography

Allison, B. (1972) Sequential Learning in Art. Paper delivered to the Rolle College Conference.

Allison, B. (1973) 'Sequential Programming in Art Education: A Revaluation of Objectives', in D.W. Piper (ed.) *Readings in Art and Design Education Book 1 – After Hornsey* pp. 59-68. London: Davis-Poynter.

Allison, B. (1982) 'Identifying the Core in Art and Design'. *Journal of Art and Design Education,* 1, (1), 59-66.

Allison, B. (1988) 'Art in Context'. *Journal of Art and Design Education,* 7, (2), 175-84.

APU (1983) *Aesthetic Development.* Discussion document on the assessment of aesthetic development through engagement in the creative and performing arts. London: APU.

Atkinson, D. (2002). *Art in Education: Identity and Practice.* London: Kluwer Academic Publishers.

Bancroft, A. 'What Do Dragons Think About in their Dark Lonely Caves? or Critical Studies: The Importance of Knowledge', in R. Hickman (ed.) (2005) *Critical Studies in Art and Design Education.* Bristol: Intellect. Originally published in *JADE* 14 (1).

Barb, W. B. and R.H. Swassing (1979) *Teaching Through Modality Strengths: Concepts and Practices.* Columbus, OH: Zaner-Blosser.

Barber, N. (1964) *Conversations with Painters.* London: Collins.

Barkan, M. (1962) 'Transition in Art Education: Changing Conceptions of Curriculum Content and Teaching'. *Art Education,* 15, 12-18.

Barkan, M.(1966) 'Curriculum Problems in Art Education', in E.L. Mattil (ed.) *A Seminar in Art Education for Research and Curriculum Development* (USDE Cooperative Research Project No. V-002) (pp.240-55). University Park: The Pennsylvania State University.

Barone, T. (2001) *Touching Eternity – The Enduring Outcomes of Teaching.* London: Teachers College Press.

Barrett M (1982) *Art Education – A Strategy for Course Design.* London: Heinemann.

Black, M. (1973) 'Notes on Design Education in Great Britain', in D.W. Piper (ed.)

Readings in Art and Design Education Book 1 – After Hornsey. London: Davis-Poynter.

Bonnett, M. (1994) *Children's Thinking*. London: Cassell.

Bruner, J. (1960) *The Process of Education*. Cambridge: Harvard University Press.

Bruner, J. (1966) *Toward a Theory of Instruction*. Cambridge: Harvard University Press.

Bruner, J., J. Goodnow and G. Austin (1956) *A Study of Thinking*. London: John Wiley.

Chomsky, N. (1975) *Reflections on Language*. New York: Pantheon.

Church, M. (1984, May 4th) 'A Response to be Eradicated'. *Times Educational Supplement,* p. 2.

Clark, R. (1998) 'Doors and Mirrors in Art Education: Constructing the Postmodernist Classroom', in *Art Education*, 51, (6).

Cox, M. (1998). 'Drawings of People by Australian Aboriginal Children: The Inter-mixing of Cultural Styles', in *The Journal of Art and Design Education*, 17 (1) pp. 71-9.

CSAE (1982) *Broadening the Context*. Critical Studies in Art Education Project: Occasional Paper no. 1. Wigan: Drumcroon.

Csikszentmilhalyi, M. (1996) *Creativity: Flow and the Psychology of Discovery and Invention*. New York: HarperCollins.

Csikszentmihalyi, M. (1999) 'Implications of a Systems Perspective for the Study of Creativity', in R. J. Sternberg (ed.) *Handbook of Creativity*. Cambridge: Cambridge University Press.

Curriculum Development Council (2000*) Key Learning Area: Arts Education*. Hong Kong: Hong Kong Government [pp. 12-13].

DES (1977) *Education in Schools: A Consultative Document* (Green Paper CMND 5720). London: HMSO.

DES (1985a) *Better Schools: A Summary*. London: HMSO.

DES (1985b) *Education for All* (The Swann Report). London: HMSO.

DES (1992) *Art in the National Curriculum (England)*. London: HMSO.

Dewey, J. (1902) *The Child and the Curriculum*. Chicago: University of Chicago Press.

DFEE (1999) *All Our Futures: Creativity, Culture and Education*. A Report by the National Advisory Committee on Creative and Cultural Education [the

NACCCE report]. Sudbury: DFEE publications.

Dickie, G. (1971) *Aesthetics: An Introduction*. Indianapolis: Bobbs- Merrill.

Dissayanake, E. (1988) *What is Art For?* Seattle: University of Washington.

Dissanayake, E. (1995) *Homo Aestheticus. Where Art Comes From and Why*. London: University of Washington Press.

Duncum, P. and T. Bracey (eds.) (2001) *On Knowing – Art and Visual Culture*. Christchurch, NZ: Canterbury University Press.

Dutton, D. (2001) 'Aesthetic Universals', in B. Gaunt and D.M. Lopez (eds.) *The Routledge Companion to Aesthetics*. New York: Routledge.

Dutton, D. (2003) 'Aesthetics and Evolutionary Psychology', in J. Levinson (ed.) *The Oxford Handbook for Aesthetics*. New York: Oxford University Press.

Edwards, B. (1979) *Drawing on the Right Side of the Brain*. Los Angeles: J.P. Tarcher.

Efland, A. (1990) *A History of Art Education*. New York: Teachers College Press.

Efland, A. (2002) *Art and Cognition – Integrating the Visual Arts in the Curriculum*. New York: Teachers College Press.

Egan, K. and D. Nadaner (1988) (eds.) *Imagination across the Curriculum*. Milton Keynes: Open University Press.

Eisner, E. and M. Day (eds.) (2004) *Handbook of Research and Policy in Art Education*. Mahwah, NJ: NAEA: Lawrence Erlbaum.

Eisner, E. (2002) *The Arts and the Creation of Mind*. London: Yale University Press.

Eisner. E. (1998) 'Does Experience in the Arts Boost Academic Achievement?' *Journal of Art & Design Education,* 17 (1), 51-60.

Eisner, E. (1971) 'How Can You Measure a Rainbow?' *Art Education* 24, (5).

Eisner, E. (1969) *Teaching Art to the Young: A Curriculum Development Project in Art Education*. Stanford: School of Education, Stanford University.

Eisner, E. (1968) 'Curriculum Making for the Wee Folk: Stanford University's Kettering Project'. *Studies in Art Education*, 9, (3), 45-56.

Eisner, E. and D. Ecker (eds.) (1966) *Readings in Art Education*. Toronto: Xerox.

Feist, G. (1999) 'The Influence of Personality on Artistic and Scientific Creativity', in R. Sternberg (ed.) *Handbook of Creativity*. Cambridge: Cambridge University Press.

Feldman, D. (1980) *Beyond Universals in Cognitive Development*. New Jersey: Abley.

Feldman, E.B. (1970) *Becoming Human Through Art*. Englewood Cliffs: Prentice-Hall.

Fielding, M. (1996) 'Why and How Learning Styles Matter: Valuing Difference in Teachers and Learners', in S. Hart (ed.) *Differentiation and Equal Opportunities*. London: Routledge.

Field, D. (1970) *Change in Art Education*. London: Routledge and Kegan Paul.

Finney, J. (2002) 'Assessing What is Important', in *Name – The national Association of Music Educators Magazine*, (2) 9.

Finney, J., R. Hickman, M. Morrison, B. Nicholl and J. Ruddock (2005) *Rebuilding Pupils' Engagement through the Arts*. Cambridge: Pearson.

Gardner, H. (1973) *The Arts and Human Development*. New York: Wiley.

Gardner, H. (1980) *Artful Scribbles: The Significance of Children's Drawings*. New York: Basic Books.

Gardner, H. (1982) *Art Mind and Brain: A Cognitive Approach to Creativity*. New York: Basic Books.

Gardner, H. (1983) *Frames of Mind: The Theory of Multiple Intelligences*. New York: Basic Books.

Gardner, H. (1990) *Art Education and Human Development*. (Occasional Paper 3). The Getty Centre for Education in the Arts.

Gardner, H. (1993) *The Unschooled Mind*. London: Fontana.

Gardner, H. (1993) *Multiple Intelligences: The Theory in Practice*. New York: Basic Books.

Gardner, H. (1999) *Intelligence Reframed: Multiple Intelligences for the 21st Century*. New York: Basic Books.

Gardner, H. and Perkins, D. (eds.) (1989) *Art Mind and Education*. Urbana: University of Illinois Press.

Gardner, H., E. Winner and M. Kircher (1975) 'Children's Conceptions of the Arts'. *Journal of Aesthetic Education*, 9, (3), 60-7.

Giroux, H. (1996) 'Towards a Postmodern Pedagogy', in L. Cahoone (ed.). *From Modernism to Post Modernism: An Anthology*. Cambridge, MA: Blackwell.

Goldsmith, L.T. and D.H. Feldman (1988) 'Aesthetic Judgement: Changes in People and Changes in Domains' [commentary on M. Parsons (1987) *How We Understand Art*]. *Journal of Aesthetic Education*, 22, (4), 85-92.

Greene, M. (1995) *Releasing the Imagination – Essays on Education, the Arts and*

Social Change. San Francisco: Josscy-Bass.

Greer, W.D. (1984) 'Discipline-Based Art Education: Approaching Art as a Subject of Study'. *Studies in Art Education*, 25 (4), 212-18.

Hall, J. (2004) 'The Spiritual in Art', in R. Hickman (ed.) *Art Education 11-18: Meaning, Purpose and Direction* (2nd ed.). London: Continuum.

Hargreaves, D.H. (1983) 'The Teaching of Art and the Art of Teaching', in M. Hammersley and A. Hargreaves (eds.) *Curriculum Practice: Some Sociological Case Studies*. London: Falmer.

Harland, J., K. Kinder, P. Lord, A. Stott, I. Schagen and J. Haynes with L. Cusworth, R. White and R. Paola (2000) *Arts Education in Secondary Schools: Effects and Effectiveness*. Slough, Berks: NFER.

Hickman, R. (1999) 'Representational Art and Islam – A Case for Further Investigation', in R. Mason and D. Boughton (eds.) *Beyond Multi-Cultural Art Education – International Perspectives*. London: Waxmann.

Hickman, R. (2000) 'Adolescents' Concepts of the Concept "Art"'. *Journal of Aesthetic Education* (Spring 2000) 107-12.

Hickman, R. (2001) 'Art Rooms and Art Teaching'. *Art Education* January 2001, 6-11.

Hickman, R. (2002) 'The Role of Art & Design in Citizenship Education', in L. Burgess and N. Addison (eds.) (2003) *Issues in Art & Design Education*. London: RoutledgeFalmer.

Hickman, R. (ed.) (2004) *Art Education 11-18: Meaning, Purpose and Direction* (2nd ed.). London: Continuum.

Hickman, R. (ed.) (2005) *Critical Studies in Art and Design Education*. Bristol: Intellect. Originally published in *JADE* 14 (1).

Hickey, D. (1975) *The Development and Testing of a Matrix of Perceptual and Cognitive Abilities in Art Appreciation, Children and Adolescents*. Unpub. Ph.D. Thesis: University of Indiana, Minneapolis.

Housen, A. (1983) *The Eye of the Beholder: Measuring Aesthetic Development*. Unpub. Ph.D. Thesis: Harvard Graduate School of Education.

Kemp, A. (1981) 'The Personality Structure of the Musician. Part 1: Identifying a Profile of Traits for the Performer'. *Psychology of Music*, (9) 3-14.

Klausmeier, D., E. Ghatala and D. Frayer (eds.) (1974) *Conceptual Learning and Development: A Cognitive View*. New York: Academic Press.

Kohlberg, L. (1981) *Essays on Moral Development,* vols. 1 and 2. San Francisco:

Harper and Row.

Kolb, D. (1984) *Experiential Learning*. Englewood Cliffs: Prentice-Hall.

Lansing K. (1971) *Art Artists and Art Education*. New York: McGraw-Hill.

Lowenfeld, V. (1947) *Creative and Mental Growth*. New York: Macmillan.

Mason, R. (2004). 'The Meaning of Craft', in R. Hickman (ed.) *Art Education 11-18: Meaning, Purpose and Direction* (2nd ed.). London: Continuum.

Matthews, J. (1999) *The Art of Childhood and Adolescence*. London: Falmer.

McFee, J.K. (1986) 'Cross-cultural Inquiry into the Social Meaning of Art: Implications for Art Education'. *Journal of Multi Cultural and Cross Cultural Research in Art Education*, 4, (1), 6-16.

McFee, J.K. (1980) 'Cultural Influences on Aesthetic Experience', in J. Condous, J. Howlett and J. Skull (eds.) *Arts in Cultural Diversity*. Sydney: Holt, Rinehart and Winston.

NAEP (1981) *Art and Young Americans, 1974-1979: Results from the Second National Assessment in Art*. (Art Report No. 10-A-01) Denver.

Noddings, N. (1992) *The Challenge to Care in Schools*. New York: Teachers College Press.

Noddings, N. (2003) *Happiness and Education*. Cambridge: Cambridge University Press.

NSAE (1984) 'Response to "Aesthetic Development"'. *Journal of Art and Design Education*, 3 (3), 303-316. The quotation is from p. 313.

Pariser, D. (1988) 'Review of Michael Parsons' *How We Understand Art'*, in *Journal of Aesthetic Education*, 22, (4), 93-102.

Parsons, M. (1987) *How We Understand Art: A Cognitive Developmental Account of Aesthetic Experience*. New York: Cambridge University Press.

Perkins, D. (1994) *The Intelligent Eye – Learning to Think by Looking at Art*. Santa Monica: Getty, p. 15.

Peel, E.A. (1971) *The Nature of Adolescent Judgement*. London: Staples Press.

Piaget, J. (1952) *The Origins of Intelligence in Children*. New York: International University Press.

Pinker, S. (1997) *How the Mind Works*. New York: Norton.

Pinker, S. (2003) *The Blank Slate*. London: Penguin.

Polanyi, M. (1967) *The Tacit Dimension*. London: Routledge.

Proulx, E.A. (1993) *The Shipping News*. London: Fourth Estate.

Read, H. (1947) *Education Through Art*. London: Faber and Faber.

Quick, R. (1891) *Essays on Educational Reformers.* (2nd ed.) London: Longmans.

Ree H. (1981) 'Education and the Arts: Are Schools the Enemy?' in M. Ross (ed.) *The Aesthetic Imperative*. Oxford: Pergamon, pp. 90-9.

Reid, L.A. (1986) *Ways of Understanding and Education*. London: University of London Institute of Education.

Richardson, M. (1948) *Art and the Child*. London: London University Press.

Richmond, S. (1998) In Praise of Practice: A Defence of art-making in Education. *Journal of Aesthetic Education*, 32, (2), 11-20.

Rosentiel, A., P. Morison, J. Silverman and H. Gardner (1978) 'Critical Judgement: A Developmental Study'. *Journal of Aesthetic Education*, 12, 95-197.

Ross, M. (1985) 'Beyond the Blue Horizon: Arts Education and the New Curriculum'. *Secondary Education Journal*, 15, (3), 8-10.

Ross, M. (1986) 'Against Assessment', in M. Ross (ed.) *Assessment in Arts Education*. Oxford: Pergamon.

Scarry, E. (2000) *On Beauty – and Being Just*. London: Gerald Duckworth.

Schools' Council (1976). *Research Programme Report* (Crafts Commission Group). London: Schools' Council.

Siegesmund, R. (1998) 'Why Do We Teach Art Today?' in *Studies in Art Education*, 39, (3), pp. 197-213.

Sikes, Patricia J. (1987) 'A Kind of Oasis: Art Rooms and Art Teachers in Secondary Schools', in L. Tickle (ed.) (1987) *The Arts in Education – Some Research Studies*. Beckenham: Croom Helm.

Smith, R.A. (1992) 'Building a Sense of Art in Today's World'. *Studies in Art Education*, 33 (2) pp. 71-85.

Steinhart, P. (2004) *The Undressed Art – Why We Draw*. New York: Alfred A. Knopf.

Steers, J. (1997) Ten Questions about the Future of Art Education. *Australian Art Education*, vol. 21, nos. 1 and 2.

Steers, J. (2004) 'Art and Design', in J. White (2004) (ed.) *Rethinking the School Curriculum*. London: RoutledgeFalmer.

Sternberg, R.J. (ed.) *Handbook of Creativity*. Cambridge: Cambridge University Press.

Tallack, M. (2004) 'Critical Studies: Values at the Heart of Education?' in R. Hickman (ed.) *Art Education 11-18: Meaning, Purpose and Direction* (2nd ed.). London: Continuum.

Tallack, M. (2001) *Artists in Education Intercultural Research Report*. Chelmsford: Essex County Council.

Tay Eng Soon (1989) Dialogue Session, reported in *Commentary* 8 (1 and 2), p. 26.

Thistlewood, D. (1993) 'Herbert Read: An Appreciation'. *Journal of Art and Design Education*, 12 (2) 143-60, p. 144.

Tickle, L. (ed) (1987) *The Arts in Education – Some Research Studies*. Beckenham: Croom Helm.

Toku, Masami (2002) 'Cross-Cultural Analysis of Artistic Development: Drawing by Japanese and U.S. Children', in *Visual Arts Research* 27 (1) issue 53.

Viola, W. (1936) *Child Art and Franz Cizek*. New York: Reynal and Hitchcock.

Walling, D.R. (2000) *Rethinking How Art is Taught: A Critical Convergence*. Thousand Oaks, CA: Corwin.

Williams, R. (1983) *Keywords*. London: Flamingo.

Wilson, E.O. (1984) *Biophilia*. Cambridge, MA.: Harvard University Press.

Wolf, D. (1988) 'The Growth of Three Aesthetic Stances: What Developmental Psychology Suggests about Discipline Based Art Education'. *Issues in Discipline Based Art Education: Strengthening the Stance, Extending the Horizons*. (Proceedings of Seminar held at Cincinnati, Ohio, May 21-24, 1987). Los Angeles: The Getty Center for Education in the Arts.

Subject Index

Name Index

Appendices

Appendix I: Coding system for determining levels of understanding in art

During normal lesson time (i.e. during an art lesson), the school students were shown examples of actual artworks and were encouraged to talk about them, prior to writing down their individual responses. This served as a 'warming up' process and involved them in general dialogue about the art objects before focusing on seven core art concepts. Three art objects were used as stimulus material, selected to give a broad representation of art objects: a ceramic sculpture, a silk-screen print and a Chinese watercolour painting. The task involved responding to these artworks in writing and/or pictorially, in any language, under the headings of Process, Content, Form, Colour and Composition, before responding to a section which asked respondents to put forward their understanding of 'Art' and 'Design'.

The responses were analysed by two art specialists, trained to identify levels of understanding of core art concepts. They were given guidelines that were based on the descriptions of theoretical levels given above and on responses from 395 secondary school students received when piloting a related aspect of a larger study. The guidelines included the following descriptions of types of response to facilitate coding:

Code 1): The concept art may be used in a restricted and particular way:

'Art is what we do in school.'

Or may be dependent upon a limited media based view:

'Art is painting and drawing.'

Code 2): This code refers to responses where the concept of art is broader than those coded '1', referring to a more extensive range of media:
'painting and drawing, sculpture, printing etc.'

There may be a 'concept based' view limited to a single viewpoint:

'Art is self-expression.'
'Art is creativity.'
'Art is anything you want it to be.'

Code 3): Responses given this code might be termed 'extended concept based'; art is seen as being concerned with the (skilful) arrangement of visual elements according to principles of organisation, to achieve meaningful (expressive, didactic, beautiful or 'significant') form. Art is perceived in a generalised way as an area of human endeavour, concerned with expressive, imaginative, creative and communicative activities and ideas associated with them.

Each script was analysed by each art specialist. Discrepancies between the analyses were noted and discussed until a satisfactory consensus was achieved.

Appendix II: General educational aims and the role of art in education

Adapted from Lansing K. (1971) *Art Artists and Art Education*. New York: McGraw-Hill.

1. The educated person is skilled in listening and observing. Art helps the individual to become skilled in sight because it forces one to look more attentively than usual at the environment; it helps people to become more perceptive by causing them to practice more intensive perception.

2. The educated person has mental resources for the use of leisure. The art process and product help individuals to develop their mental resources; art can make a unique contribution to individuals' cognitive and affective development.

3. The educated person appreciates beauty. Because art is inherently aesthetic, it involves the individual in the recognition, production and the appreciation of beauty.

4. The educated person gives responsible direction to his or her own life. Art provides some of the knowledge that it takes to make responsible decisions; it is the model of the human condition; it provides possibilities for thinking, feeling and imagination. By making those alternatives available; it gives the individual a wider choice in what to become. Thus it provides one with the freedom of mind that is necessary for the full development of character.

5. The educated person has respect for human relationships. Art is said to be a humanistic activity. People who produce or appreciate it exercise and become aware of those qualities within themselves that identify them as human beings.

6. By developing a greater awareness of their own strengths and weaknesses, they come to respect the human qualities in others. Art places a high value upon individuality. It fosters individuality and, consequently, causes its creator to appreciate and respect uniqueness in others.

7. The educated person can cooperate with others. Before people can cooperate effectively with other people they must understand themselves. The production of art brings about a greater understanding of the self through extensive concentration on one's own concepts and emotions.

8. The educated producer knows the satisfaction of producing good work. Art is work of a very high quality and often requires the total involvement of the personality. By engaging in artistic production or appreciation the individual comes to know the satisfaction of good workmanship.

9. The educated producer understands the requirements and opportunities for various jobs. Many persons wish to be professional artists. Involvement with art helps them to understand the requirements and opportunities of the profession.

10. Educated consumers develop standards for guiding their expenditure. Because the production and appreciation of art requires aesthetic sensitivity, it equips people with aesthetic criteria.

11. The educated person is an informed and skilful buyer. As producers and appreciators of art develop aesthetic standards, they become more informed and skilful buyers.

12. The educated person is sensitive to the disparities of human circumstance. Art requires sensitive observations which are often aimed at the social scene and which are concerned with some aspect of the human condition. This enables the creator and the appreciator to become more aware of social issues.

13. The educated person acts to correct unsatisfactory social conditions. Social activity is not always a matter of participating in civic groups. Writers, playwrights or painters who call attention to unsatisfactory social conditions through their work are engaging in social activity. In fact artists of all kinds frequently take the lead in such matters.

14. The educated person has defences against propaganda. Art can be an extremely effective form of propaganda because of its pleasurable and its emotional qualities. Therefore, who would be more aware of propaganda and its damaging effects than students of art?

15. The educated person respects honest differences of opinion. Art causes a person to be aware of one's own strengths and weaknesses. Such awareness is essential for the understanding and tolerance of others.

16. The educated person respects the environment. Through developing perceptual awareness and sensitivity, art helps further greater understanding of and respect for the natural and built environment.

17. The educated person is sensitive to different cultures. Understanding and appreciating the art of different cultures enables people to become more aware of and sensitive to a wide range of philosophies and beliefs.

18. The educated person is aware of the historical. A knowledge of art from different periods and contexts from which societies develop can give insights into contemporary accompanying values and issues.

Appendix III: 'Some worthwhile outcomes . . .'

From Barrett, M. (1982) *Art Education – A Strategy for Course Design.* London: Heinemann.

1. To develop the ability to perceive the world in visual, tactile and spatial terms.

2. To develop sensitivity in response to changing perception.

3. To be able to recognise the nature and form of problems inherent in self, society and the environment, with particular reference to visual and tactile experience.

4. To be able to work flexibly within an infinite range of possible solutions.

5. To be able to discriminate between the various solutions to a problem and to choose the most appropriate to self, society and the environment.

6. To be able to realise personal uniqueness in a community or in society as a whole, so that the pupil can learn from and contribute to society.

7. To develop a wide range of expression and communication skills, based upon visual and tactile experience.

8. To be able to see that all manmade objects are the result of his manipulation and organisation of the physical environment.

9. To develop self-reliance by experience in problem-solving and decision-making.

10. To be aware of the quality and effects of ideas and decisions stemming from others.

11. To understand the expression of personal feelings and impulses to such an extent that sense can be made of a world shared with others.

12. Art should be recognised as a form of thinking able to sustain creative ideas and provide a framework for judgement.

13. To develop the ability to modify what is seen so that a personal response to it can be demonstrated.

14. To develop the ability to organise marks, shapes and forms so that they communicate or demonstrate our response to what has been observed.

15. To recognise that the content of any work of art is expressed through the personal manipulation of form.

16. To externalise our personal reality through the manipulation of visual form.

17. To understand the dynamics of visual form.

18. To develop the ability to record what one has seen in two dimensions as objectively as possible.

19. To discover and understand the environment through direct manipulation of it.

20. To explore media so that they can be understood and used appropriately.

21. To externalise our personal reality through the manipulation of materials.

Appendix IV: Prompt questions

Pertaining to reasons for making art

- Do you like to draw and paint and make things [make art]?
- When did you first start to make art?
 - what form did it take?
- What caused you to make it?
- Have you ever felt compelled to make art (an inner urge)?
- Have you ever engaged in an art-making activity even though you did not feel like it?
 - if so why?
- Do you like to see the finished product?
 - is it important for you to complete the work?
- Do you enter competitions?
 - do you win?
- If the artwork were destroyed, how would you feel?
- Do you keep a record of your artwork (such as photographs)?
- Is it important for you for others to see you work?
 - anyone in particular?
- Do you get praise and encouragement when you make art?
 - from teachers?
 - from parents?
 - from friends?
 - from others?
- Do you feel that you are expressing something?
- Do you feel that making art enhances your sense of self – your identity?
- Do you feel more fulfilled or more at peace when you have made art?
- Does art-making relax/energise you?
- What kind of person is an artist?
- Are artists different?

Pertaining to views about art in schools

- Why do you think art is taught in schools?
- Do you think art should be taught on schools?
 - if so, what kind of activities should it entail? How would this benefit you?
- Should it be mainly practical?
- What about learning about artists?

Pertaining to achievement in art

- Do you think that if you do art in schools, it should be assessed?
- When you produce artwork, do you like it to be assessed?
- What would be the best way to assess artwork?
- Should it be given a grade?
- Should there be examinations in art?
- What kind of feedback would you like?

Appendix V: Questionnaire on aims for art and design in education

Prioritise in terms of what *you* feel to be most important to bear in mind when planning your lessons

Which aims are likely, in your view, to be the most important and least important in the future?

PRIORITY [1-8, 8 being lowest priority] N=47 respondents

	1		2		3		4		5		6		7		8	
[1] Enhancing students' knowledge and understanding of their cultural heritage	2	4	5	8	5	7	6	8	7	4	8	8	8	6	6	2
[2] Enhancing students' knowledge and understanding of the cultural heritage of others	2	11	4	7	6	8	4	5	4	6	12	6	10	2	5	2
[3] Enhancing students' understanding of their inner world, of feelings and imagination	10	3	4	2	9	8	3	0	3	3	2	4	5	9	11	18
[4] Facilitating practical problem-solving through manipulation of materials	8	10	15	10	5	8	6	4	4	7	4	5	4	3	1	0
[5] Facilitating creativity through developing lateral thinking skills	9	5	9	8	4	4	5	8	6	6	4	6	8	7	2	3
[6] Facilitating inventiveness and risk-taking	0	2	5	5	12	8	11	5	5	2	6	9	4	8	4	8
[7] Enhancing students' ability to make informed judgements about the made environment	4	4	1	3	1	5	5	7	7	13	8	3	5	8	16	4
[8] Enhancing students' understanding of the visual world through perceptual training	12	8	4	4	5	0	7	10	11	6	3	5	3	4	2	10

(Row label column: A I M S)